Victorian &
Edwardian
Sussex

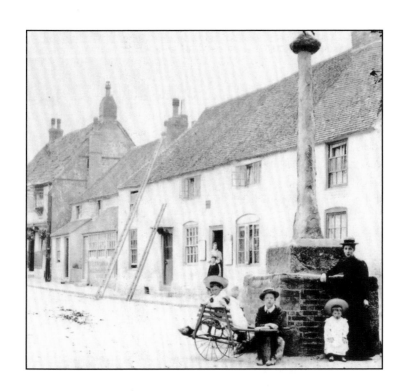

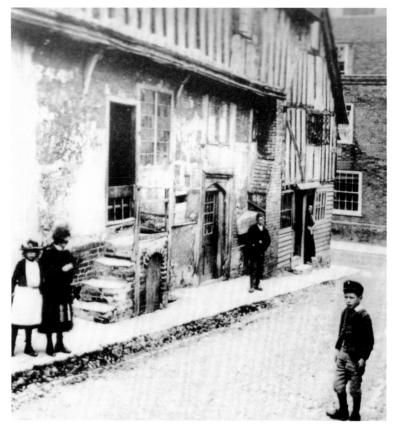

WEST STREET, RYE

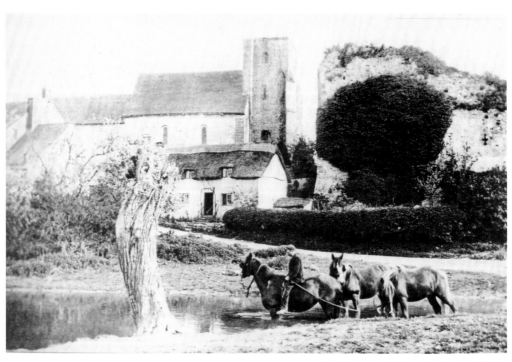

AMBERLEY CHURCH AND CASTLE

Victorian &
Edwardian
Sussex

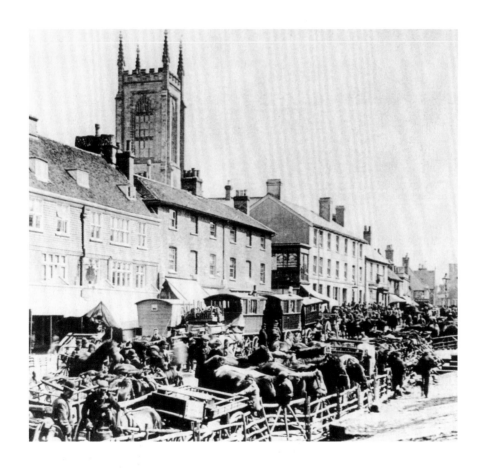

Aylwin Guilmant

AMBERLEY

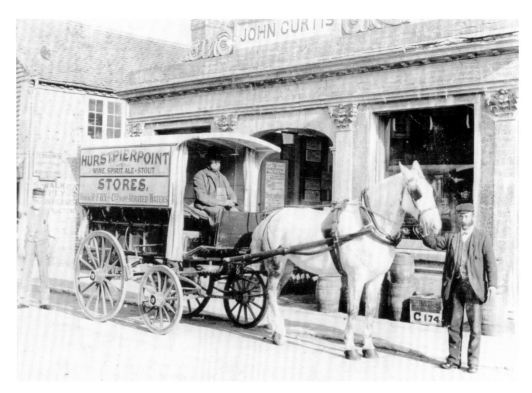

GROCER'S VAN, HURSTPIERPOINT

First published 1993 under the title *Sussex of 100 Years Ago*
This revised edition first published 2008

Amberley Publishing
Cirencester Road, Chalford,
Stroud, Gloucestershire, GL6 8PE

ISBN 978-1-84868-024-1

Typesetting and origination by Amberley Publishing
Printed in Great Britain by Amberley Publishing

God gives all men all earth to love,
But since man's heart is small,
Ordains for each one spot shall prove
Beloved over all.
Each to his choice, and I rejoice
The lot has fallen to me
In a fair ground—in a fair ground—
Yea, Sussex by the sea!

Rudyard Kipling

The origins of the people of Sussex may be seen today in our traditional character, our place names, even our colouring all can be traced to the people of the South Saxons.

In this book my aim has been to present a picture of past lives, not of the wealthy and well-born, but of the ordinary man and woman. Their lives were harsh with the threat of the workhouse ever present and few pleasures to alleviate their sufferings. The privileged minority exhorted those less exulted to a lifetime of work. However, rich and poor all faced infant mortality for this was the scourge of the times.

The photographs are mainly from the years 1880–1920 and the text, written by those who lived and loved this land, is contemporary. Certain licence has been taken with both photographs and text in order to give a broader flavour of life.

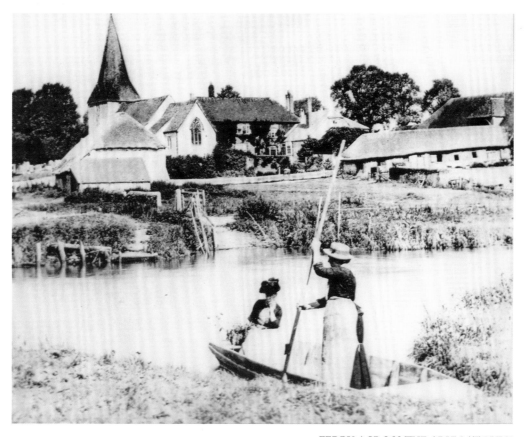

FERRY ACROSS THE ARUN AT BURY

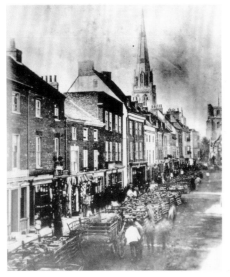

CHICHESTER CATHEDRAL AND MARKET

The majority of inhabitants in Sussex were mainly agricultural workers and as such they suffered considerably during the periods of the agricultural depression, and the era of cheap imports of meat and grain from the Colonies. Others worked on the railways, for the county had a fine network of lines which opened over a period from the 1840s to the early years of the twentieth century. In the coastal towns men were also engaged in fishing—hard work with little remuneration, where the elements had a significant influence.

Life for Victorian children, whether they lived in a cottage or a mansion, was equally hard with corporal punishment a part of life. Children attended school as young as two or three years of age, in order to enable their mothers to return to work. Domestic life was the only alternative for the daughters of the poor. Boys as young as ten were fully employed and were expected to be self sufficient. They were often semi-literate as much of their attendance at school had been seasonal. Homes were overcrowded both in the country and the towns, with three and four children sleeping in one bed. There were frequently no material possessions in their homes and food was at all times scarce, with potatoes and bread being the main ingredients of their diet. Any meat was usually reserved for the father and surprisingly there was little or no milk available in the rural areas.

The village store played a large part in the social scene. Goods were sold loose with provisions then wrapped in coloured cones of paper and the grocer bought in bulk. There was a certain amount of bartering among the poorer section of society, while credit was common among the well-to-do, who often only paid their accounts twice yearly.

Church and Chapel played a large part in the social life of the better-off middle classes. The poor had neither the energy nor the inclination to attend.

It was from my grandmother Esther Aylwin, born in 1870, that I learnt to enjoy hearing about the past and came to know and love the county of my birth.

I lived my early years on a farm. I have distant memories of stone-flagged kitchens with the adjoining dairy far more vivid than the parlour, for it was the kitchen which was the hub of a farmhouse. Other early memories relate more to smell: the friendly pig looking over the wall of his sty, the apple store, the frothing milk spurting into the pail, the smell of the new mown hay and the thrill of riding home in the waggon.

A country upbringing has much to recommend it. The roaming free in field and yard, the search for eggs and the scolding hen, the joy in finding a field of mushrooms and a stream with watercress, and in its due season the picking of flowers, nuts and berries.

A book of this nature has only been possible by the generosity of libraries, museums and other organizations who have made available their collections of photographs, many taken by local people who have captured a moment in time for posterity.

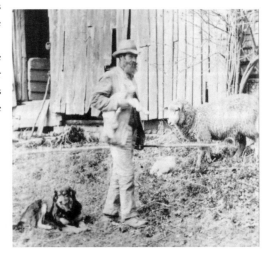

I'm just in love with all these three,
The Weald and the Marsh and the Down Countrie,
Nor I don't know which I love the most,
The Weald or the Marsh or the White Chalk Coast.
Rudyard Kipling

ORPHAN LAMB

The face of Sussex is epitomized for many by the long line of the Downs, the Weald, all that remains of a dense forest and the even-changing coastline. Sussex measures 73 miles at it longest point, and 27 miles at its broadest.

The county's coastline has changed over the years due to the longshore or littoral drift, the eastward flow of currents causing erosion in the west, the silting-up of large areas in the east. and the great storms of the twelfth and thirteenth centuries. The course of the eastern River Rother has also altered, since it previously had its outlet to the sea at New Romney in the County of Kent but after 1287 discharged its waters into Rye Bay.

Man has lived intermittently in Sussex from the Palaeolithic age to the present and the face of Sussex has changed according to the people who settled within its shores. From earliest times people from Europe had made their way across the Channel: the low coastline made invasion easy. The country's wealth in its tin, corn and fertile soil coupled with an equable climate, made it a profitable venture.

It was not until AD 43 that Sussex was successfully invaded by the Romans, and this in the main was relatively peaceful. It is believed that the Romans integrated with the local inhabitants in order to retain a strong base for their links with the continent and also to have a strategic stronghold from which to attack the warlike tribes of the west. Roman culture ultimately became superimposed on the native people. The core of Roman administration and civilization was based on the towns, the greatest of these being Noviomagus Regnum, or modern Chichester. Many of the great villas are in the west of the county, including the Roman Palace at Fishbourne. In order to serve these towns and also London the Romans built a sophisticated network of roads, the best known of which is Stane Street.

The term 'Saxon' does not appear until the seventh century but infiltration by these people into Sussex occurred from the fourth century; landing in West Sussex they mainly followed the river valleys and only later penetrated into the wooded country of the Weald. One of the earliest known tribes were the Haestingas who first arrived in Kent, subsequently spreading into Sussex as far as Hastings. They settled on an area of dry land

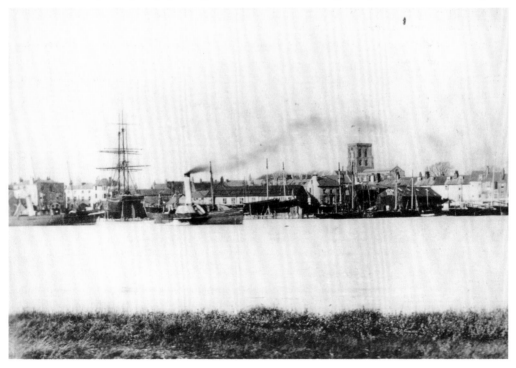

SHOREHAM HARBOUR

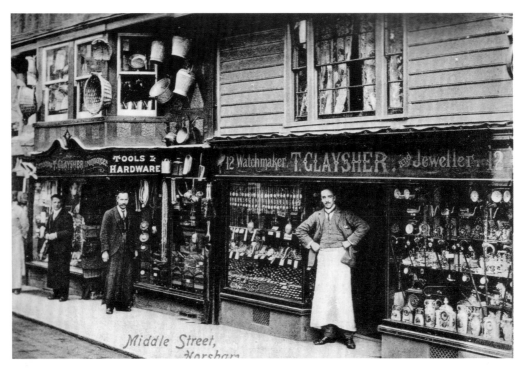

MIDDLE STREET, HORSHAM

lying between Romney and Pevensey marshes and it was these people who first made the inroads into the forests of the Weald.

Saxon domination for more than five centuries helped to bring law and stability to the country. As early as the eighth century Offa, King of Mercia, drew up a charter in which the rights of the thegns, minor nobility of the age, were defined. For the first time since the time of the Regni, Sussex became a distinct political unit. The Saxons had a system of government called 'the Witan', the forerunner of modern parliament with king and court.

The South Saxon kingdom of Sussex was the last area in the whole country to have Christianity. The seventh century saw the creation of a bishopric at Selsey, although unfortunately the cathedral there no longer exists. Many of the early churches were of wood but Sussex has a fine collection of Saxon churches, the most remarkable being Sompting, unique in the possession of a cap to its tower known as a 'Rhenish helm'.

Many Saxon place names have survived In Sussex, those with the suffix 'ing' in particular; for example Steyning, Tarring and Malling.

Modern English history may be said to commence with the Battle of Hastings in 1066, fought between the forces of Harold, the last Saxon king, and those of Duke William of Normandy. Prior to 1066 the Normans had a foothold in the county. The Manor of Ramelsie, with its port of Hastings, belonged to the Abbey of Fecamp in Normandy, as did the royal land of Steyning given to them by Edward the Confessor, but subsequently repossessed by Earl Godwin, father of King Harold. After his defeat it reverted to Fecamp.

William Duke of Normandy and King of England divided the Saxon burghs and reorganized them into six Norman Rapes, each with a port and a castle.

Hastings was one of the five original Cinque Ports, instituted by the Normans for the better defence of the coast. Rye and Winchelsea subsequently joined the confederation and their title became the 'Two Ancient Towns'. Pevensey and Seaford were later included as corporate members. Battle Abbey, a Benedictine House, was founded in fulfilment of a sacred vow made by William before the battle, that if victorious he would erect an abbey. This abbey was richly endowed by the Crown and enjoyed special privileges. Heavier rents and taxes in Norman times led to the taxation record and survey known as the Domesday Book 1086, which is the most complete record of the time in existence.

King William took over the feudal system and introduced Knight service. He demanded that the barons, to whom he gave land, should provide him with a fixed number of knights for his army. All men who owned land took an oath to his immediate superior, and he in turn to those above him for 'everyone had his lord'.

Two centuries after the Norman conquest the barons challenged the right of the king. Lewes castle was attacked by Simon de Montfort and the forces of Henry III defeated. The barons imposed certain conditions on him which may be regarded as the starting point of parliamentary democracy in England. Future sovereigns forbade the building of all private castles, therefore the nobles built instead fortified manor houses such as Hurstmonceux. one of the earliest examples of a large brick building in the country.

During the fourteenth century the French were active in raiding the coastal towns, in particular Rye and Winchelsea. Bodiam Castle was built in 1385 in order to guard the upper reaches of the eastern River Rother. The war with France curtailed trade with Europe and led to a serious decline in Sussex as a maritime commercial county.

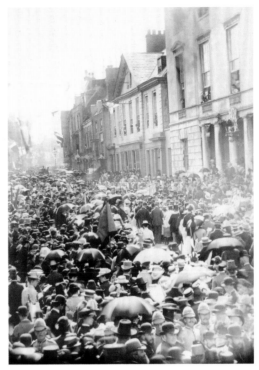

LEWES, 1887

The Middle Ages were a time of the 'Black Death' which decimated millions in Europe and left England with approximately one-third of the original population; villages were destroyed and a way of life vanished. In Sussex there are over forty 'lost' or abandoned villages, largely as a result of the plague. Throughout this same period the ravages of the sea continued causing further death and destruction.

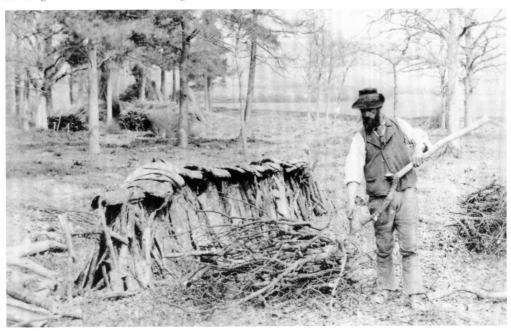

CUTTING THE COPPICE

During the Tudor era there was considerable rebuilding in Sussex; the only time this was greater was in the inter-war years of the twentieth century. Part of this surge may have been due to the Dissolution of the Monasteries, with their demolition leading to a new fund of building materials. The general population appeared to be little disturbed by the closure of these religious Institutions. 'Parham' and 'Danny' are two good examples of dwellings from this period. However, by comparison and much more numerous were the houses of the yeomen which developed into a regional vernacular style unique to this county. They were built on a timber frame and known as 'Wealden'.

It was during the mid-sixteenth century that many Protestants, persecuted for their beliefs on the Continent, arrived in Sussex and settled principally in Rye and Lewes. The former had over 1,500 persons of French extraction living in the town. Many were skilled weavers and craftsmen and they were responsible for the development of this industry.

Sussex became known as the 'black country' of England, when the iron industry was at its zenith. Inroads were made into the Wealden forests for timber—used both for charcoal working and by the Navy. Heavy Wealden clay made wet-weather travel almost an impossibility; the road system, little altered since the time of the Romans occupation, remained sadly neglected until the coming of the toll system. The iron-masters built wisely and well and many of their houses are still in domestic hands, those in the towns often having their sixteenth-century façades hidden behind later plaster. Two good examples of their houses are 'Brickwall' at Northiam and 'Batemans' at Burwash.

Land value increased and the coastal plain was subject to enclosure often instigated by the will of the more powerful landowners. Ashdown Forest was another area in dispute, only settled by the intervention of the Parliamentary Commissioners who upheld the rights of the ordinary people to graze their animals on certain areas within the confines of the forest. Corn continued to be grown on the coastal plain thereby further increasing seaborn trade from Chichester, despite the fact that its quays lay some distance from the town. Sheep flourished on the Downs, sustaining the wool trade which had been important to the economy of the county for centuries. Many local gentry experimented in the breeding and rearing of cattle, while others turned to improving the quality of the local sheep.

During Mary Tudor's brief reign, religious differences came to a head, with Protestants being burnt as heretics. In Sussex alone, twenty-seven men and women perished. The worst of these burnings took place at Lewes, ten men and women being burnt at the stake in the market place.

The war with Spain, during the reign of Elizabeth I, proved a real threat to Sussex, with warning beacons on the highest points. The Spaniards may have fought the English with guns made in Sussex as the first iron cannon had been cast at Buxted in 1543 and many were sold abroad.

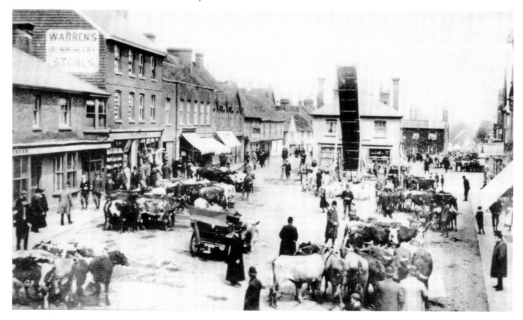

CRAWLEY MARKET

Towards the latter part of the sixteenth century prosperity in the county declined. Many of the older towns deteriorated while certain coastal ones suffered from the littoral drift. A fresh port appeared when a new cut was made to bypass the shifted mouth of the Ouse in 1539, and the village of Meeching became the port of Newhaven, still in use today.

The Civil War split local communities and caused a rift between the closely-knit Sussex aristocracy. No major engagement took place with only minor skirmishes near important iron workings. Certain of the Royalists suffered more than others: John Ashburnham had his entire estate sequestered. Ten Sussex men served among the king's judges in 1649, but it is to their credit that they abstained from signing his death-warrant. During the relatively calm years of the interregnum Sussex was further attacked by the Dutch who raided the coastal towns.

With the Restoration of the Monarchy many members of the ruling class became involved in the process of aggrandizement. Small market towns flourished and the Wealden ones often became regional centres for craft specialization.

Quakerism emerged in the 1650s, followed by other non-conformist religious groups. In addition to these new sects there were those who remained loyal to their Catholic beliefs, many of whom were found among the wealthier class. The Dissenters used private houses as meeting places as most of their congregations were drawn from the rural communities. One of the original Quaker Meeting Houses, the 'Blue Idol' at Coolham, is still in use.

It was during the period of Georgian Sussex that the large country houses were at their zenith for they epitomized the wealth and power of the ruling class. They served as general assembly rooms, the focus of the estates, their vastness alone permitting their occupants to live in comparative luxury, surrounded by ornamental parks either laid out in the new Italianate classical style or more simply as defined by 'Capability' Brown, the great landscape designer of the era.

The aristocracy took their duties seriously: they controlled not only the county, but nominated their representatives to the House of Commons, for this was the time of 'rotten boroughs' when, until the Reform Act of 1832, Sussex sent twenty-four representatives to the House of Commons, while the growing industrial towns of the north of England had none.

It was from within this leisured society that Dr Russell of Lewes first propounded the virtues of drinking and bathing in sea water. Brighton, previously a small fishing village known as Brighthelmstone, had relied entirely on its coastal trade and fishing fleet. Within a decade, c. 1760, the town was catering for a mass of visitors, many encouraged by the fact that the Prince of Wales settled there. The Prince, assisted by John Nash, converted his modest seaside residence into the Royal Pavilion. Others emulated their royal master, settling quickly into the

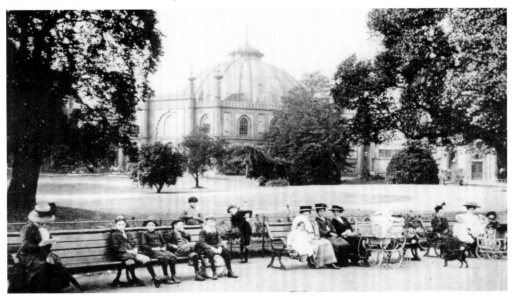

THE DOME, BRIGHTON

beautiful crescents and Squares built for them, and for which Brighton is still famous today.

England and France were again at war and during the early years of the nineteenth century Martello towers were built to defend the vulnerable coastline, together with the Royal Military Canal, which runs from Fairlight near Hastings to Shorncliffe in Kent. Many of the king's Hanoverian troops were stationed in the coastal towns and inland villages and names such as Barrack Square and Barrack Road are reminders of this period in our history.

Following the turbulunt war years the country suffered from an agricultural depression and Sussex was no exception. Local agricultural workers took part in acts of violence against many of the leading landowners, particularly in the eastern half of the county. The most common form of protest was arson with the burning of ricks and farm machinery, and only in rare cases was there a threat of personal violence. Repression followed with many of the ringleaders being transported for life.

Smuggling had become a way of life throughout the centuries, often with the backing of many of the well-known families; it was only wiped out with the release of many naval personnel who reinforced the coastguards in their fight against such lawlessness. It must, however, be accepted that the rapidly-rising population suffered poverty and hardship of untold proportion. Many of the leading landowners, Lord Egremont of Petworth among them, instituted a 'voluntary' emigration policy for some of their local tenants encouraging them to set up a new life in Canada and Australia.

Major changes had come about with the 'turnpiking' of many of the county's roads during the late eighteenth century. This led to a considerable rise in road traffic especially to the new seaside resorts. The countryside suffered more change through the railway network than at any time in its previous history. The railway opened between London and the coast in the 1840s and became the biggest single employer, with even their lowest paid employee earning one-third as much again as a farm labourer. It has been said that after the gasworks the building of the railways was the largest industrial undertaking in the county; by the early part of this century no place or community was more than ten miles from the nearest railway station. By the beginning of the First World War many Sussex men were employed by the railway companies.

The coming of the railways led to further expansion of the coastal resorts particularly in Worthing, Eastbourne and Bexhill. The development of Eastbourne and Bexhill was encouraged by the aristocracy: the Dukes of Devonshire at Eastbourne, and the Earls De La Warr at Bexhill. One purely speculative venture took place in the 1830s: Burton's St Leonards was built to serve all members of society, and had as its core the 'Royal Victoria Hotel' on the seafront, thus encouraging visitors and residents alike to the vicinity. It was built by father and son

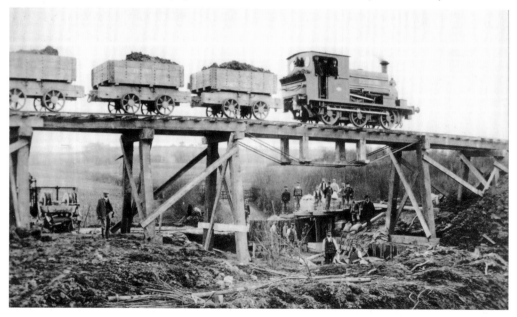

CONSTRUCTION OF CROWHURST-BEXHILL WEST RAILWAY

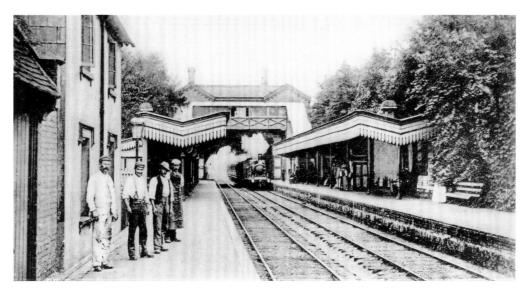

RAILWAY WORKERS AT BURGESS HILL

and followed a previously successful venture at the spa town of Tunbridge Wells.

With the running of special excursion trains to the coast, recreational facilities increased in seaside resorts, with the construction of piers and promenades. As early as the 1830s there had been a packet boat service between Rye and France, although this did not prove a successful venture; the port of Newhaven rose to prominence later in the century an a regular service ran from here to Dieppe several times daily.

People no longer needed to live in London as commuting increased, leading to the wholesale development of towns along the main London-Brighton railway line. Many of the cheaper new houses were built without adequate sanitation and this in turn led to outbreaks of typhoid when the water supply became polluted. Other streets became slums in a very short space of time. Churches were built in profusion, particularly in Brighton and Hastings. Today some of these remarkable and substantial buildings have been put to other use.

Schools flourished, and many had a religious core, particularly those constructed under the Woodard Foundation. Formal education had begun in the middle of the nineteenth century, and at that time it was believed that two-thirds of Sussex children were receiving some form of schooling. Between the two extremes in education were the old Grammar schools: originally these had been set up to educate the sons of the tradesmen and other dependents of the small-town hierarchies.

In 1888 the Local Government Act created two new administrative counties, East and West Sussex. The former had its headquarters at Lewes while the latter was based in Chichester. Large tracts of land of marginal quality were no longer economically competitive and were returned to grass. The chequer-board picture of Sussex changed dramatically. Certain of the rural areas declined in population while others suffered from a sprawling and unrestricted development. Today it is believed that changes in agriculture and a certain degree of planning law led to some areas within the county becoming closer in pattern to that of 150 years ago.

Limited industrial workings have come about this century with the extraction of gypsum, chalk, sand and gravel, interspersed throughout Sussex, but in the main the geological formation of the county has remained little altered during the last two thousand years. Crops, many grown under glass, proliferate on the coastal plain. The draining of Pevensey marshes has led to the land being utilized throughout the year. The Weald, previously a wild and hostile place, is rich in mixed farms and only a fragment of the vast forest remains. Even the Downs have 'lost' the great sheep-walks of the eighteenth century and succumbed to the plough. However, it is in the north-west that the greatest change has taken place, with the building of Crawley 'new' town and the siting of London's second airport at Gatwick, both of which dominate their surroundings.

From the last century guidebooks have stressed the extreme healthiness of coastal resorts, claiming the climate to be 'both bracing and equitable'. The adoption of the 'bungalow' has given rise to whole new estates built in

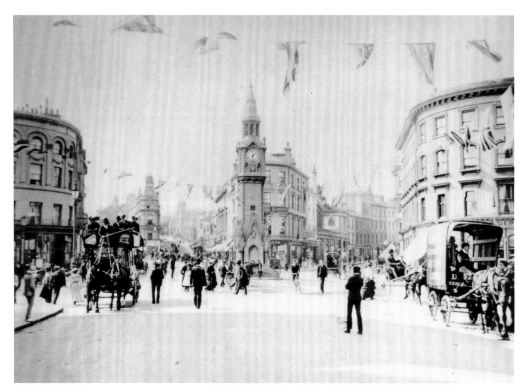

ALBERT MEMORIAL, HASTINGS

this manner and appealing to the more elderly of the population. These towns grew dramatically between 1900 and onset of the Second World War. Small shops catering for the increased population flourished and country girls left their village homes for a life of domestic service within the towns.

The increasing percentage of those over sixty-five years of age has thrown up an acute social dilemma, not only on the elderly residents themselves, but also on the Social Services, placing a major strain on the available workforce, which in turn is in itself growing older. Many younger members of the county have moved away from the area as more conducive work becomes available elsewhere.

Brighton of all the Sussex towns has, perhaps, seen the most significant change in its history, from small fishing village to premier resort. With the siting of the University of Sussex at Falmer, and the construction of a marina, it is unique in its heritage.

Sussex has suffered the loss of much of its hedgerows in pursuit of mechanization and the shift to larger fields. For centuries primarily an agricultural county, it is now moving back to its heritage: farmers are being encouraged to allow their land to lie fallow, or to seek alternative use, mainly in leisure activities, such as 'nature trails' or the more artificial environment of golf links. The county's growing tourist industry, with many visitors from home and abroad being encouraged to enjoy not only the more popular of its towns, but also to experience the freedom of its countryside, is a reflection of this.

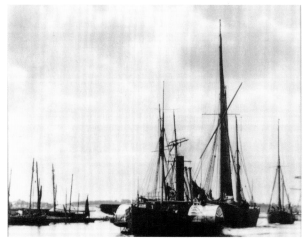

RYE HARBOUR

Victorian
& Edwardian
Sussex

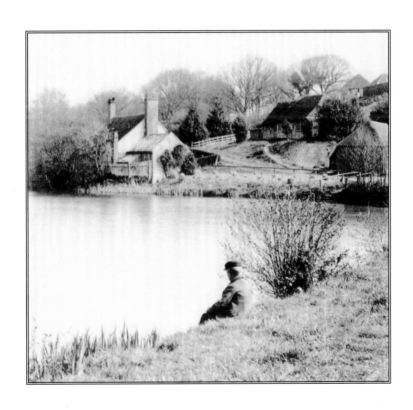

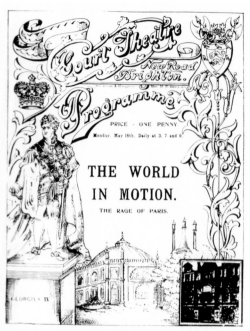

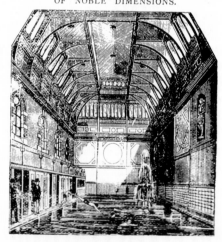

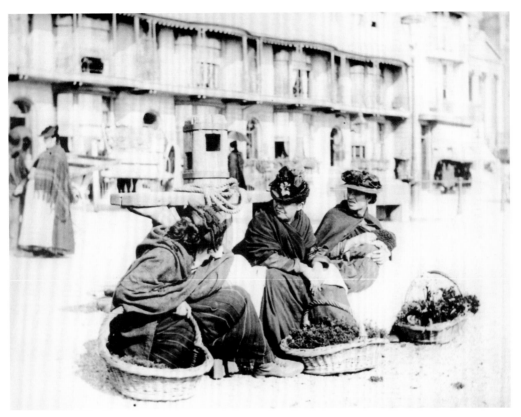

FLOWER SELLERS

WISE AND ANCIENT LORE

In out of the way parts of Sussex, even now, many of the older women, brought up by a generation which knew nothing of the present day patent medicines, stoutly uphold the superior efficacy of all sorts of quaint old, home-made cures of one kind and another. One example of this is the rough and ready remedy of a 'blue-bag' applied in every country cottage to the sting of a wasp or bee, and guaranteed to reduce the pain and swelling.

Another is the slipping of a door key down the back of a sufferer from nose bleeding, which has the same effect in arresting the complaint as the more scientific cold compress.

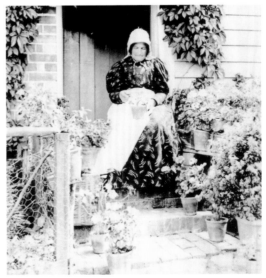

The uses of brimstone and treacle are proverbial. Until recent years many a country household habitually manufactured its own cold cream from rose petals boiled down in lard, and very good it was. Most people can testify to the soothing effect on acute toothache of a simple poultice made of poppyhead and camomile boiled down and pulped together, afterwards applied by some elderly and kindly relative. A country mother whose child gets itself stung by a nettle while gathering flowers would to this day settle the trouble by simply telling the small sufferer to apply to the finger affected one of the cool dock leaves generally to be found conveniently at hand. The same mother will also tell

TENDING BLOOMS

PERRYMANS, NORTHAM

one that her own mother knew of nothing better for cuts and bruises than the petals of the Madonna lily, pickled in brandy, and laid on as a skin, which adheres to the injured part, healing and keeping out dirt at the sale time; as does the thin membrane from the inside of an egg shell when the first remedy is not to hand. A less pleasant cure of the same description was the thick gossamer of a spider's nest.

One old Sussex lady I know still swears by a boiled onion in preference to all modern cold cures, and much prefers a simple brew of linseed tea to any other cough mixture. Ordinary whitening made into a plaster with vinegar and laid on the chest as an application for bronchitis is also one of her remedies; and flowers of sulphur swallowed dry in small quantities she recommends for the alleviation of sore throat.

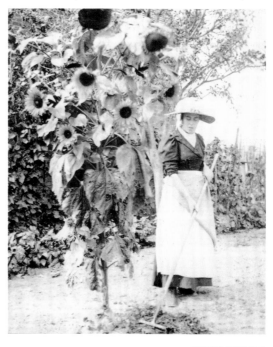

Not a few people in more unsophisticated parts still keep profound faith in the efficacy of 'wearing a potato' as a cure for rheumatic complaints, the tuber being hung somewhere about the body and kept there permanently until shrivelled and hard as a stone, by which time it is said to have drawn quantities of uric acid into itself from the body of the wearer and should be replaced by a fresh one. A slice of raw potato is still used as an application for burns on the body.

Plants almost wholly neglected in most places now were formerly freely used as remedies, and one must believe efficaciously, from what the older country folk maintain, such as chickweed, bruised and laid

SUNFLOWERS

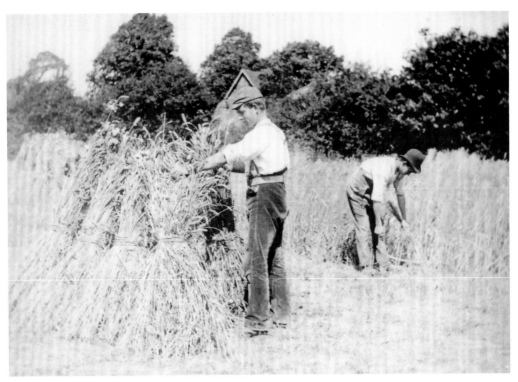

STACKING CORN

on to relieve the pain of rheumatism; 'blanket-leaf, a woolly plant still seen in many a Sussex hedgerow, and said to make a mixture excellent for whooping cough; wood sage, from which was concocted a blood mixture. Meadow-sweet had many medicinal uses, and extract of wild campion was considered a good tonic. Bog myrtle, notable for its pungency, was placed between linen, scattered among clothes packed away, or burnt as a deodoriser in the same way as lavender still is in every country cottage, and much preferred to bought disinfectants.

But there was no end to their number. The only pity is that the wise and ancient lore of them all is being lost among the new generation.

Eva Bretherton, The Sussex County Magazine

LEASING

The reaping machine at the present time cuts the corn and ties it up in sheaves, and very few ears are lost and left on the ground; but in former days when corn was cut with the swap-hook, and still more when it was reaped, a large number of ears were left, and as soon as the last sheaf was in the waggon, the villagers, chiefly the women and children, began gleaning or leasing, as it was generally called. In tine weather leasing was a very pleasant occupation; they took their food with them and remained in the field from early morning till evening. The village National School was always closed during harvest so that the children might assist. The wheat collected was threshed and sent to a local mill to be ground, and the flour, which in some families amounted to several bushels, was an important item during the winter. One cannot help looking back with regret at the disappearance of numberless windmills and watermills and other industries which provided employment for numbers of men, and which, owing to the heavy taxation and other burdens on land, and the free import of agricultural produce (much of this latter being of interior quality and adulterated, and, therefore, unwholesome, especially for children), have rendered everything connected with agriculture unremunerative, and have, to a large extent, reduced the rural population, which has migrated into the towns.

N. P. Blaker

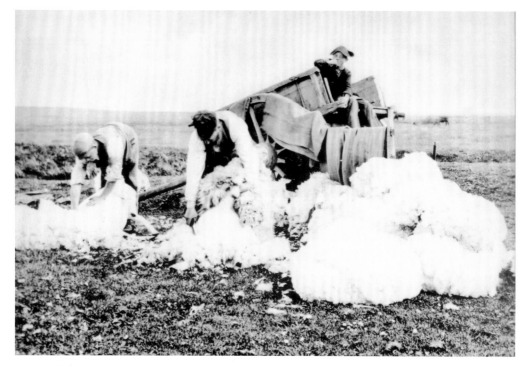

SHEARING ON PEVENSEY MARSH

THE SMALLEST CHURCH

The 'Long Man of Wilmington' is an enormous figure marked upon the steep hillside of one of the South Downs. The local patriots, fearful lest the grassy outlines should grow dim, have marked them out with bricks. A ruder pictorial effort could hardly be imagined, but gradually as we move about there is something of distinctness in the huge image. A shapeless cap appears to surmount a face which has eyes and nose, but no mouth. A stiff but sturdy right arm is outstretched to clasp a staff that is the exact length of the whole figure. The left hand holds a similar walking-stick. With these aids to locomotion the 'Long Man' appears to be making a step forward on the hillside. The feet are enormous and unshapely lumps. The figure is 230 feet in length, and the width from staff to staff is 119 feet. As we walk round its outlines m the stiff short grass with which the chalky downs are covered, we recognise the enormous size of this Sussex Giant. His greatness grows upon us. Seen from below, the outlines are not always quite easy to discern, and his proportions do not seem impressive; but a 'perambulation of the boundaries' proves him to be a veritable son of Anak. When this grassy sculpture was first carved, and with what object, are matters of plentiful conjecture, but scant certainty. There is a similar figure at Cerne Abbas, in Dorsetshire, which is 180 feet long. The Cerne Giant holds in his hands a club 121 feet long. This is close to a former Benedictine monastery, just as the 'Long Man' is near an Augustinian priory. Hence these rude earth sculptures have been attributed to monastic influences. Others regard them as of much greater antiquity, and believe them to be representations of ancient British deities. This is the view taken by the Revd W. de St Croix, who, in 1874, with the concurrence and assistance of the Duke of Devonshire and others interested in the locality, had the fading outlines marked with bricks. Dr J. S. Phenè is a strong supporter of this theory. Both quote the well-known passage in Caesar as to the images which the Gauls made of their gods. Dr Phenè thinks that this spot at Wilmington was a sacrificial area.

We now leave the Long Man of Wilmingtom in his solitary state, and ascending the steep above his head, we are soon amid the breezes of the South Downs. After this blow, we descend until we reach the lane that leads to Folkington, but instead of descending upon that tiny Saxon settlement, we find a track over a hill of lower range, and after a time we see across the fields the church of Lullington, and are quickly at it. There is an ample churchyard, but the tombstones are very few. As the church door is fastened, we seek the key, and find it in the

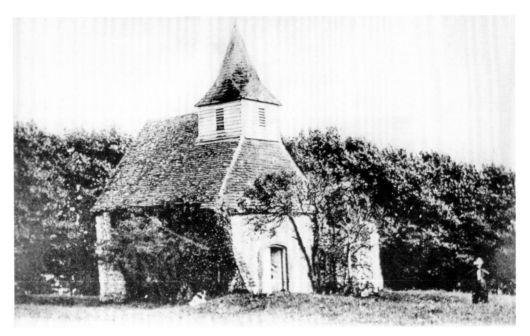

LULLINGTON CHURCH

keeping of a cottager close by. The entrance may be described as a second-hand barn-door, and it opens into a room that is said to be sixteen feet square. The description appears to be accurate. On the wall in front the Creed and the Commandements are painted in fading colours. To the right and in the corner is the pulpit; to the left is the space allotted for the choir. To the right of the entrance door stands a plain but massive font; to the left is a very small stove let into the wall. That is all. We return to the churchyard, and look again at the outside. The edifice is a single square tower, surmounted by what looks like a wooden belfrey, ornamented with a weather-vane. In the wall by the door is a tablet to the memory of a former rector, but Time's effacing finger has made most of the laudatory epitaph illegible. Close by, and jutting out from the wall, is a low ruined wall, including the fragmentary tracery of a Gothic window. One famous name is associated with this tiny parish, for when Elizabeth was Queen, the lord of the manor of Lullington was Sir Philip Sidney. We enter iuto conversation with the woman-sacristan of this tiny edifice.

'What is the population of Lullington now?'

'There are only sixteen in the parish, sir.'

'There were more a few years ago, were there not?'

'Yes, there were twenty-six people in the parish twenty-five years ago.'

'And how often do you have service here?'

'Every other Sunday, in the afternoon.'

'What sort of a congregation is there?'

'Well, the attendance has been increasing. There were only six or seven some time ago, but now we have large congregations, as many as sixteen or twenty. Of course they don't all belong to this parish; but our minister is rector of Wilmington, and when he comes here he brings his choir with him.'

'What is the age of Lullington Church?'

'It is 500 years old, for it was built in 1300. The little stone wall near the door is what came from the tower when it was struck by lightning.'

This is not the view of the archaeologists, who hold that the church was once much larger. The reduction of its size is said to have been made in the time of Cromwell.

'And is this really the smallest church in England?'

'Yes, sir, this is now the very smallest, I believe. There was one in the Isle of Wight that was as little, or less,

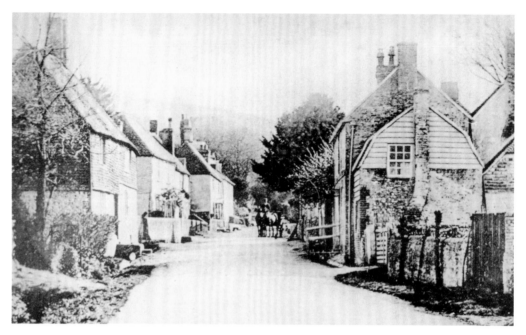

WILMINGTON

but it has been made bigger; and so Lullington is now the least church in England.'

'You have a large churchyard, but there appears to be very few tombs. Are there ever any burials?'

'There has been one burial in my time, sir, but it was a man from another parish.'

'And how long have you been in Lullington?'

'Seventeen years, sir.'

Clearly it is not Death that is depopulating Lullington.

William E. A. Axon

DOG LANGUAGE

A Meet of the Foxhounds, especially on a fine morning, is a grand sight and one always to be remembered. The men in 'Pink', with some ladies, all mounted on the best of horses, in the best condition, with coats shining like satin, and the splendid hounds (there is no more beautiful dog than a foxhound) present a feature scarcely to be surpassed. When I can first recollect there was the same picture, but in more sober colours. There were fewer men in 'Pink' and very few, if any, ladies. The horses were of a somewhat stouter build and their coats were rough, for clipping and singeing had scarcely been introduced (Dr Taylor, as he was called who lived in the Old Smile, once shaved a horse), and the hounds were stouter and heavier. Foxes were much fewer in number, and it was sometimes late in the day before a fox was found; occasionally there was an absolutely blank day. When a fox was found he was not so quickly killed or lost, but was steadily hunted by these hounds, and those long runs were possible which are related in old sporting volumes. I can well recollect that, when my father went with the foxhounds, stewed beef, or something which could not be spoiled by too much cooking, was provided, and this would be ready on his return, sometimes at 7 or 8 p.m., or ever later. I recollect also the time and work it took grooms to get the tired horses, with their long coats, dry and comfortable and fit to be left for the night. Strong language, or 'dog language' as it was called, was very freely used by masters of hounds and huntsmen. I once called on an old retired huntsman and casually said:—

'Why did you swear at me one day in Jointure Copse for no cause whatever?' The answer was:

'Half the times I didn't know what I was swearing at.'

N. P. Blaker

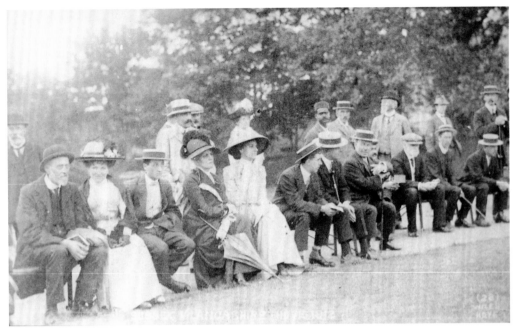

SPECTATORS AT THE COUNTY GROUND, HOVE

COUNTY CRICKET

I feature of Sussex cricket will be the re-appearance of K. S. Ranjitsinbji, who is expected back in England during the ensuing month, and who will once more play regularly. All the regular members of the side last summer will again be available, and trials will also be given to several young players who showed very promising form during last season. Further 2nd XI matches are being played with Hampshire and Kent, with the idea of developing and discovering young cricketers of ability. The first-class card consists of out and home matches with Kent, Surrey, Middlesex, Hampshire, Essex, Gloucestershire, Somerset, Notts, Lancashire, and Yorkshire, with the addition of Worcestershire. The Australians will enjoy a few hours by the seaside in July, M.C.C. and Ground will be opposed at Lord's, and the 'Varsities in turn at home in June. The Light Blues will, however, be met at Eastbourne, while Hastings has been allotted the Middlesex fixture. The County Ground at Hove, in spite of a trying season, is looking in very good order, and promises to provide the good pitches for which it has gained such an enviable reputation.

Sussex Express

DARK-SKINNED STRANGERS

Gipsies were in great force on our fair day—those strange, mysterious, unapproachable people. I remember them well, and the oak in Hempstead Lane, a solitary tree, around which they camped and lit up their tires. The roadside waste is gone now; so is the oak, and so, too, are the gipsies. These dark-skinned strangers, who do not like improvements, never visit us now. At the time I write about their presence was no novelty—men tinkering, women hawking and fortune-telling, beguiling country maidens and drawing the coin out of their pockets; boys and girls begging, scouring the country round about, and for days and weeks beforehand making the fair the climax of their visit to this locality. What questions, what visions of the past, do the presence of these people call up—these lean and hungry-looking men and women and shivering, bareheaded and barefooted boys and girls! Inbred vagabonds! Whence do they come and whither do they go? Without a country, history, religion, or morals; born never to rise to well-doing! We may pity them, but they thank us not; for, like all fatalists, these people welcome and cheerfully submit to the customs they were born to and the habits which bind them for life, and it may then run for ever. We may boast of our aristocratic beauties, but go among these poor people if you would

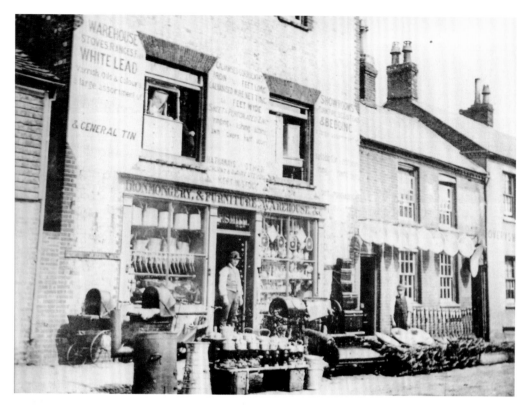

HAILSHAM

have models for the artist, or living features for your eye to feed upon, or the painter to fix on canvas. To my mind I have seen more classic form, unique and of the highest order, in our country fair among these gipsies, than I have ever seen out of it—the young women, many of them as beautiful in shape as in feature, and as lithe and graceful in motion as a flag in a breeze. Prudes might have called them voluptuous. But withal they were natural.

There was one stall owned by a gipsy, and kept by mother and daughter, 'choke' full of allurements for all young eyes. This place in the fair was a great attraction for boys and girls. The latter especially would egg their mothers off

to this booth and point out the lovely flaxenheaded, blue-eyed dolls; or if one preferred the dark beauty, here was the choice. The inventory would be too much to attempt. The attraction to some visitors was the dark-eyed widow and her married daughter—the first a grand woman of fifty, the other about half that age—both tall, upright and majestic. It was evident from their poise of body and self-possession that liberty and they had, all their days, been playfellows. We will not talk about black hair, nor eyes, nor olive complexion, nor oval face; these marks of race were all in perfection. Add to these the heavy finger-rings and pendant ear ornaments with their gaudy dresses, and we have two as fine women and as characteristic as I have ever looked upon, be they gipsies, Jews, or Christians; and if one was the most grand, the other was the most beautiful.

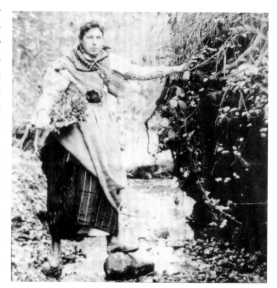

Thomas Geering GATHERING WOOD

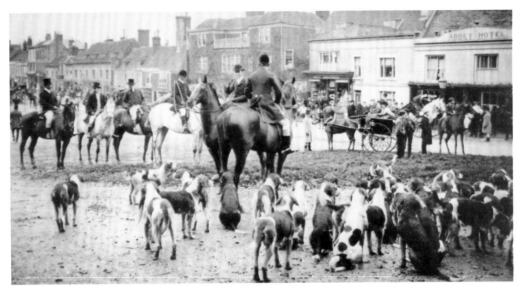

BATTLE

FOX-HUNTING

Where we rode the winter sunshine was falling warmly into the wood, though the long grass in the shadows was still flaked with frost. A blackbird went scolding away among the undergrowth, and a jay was setting up a clatter in an ivied oak. Some distance off Jack Pitt was shouting 'Yoi-over' and tooting his horn in a leisurely sort of style. Then we turned a corner and came upon Denis. He had pulled his pony across the path, and his face wore a glum look which, as I afterwards learnt to know, merely signified that, for the moment, he had found nothing worth thinking about. The heavy look lifted as I approached him with a faltering smile, but he nodded at me with blunt solemnity, as if what thoughts he had were elsewhere.

'Morning. So you managed to get here.' That was all I got by way of greeting. Somewhat discouraged, I could think of no conversational continuance. But Dixon gave him the respectful touch of the hat due to a 'proper little sportsman' and, more enterprising than I, supplemented the salute with 'Bit slow in finding this morning, sir?'

'Won't be much smell to him when they do. Sun's too bright for that.' He had the voice of a boy, but his manner was severely grown-up.

There was a brief silence, and then his whole body seemed to stiffen as he stared fixedly at the undergrowth. Something rustled the dead leaves; not more than ten yards from where we stood, a small russet animal stole out on to the path and stopped for a photographic instant to take a look at us. It was the first time I had ever seen a fox, though I have seen a great many since—both alive and dead. By the time he had slipped out of sight again I had just began to realize what it was that had looked at me with such human alertness. Why I should have behaved as I did I will not attempt to explain, but when Denis stood up in his stirrups and emitted a shrill 'Huick-holler,' I felt spontaneously alarmed for the future of the fox.

'Don't do that; they'll catch him!' I explained.

The words were no sooner out of my mouth than I knew I had made another fool of myself. Denis gave me one blank look and galloped off to meet the huntsman, who could already be heard horn-blowing in our direction in a in a maximum outburst of energy.

'Where'd ye see 'im cross, sir?' he exclaimed, grinning at Denis with his great purple face, as he came hustling along with a few of his hounds at his horse's heels.

Denis indicated the exact spot; a moment later the hounds had hit off the line, and for the next tell or fifteen minutes I was so actively preoccupied with my exertions in following Dixon up and down Park Wood that my indiscretion was temporarily obliterated. I was, in fact, so busy and flurried that I knew nothing of what was happening except that 'our fox' was still running about inside the wood. When he did take to the open he must

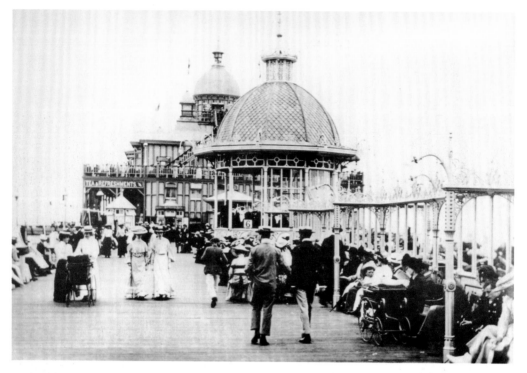

EASTBOURNE PIER

have slipped unnoticed, for after we had emerged the hounds feathered dubiously over a field and very soon I found myself at a standstill.

Siegfried Sassoon

CARNIVAL

This fair of my early days was a revival. The old fair had quite died out excepting one solitary booth for gingerbread and a few other juvenile knick-knacks. About the year 1820 a stir came among our people. Pleasure on her gaudy wing presented herself and put in her claim. There were soon found hearts to sympathise and heads to reason. 'What is life,' 'twas said, 'without some change? Why should man always be working?' Then Saint Lubbock had not lived, and we were a law unto ourselves. The gay goddess so artfully displayed her charms that numerous votaries came to her service. With some people to will is to do, and so it came about that the old fair revived and lived again. So heartily was the case taken in hand, that the good-natured Curate, with his beaming face and guileless mind, saw nought amiss, and he patronized with his presence the new-born institution. The day was our carnival. Fathers and mothers, as well as girls and boys, lived for it, and counted the hours as the days rolled away and the time drew nigh again for the fair. We had our dancing booth with raised orchestra, and planked floor for the dancers. This was the meeting-place for lovers. The fiddle screeched, the basses twanged and grunted, as Hodge in his shirt-sleeves, with collar unbuttoned, and his Molly at his side, went up and down the middle, or struck off to the tune of the 'Triumph'—a great favourite in those days. The hobnails glistened and rattled on the boards as John's heels flew up, so much had he possessed while Molly, in her more gentle mode, clung to her partner as they both whirled away the happy hour—to use the phraseology of the day. They had become hot and blowzed, and would retire and take a seat in the drinking booth, to rest and wet the neck with a cordial draught of ale, and to have a wipe up with the cotton—red, white, or blue—handkerchief. Cambric and silks were not in these days sported by the working classes. And who could be happier than these people? Perhaps in less than a year they had become husband and wife, and the first child born. And so these meetings and greetings had their uses; the start in life had been made and many things appertaining were reckoned from the date of this fair.

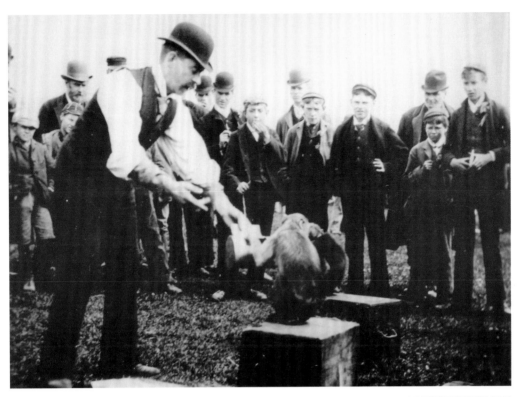

MONKEY BUSINESS

We, too, had our peep-show, where could be seen smuggling by moonlight, the Battle of the Nile, and the last charge at Waterloo, all for a penny. Punchinello and her matchless husband were there. But who can catch and describe the ever-changing wit of that greatest of all comedians, Mr Punch? I will not venture further than to note his august presence. Then we had Wombwell, with his family of quadrupeds of all grades, from the roaring lion to the chattering monkey, not forgetting the grand old elephant. The monkey, above all, was the boys' favourite—hanging by the tail, catching nuts or any other edibles offered him, but never saying, 'Thank you,' nor giving a single look of pleasure or gratitude. Sordid creature! How he would munch away! Doubly interesting now is the monkey; for at that time little did we think that 'science' would level man down, down, down until Jacko should become man's progenitor, elbowing out poor old Adam and Eve from the post of honour.

Thomas Geering

LEWES

I was sent to Miss Lee's School, 170 High Street, Lewes, at Christmas, 1843, and remained there one year. Small children in those days generally slept two in a bed, and my bedfellow was William, afterwards Sir William Grantham. Miss Lee had two brothers, both very clever men, and one certainly, and I believe both, were connected with the *Sussex Express*, the chief agricultural paper of East Sussex, and wrote at times very witty articles. At about that time there was living in Lewes an old horse-dealer named Drowley, very illiterate and eccentric, of whom numerous anecdotes were told. This old man once asked Mr Lee to write something pretty to put on his tombstone. He wrote:—

> Here lies the man that lived by lying,
> Some people thought 'twould leave him dying,
> But to the nation's great surprise
> Even in his grave he lies.

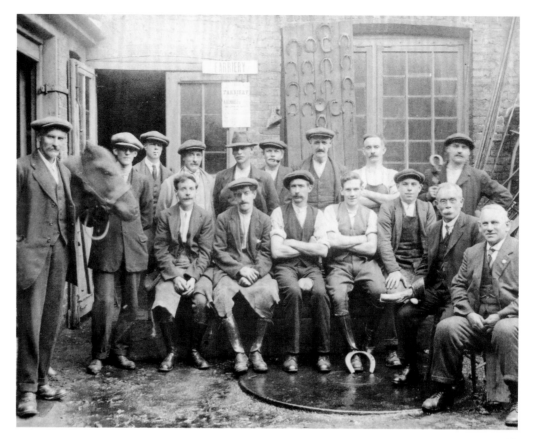

THE SMITHY IN OFFHAM

The garden at the rear of 170 went back in the form of two terraces to a wall of the old castle which at that time formed the side of a brewery (I believe Mr Langford's). One night this wall fell into the garden, covering it with an enormous mass of debris. School life in those days was very different to what it is at the present time, but we were kindly treated and well fed, and I think were far healthier and tougher than children of the present day who are brought up more luxuriously and fed with less plain and much less nutritious and wholesome food; for example, articles of diet from very white, that is, inferior blanched flour.

Lewes was then not only the County Town but a very gay and busy place, though it had ceased to be the winter residence of the nobility and gentry of, at all events, the eastern part of the County, whose residences, with the remains of their former grandeur, especially in the form of old oak carving and gardens and things of a like nature, still remain. A cattle-market was held in the Town on alternate Tuesdays, and pens formed of oak wattles for sheep extended from the White Hart Hotel for some distance towards St Michael's Church and occupied a considerable part of the road. Besides the sheep there were numbers of bullocks and horses, and these, together with the sheep, took up a great part of the width of the road and interfered a good deal with the traffic.

In the days before railways, Lewes was the main artery through which nearly all the traffic between east and west Sussex passed, as well as that to and from Brighton. There was no other bridge over the Ouse either up or down the stream for some miles, and the High Street of Lewes was therefore a very busy place. Besides the ordinary traffic, which was of a very considerable amount, coaches, four-in-hand, 'Unicorn' and pair-horse, both from east and west, were constantly dashing through the town; the pace at which they went down School Hill and the rattle they made can scarcely be imagined; and to this must be added the crowds at the booking-offices and sometimes the scramble for places. I well recollect the railway between Lewes and Brighton being made. I was told that there were great difficulties in its construction. The curved viaduct over the London Road and the skew-arch at Hodshrove in those early days of railways presented problems very difficult of solution. Mr Lutley,

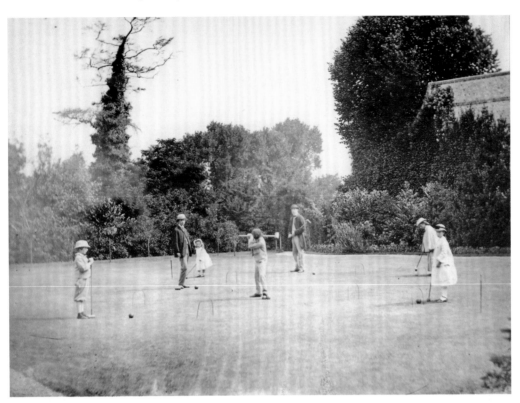

CROQUET AT SHELLEYS

who had a good deal to do with the construction of the line, told me he had more than once driven up Falmer Hill sitting on the safety valve of his engine.

Lewes was a place to which a large lumber of people in advanced life came to reside and these, with the usual inhabitants, formed a very sociable and friendly community. In summer in the afternoon there was generally an assemblage of elderly gentlemen at the bowling-green which was situated just through the Castle Gates by the Barbican. They took the greatest interest in the game and played as if their whole future in life depended on it. In those days dinner was usually at 1 p. m. , tea at 5 p. m. and supper at 9 p. m. Social visits in the evening were very frequent. During the greater part of the year whist, or a round game of cards or chess was played, and after supper a glass of hot spirits and water, brandy, rum or gin, went round. Conversation, very slow at first, became much more lively after the first or second glass. With *The Times* at sixpence, and other papers at threepence or fourpence, a newspaper was taken only once or twice a week and conversation was confined very much to local topics, and the same old anecdotes were related and old stories told perhaps for the hundredth time. Everyone knew what was coming and everyone laughed at the proper time, as if they had never heard them before. Among many remains of old customs at Lewes was

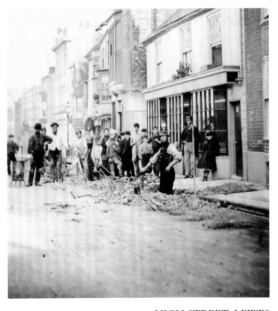

HIGH STREET, LEWES

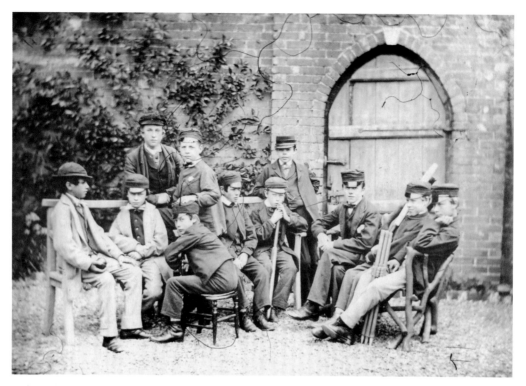

YOUNG CRICKETEERS

the night watchman who walked about the town during the night, I believe with a bell, and called out the time and the weather. I was in the Convict Hospital which was then in the Old Jail, in 1858, and well recollect the first night I slept there hearing him call out 'Twelve o'clock and a moonlight night.' He has now disappeared.

There were two fairs at Lewes, chiefly for sheep, though horses and other cattle were well represented. They took place on May 6th and on September 21st. These fairs were very important. People came long distances to buy the Southdown sheep, and a very large amount of business was done. They also marked in the town and neighbourhood the change from summer to winter and from winter to summer. Among the older inhabitants after May 6th, black bars in the fire grates were taken out and replaced by bright polished ones, and after this no fire was lighted however cold the weather; winter clothes were exchanged for summer, and on September 21st these bright bars were taken out and the black bars put in and fires were lighted. Winter garments were put on, winter curtains were put over the windows and they 'shut up for the winter'.

The fifth of November was always, from time immemorial, a great institution at Lewes. I well remember when at school in 1843, hearing the noise of blazing tar-barrels rolled through the street, and the shouting and racket. Squibs and crackers and fireworks of all sorts were thrown about and all windows had to be protected with shutters. There was a large bonfire in the middle of the town in front of the County Hall, not far from the spot where the martyrs were burned, and with this and the fireworks and rockets, the sky was illuminated all round. For several hours the town was given up to the mob and all traffic through the streets was suspended. With the altered state of modern social life and the advent of motors, this state of things could no longer continue, and the 'fifth of November' was, a few years ago, entirely given up.

Lewes people in those days were all sportsmen. The Dripping Pan was famous for its cricket matches, and though at the present time it would not be large enough, in those days when cricket was a game in which all could join, and not in exhibition of professional athletes, when one parish played against another parish and one local club against another, it was considered an excellent ground. Friends met and watched the game and took a real interest in the play of their friends and acquaintances, and there was probably more real enjoyment than in the scientific contests of athletes of the present day.

FAMILY GROUP, EASTBOURNE

I believe the last battle of Lewes was fought by my grandfather and Mr Gallop, who lived at Edburton, on Plumpton Plain. They had been to Lewes races and were returning home in the evening on horseback in company with several friends who were going in the same direction, when Mr Gallop said something very derogatory about the troop raised by Lord Gage, in which my grandfather held the position of Sergeant, and of which he was very proud. (In the wars of Napoleon, it was the custom for noblemen and gentlemen of wealth and position to raise troops at their own expense among their tenants and others). My grandfather much resented Mr Gallops' remarks and the quarrel go so hot that they came to blows. They got off their horses, which two of their friends held, and fought it out. Many years afterwards I was told of it, and asked my grandfather if it was true. He said 'Yes, and 'twas lucky for me Gallop did not want much licking.'

The Brookside Harriers were a great institution in Lewes; Mr John Saxby was for many years huntsman, a thorough sportsman and most popular man, and Mr Charles Beard was the master, a most genial man and liked by everyone. I was attending his sister, who was rather seriously ill, and we were walking together in her garden one Sunday morning, when Mr Beard said 'I am not at all well, doctor, I wish you would send me some medicine.' After a short pause he continued: 'I don't know when I can take it. Tomorrow there are our hounds, Tuesday is Lewes Market, Wednesday the foxhounds, Thursday our hounds, Friday and Saturday the foxhounds. I can't take any medicine this week.' I did lot think he required any.

Lewes in former times, as the County Town, was a rather festive place. Balls and parties were frequent. The County Ball, an important function, was held at the County Hall, and there were several other balls during the season, and others were held at the Star, where there was a large room. I occasionally went to one of these balls and returned rather late. The prison where, as I have said, I was acting as Medical Officer, was closed at 10 p.m., and if the doors were opened between that hour and 6 a.m. it was entered in a report book, which was sent up and examined at Headquarters. The Governor therefore suggested to me that I should not return till after 6 a. m., when the doors were opened for the day. One night I went to one of these balls with my cousin, Mr Montague Blaker, and we did lot leave till between 4 and 5 a.m. The problem was what to do till 6 a.m. My cousin kindly walked with me up to the Black Horse, and we then returned to his father's house, 211 High Street, and sat down

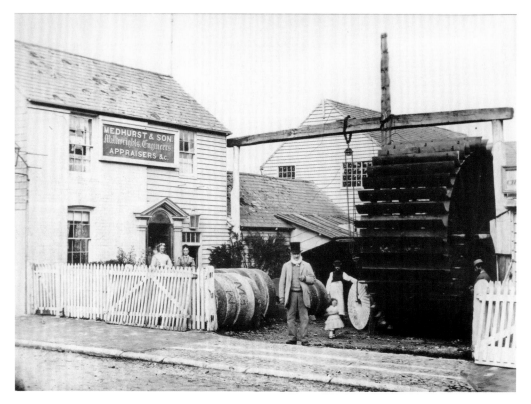

MEDHURST'S MILLWRIGHTS YARD

in the drawing-room, and talked. In a short time the door opened gently for about half all inch and through this chink we saw a streak of light, surmounted by something that sparkled. Then the door opened more widely, and disclosed old Mr Edgar Blaker in his white nightdress with his spectacles on, and armed with a poker against the burglars. After a little explanation he retired again to bed.

There were a great many dinner parties in Lewes in those days, and men drank rather freely, and strange things sometimes happened afterwards. That a gentleman should take a little more wine than he could carry comfortably was of a very common occurrence and was always treated as a joke. The late Mr Richard Turner told me that on one occasion his father, Mr R. Turner, senior, had gone to one dinner party, and he, with their assistant, Mr Boanerges Boast, had gone to another. At about 2 a.m. they all three met on the doorstep of their house in High Street. Mr Turner, senior, accused Mr Boast of being drunk, which he stoutly denied. Mr Turner said: 'Well, you can't walk on the top of the wall between our garden and Mr Gell's' (Mr Gell was coroner, and the wall was perhaps, 10 feet high, flat, and 12 inches or more wide on the top). Mr Boast said he could, so they got up and walked some distance on the top of the wall, turned and came down safely. Mr Turner said: 'You have done that, but you can't run round the dining-room table.' Mr Boast tried but could not turn at the corners quite steadily.

On looking back upon the men of those days, one cannot help feeling that they were in many respects superior to their descendants of today. They were more manly, more independent, more persevering and spoke their mind more freely though their speech was garnished very frequently with plenty of oaths. They hated untruthfulness or trickery, and anyone guilty of such conduct was held in contempt, and I well recollect the frequent use of the axiom: 'My word is my bond.' They were most kind-hearted and hospitable to a degree, and many had an innate politeness and polish, though some were cast in a coarser mould. The present generation certainly differ much from their forefathers. That great 'revolutionist', steam and the railway have taken away all the old landmarks, and education, not always of a judicious and sometimes of a mischievous character, seems to have quickened the intellect without improving the moral feeling of this generation and has to some extent taken away the sterling

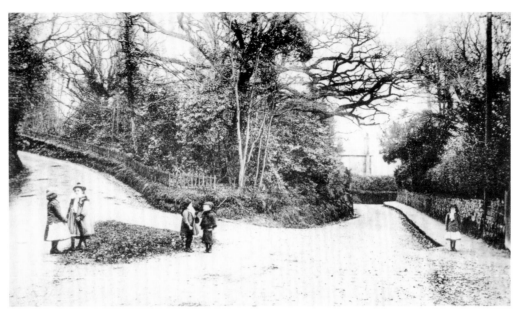

ROCKS ROAD, UCKFIELD

qualities of our predecessors. I have asked very many business men of over middle age what they thought of the present manner of transacting business, and I always received the same answer that mercantile morality is at a lower ebb, and things are done now which would not have been tolerated a few years ago, and confidence is diminished. Though this may seem to be the case, fortunately the conduct of our gallant soldiers and sailors proves that the fundamental qualities of the race have not deteriorated.

N.P. Blaker

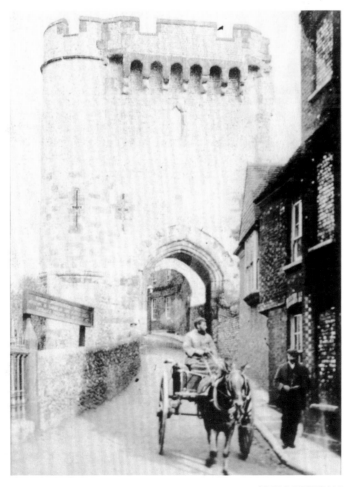

THE BARBICAN

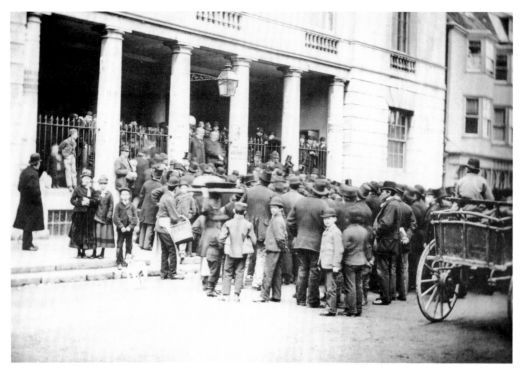

DECLARATION OF THE POLL

COUNTY POLITICS

It was not, however, one of my own people, but an inhabitant of the more enlightened borough of Lewes, who, being asked after a general election how he had given his vote, replied—

'Well, I've voted for the Tories ever so long, but this time I thought I'd give these Conservatives a turn!'

Personally I have little reason to look upon Sussex politics with satisfaction; my experience of this having been a trying one. I was once voting for the county and though it is true that the opinions which I upheld were successful, I suffered much every way in giving effect to them at the poll. The arrangements at Mayfield were such that I was crushed as badly as I ever was in a London crowd, and I escaped at last from the schoolroom in which the votes were taken only to be encountered by a more than half-drunken voter, whose unhappy memory served him to reproduce for my benefit one, I think, of Cobbett's irreverent sayings which he 'bellowed' out from the opposite side of the street—

'My politics be these: I be for more fat pigs and less fat parsons.

John Coker Egerton

GHOSTLY TROUBLES

My informant is an old parishioner now (1882) alive at the age of eight-seven. Her grandfather, from whom she received the story, was born in 1737, and died and was buried in our churchyard in 1817. The affair with the ghost happened to him when he was about seventeen years old, or one hundred and twenty-eight years ago.

Not wishing to lose such an instance as this of the possibilities of tradition, I one day found a good easy carriage for my old friend, and having found her also a driver over eighty years of age, and, singularly enough, a horse more than forty years old, I took her down to the National School. She there told her story in the hearing of the assembled children. I have kept the names of all present, so that if any of the children of ten years of age, then in the room, themselves live to be as old as the old lady, viz. eighty-seven, they will, at the end of their life,—that is in 1959, be able to say that they were told by a person who got it from the lips of the very man himself, of something done by a man who was born in 1737—or 222 years before.

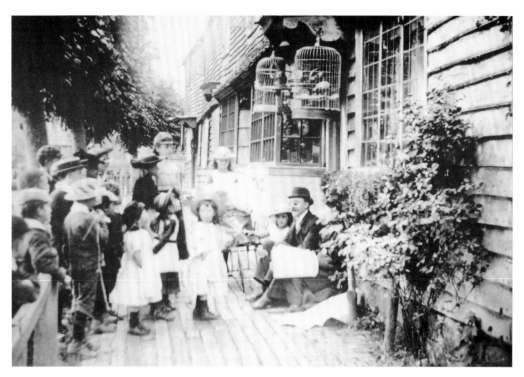

THE BLIND STORY-TELLER

Richard Balcombe, the young man in question, had newly gone to live as servant at 'The Greenwoods', a farmhouse in a very wild district on the south-western border of our parish. He was sent late one night with a message to Burwash, and he was warned before he started that a ghost was very often seen near a stile which he had to cross. He accordingly took with him a middling thick stick, and said that if any ghost interrupted him he would, by the help of his 'bat', try and find out what a ghost was made of.

As he got near to the stile, he duly caught sight of the ghost in front on him, glaring fiercely out of the hedge. He put down his basket, walked quietly up to the place, and with his 'bat' struck out boldly. He owned that he then felt a good deal frightened, for no sooner had he struck than flames on all sides came flying past his head. However, he held his ground, and then discovered that he had smashed into a hundred pieces an old rotten tree-stump which had dried up into touchwood, and the phosphorus in which shone with such mysterious brightness in the dark. A second ghost gave him more trouble. As he was going home one night from Burwash with a pair of half-boots which had been mended, he suddenly, at a stile again, came face to face with a ghost. Without more ado, he flung the boots at it. All at once the field seemed filled with ghosts, which jumped up and rushed away. The one which he had seen was an old grey horse which had been standing with its tail to the stile. The boots fell across the horse's back; the horse kicked up its heels in fright; the boots slid on to its shoulders, where they rode safely enough, and though the ghost had vanished it had taken the boots with it.

John Coker Egerton

HANDSOME RED RASCAL

It was inevitable in these tremendous times that among the many voices suggesting various drastic measures for our salvation, those of Mr Brown and Mr Smith, the poultry farmers, should be heard loud as any advocating the extirpation of foxes, a measure, they say, which would result in a considerable addition to the food supply of the country in the form of eggs and chickens. Even so do the fruit-growers remind us in each recurring spring that it would be an immense advantage to the country if the village children were given one or two holidays each week in March and April, and sent out to hunt and destroy queen wasps, every wasp brought in to be paid for by a

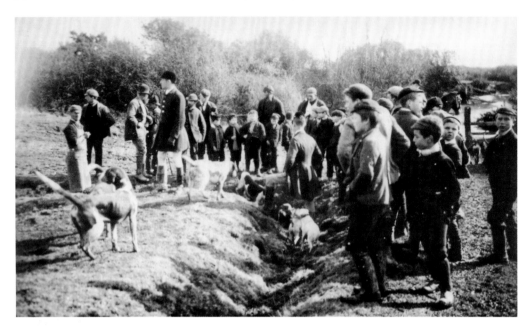

DIGGING-OUT

bun at the public cost. That the wasp, an eater of ripe fruit, is also for six months every year a greedy devourer of caterpillars and flies injurious to plant life, is a fact the fruit-grower ignores. The fox, too, has his uses to the farmer, seeing that he subsists largely on rats, mice, and voles, but he has a greater and nobler use, as the one four-footed creature left to us in these islands to be hunted, seeing that without this glorious sport we should want horses for our cavalry, and men of the right kind on their backs, to face the Huns who would destroy us.

Apart from all these questions and considerations, which humanitarians would laugh at, the fox is a being one cannot help loving. For he is, like man's servant and friend the dog, highly intelligent, and is to the good honest dog like the picturesque and predatory gipsy to the respectable member of the community. He is a rascal, if you like, but a handsome red rascal, with a sharp, clever face and a bushy tail, and good to meet in any green place. This feeling of admiration and friendliness for the fox is occasionally the cause of a qualm of conscience in even the most hardened old hunter. 'By gad, he deserved to escape!' is a not uncommon exclamation in the field, or, 'I wish we had been able to spare him!' or even, 'It was really hardly fair to kill him!'

W. H. Hudson

IVY IN THE TWITTEN

Our village has a 'twitten'. Many Sussex villages have, for it is a Saxon word meaning a narrow walk between hedges. I was going up our twitten this morning and, at the entering my ears were assailed by a tumultuous roar of many bees. It sounded like the rich full hum of a summer's swarm. Indeed, a small boy informed me, 'I think there be a swarming in that there ivy, there's an awfu' lot of bees.' I told the big-eyed boy that his ideas were astray, only bees imbecile or wit-scattered would swarm late in September.

I daresay many of my readers will notice the same thing through October. The ivy is in full bloom, it is rich in nectar, and bees for whom other and sweeter flowers have passed, flock eagerly to the ivy which, indeed provides for them the last feast of the year. The honey of the ivy is not of the best. Its taste is rank and coarse, and bees, who are very discriminating in their gustatory sense, would not look at it twice were other flowers, those of the full summertime, to be found. But now with the waning of the vintage they cheerfully sup on these last gifts of the season, and the sound of this great congregation of eager insects in the bright October sunlight is one of many reminders that the harvest is passed and summer ending.

A. A. Evans, The Sussex County Magazine

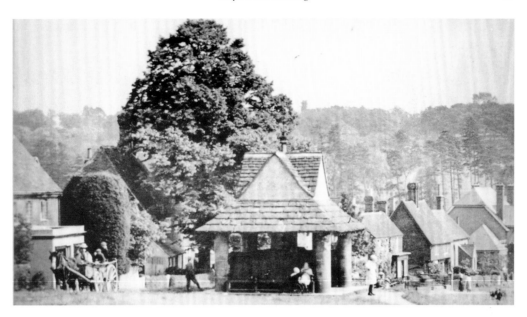

SEDLESCOMBE

NINFIELD

Most of the farms contained a certain amount of woodland (Standard Hill and Moor Hall had the most extensive acreage) and wood cutting in the winter gave employment to quite a number of farm hands.

The coppice ten or twelve years old would either be cut on a wage basis for the farmer; or bought outright in cants. The coppice when cut, would be sorted out and made into 'House faggots', that is, bundles of brushwood containing a certain number of 'bats' and fastened by 'benders', into 'lordings'—longer brushwood and suitable for use as pea boughs, and chestnut saplings set on one side, the best for hop poles and bean poles, the remainder for fencing and wattle-making. The split chestnut fencing industry had not yet entered the market.

There would be a very considerable demand for hop poles from the numerous hop growers.

'Hop pole shaving' was a part of the preparation, that is, stripping the bark from the chestnut poles using a two-handled 'draw shave' knife. This work might be entrusted to lads, and 'helping father hop pole shaving' was an excuse offered on occasion for absence from school.

The stripped poles were pointed at the stouter end and stood upright in tar engines at the home farm yards to preserve the lowest two or three feet. These 'tarry ends' were rather prized as firewood when the poles were finally discarded.

The cultivation of hops led to a demand for charcoal to be used in the oast houses when hop drying.

Each of the woods in the neighbourhood had a particular spot where charcoal burning might take place. One such spot with which we were well acquainted was a glade at the Moor Hall end of Church Wood.

STOCKS, NINFIELD

NEWBRIDGE MILL, ASHDOWN FOREST

The process often entailed night and day watchfulness. A wood fire would be lit and a conical heap of short 'bats' built up over it and covered with turf. The art in the process lay in allowing just sufficient air to reach the inner fire, through holes poked through the turf covering, to permit the wood to continue to smoulder, or char, but on no account to blaze. As the turf itself would be apt to burn, charcoal burning needed careful tending to ensure a perfect result.

The term 'charcoal burner' had a somewhat romantic flavour for us connected with a queer mixture of fairy tales, William Rufus, and Ted Crouch's gunpowder, which we could not resist.

We knew the best time to pay a visit would be after dark, so would slip away at about six o'clock on a November evening through the Churchyard and Church Wood and satisfy our somewhat sentimental urge.

There would be the old, old scene, as old as the Weald itself -just a faint glow from the red-rimmed eyes in the sides of the burning mound—not a sound—the strongly scented smoke drifting up through the overhanging branches of a couple of oaks, and yes—there he was, just discernible in the dim light—the charcoal burner himself, old Bob Kenward, seated in his turf and bough thatched watchman's hut, complete with short clay pipe and sack-covered shoulders, a model of patient intentness—a picture which by a very slight stretch of imagination could have come direct from the pages of our beloved Fenimore Cooper.

Alfred T. Ridel

SIR ISUMBRAS AT THE FORD

They were fishing, a few days later, in the bed of the brook that for centuries had cut deep into the soft valley soil. The trees closing overhead made long tunnels through which the sunshine worked in blobs and patches. Down in the tunnels were bars of sand and gravel, old roots and trunks covered with moss or painted red by the irony water; foxgloves growing lean and pale towards the light; clumps of fern and thirsty shy flowers who could not live away from moisture and shade. In the pools you could see the wave thrown up by the trouts as they charged hither and yon, and the pools were joined to each other—except in flood time, when all was one brown rush—by sheets of thin broken water that poured themselves chuckling round the darkness of the next bend.

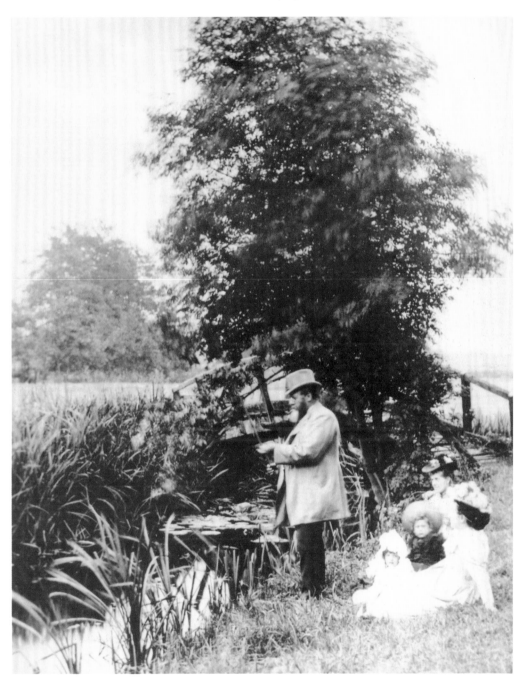

A FAMILY OUTING

This was one of the children's most secret hunting-grounds, and their particular friend, old Hobden the hedger, had shown them how to use it. Except for the click of a rod hitting a low willow, or a switch and tussle among the young ash-leaves as a line hung up for the minute, nobody in the hot pasture could have guessed what game was going on among the trouts below the banks.

'We's got half-a-dozen,' said Dan, after a warm, wet hour. 'I vote we go up to Stone Bay and try Long Pool.'

Una nodded—most of her talk was by nods—and they crept from the gloom of the tunnels towards the tiny weir that turns the brook into the mill-stream. Here the banks are low and bare, and the glare of the afternoon sun on the Long Pool below the weir makes your eyes ache.

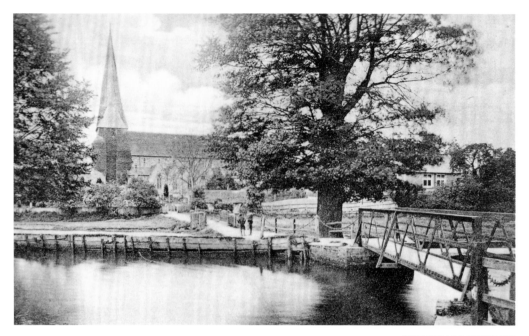

HORSHAM CHURCH

When they were in the open they nearly fell down with astonishment. A huge grey horse whose tail-hairs crinkled the glassy water, was drinking in the pool, and the ripples about his muzzle flashed like melted gold. On his back sat an old-white-haired man dressed in a loose glimmery gown of chain-mail. He was bare-headed, and a nut-shaped iron helmet hung at his saddle-bow. His reins were of red leather five or six inches deep, scalloped at the edges, and his high padded saddle with its red girths was held fore and aft by a red leather breastband and crupper.

'Look!' said Una, as though Dan were not staring his very eyes out. 'It's like the picture in your room—'*Sir Isumbras at the Ford.*'

The rider turned towards them, and his thin, long face was just as sweet and gentle as that of the knight who carries the children in that picture.

'They should be here now, Sir Richard,' said Puck's deep voice among the willow-herb.

'They are here,' the knight said, and he smiled at Dan with the string of trouts in his hand.

Rudyard Kipling

A TESTIMONIAL TO LEWES

The following is a copy of a handbill published to the inhabitants of Lewes in April 1856, at the end of the Crimean War.

The Constables of the Borough have this morning received the following communication from the Officers of the Russian Service:—

Lewes,
15th April, 1856

We, the officers in the Russian Service, cannot take our departure from England without expressing our sentiments of gratitude and goodwill towards the inhabitants of Lewes and the neighbourhood.

When by the fortune of war we became resident in this town we were received with a frank and generous courtesy, which convinced us that the people of Lewes regarded us less as the subjects of a foreign and hostile power than as men who in the discharge of their duty had fallen into misfortune. We have enjoyed the hospitality

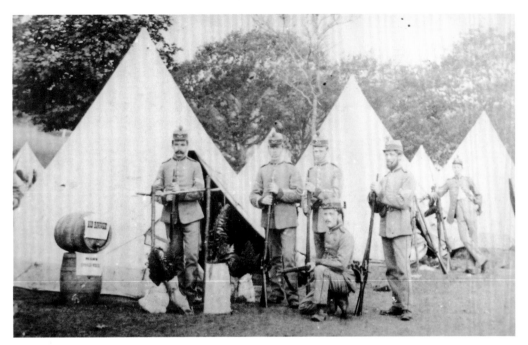

BEAUPORT PARK

of many and urbane treatment from all. A somewhat lengthened captivity has thus been greatly alleviated and our pleasure in the anticipation of returning to our native country is much modified by the regret we feel in thus bidding farewell to those who have shown us so much kindness. We shall always cherish a lively remembrance of the good old town and of the many hospitable abodes which surround it, and thus wishing all prosperity to Lewes we take a respectful and affectionate adieu.

Signed in the name of the officers,

> Gustaf Grahn,
> Lt.-Col.

To the Senior Constable of Lewes.

To which the following answer has been returned:—

> Lewes,
> April 17th, 1856

Sir,

We have the honour to receive the communication signed by you on behalf of the Officers of the Russian Service who are now leaving this town, which we will take the earliest opportunity of laying before our fellow townsmen.

It is highly gratifying to us to know that those gentlemen have been satisfied with the reception and treatment of the inhabitants of Lewes and its neighbourhood. We have on our part to wish them a safe and speedy return to their native country on an occasion so happy as the restoration of peace between their country and our own.

We have the honour to be sir,
Your obedient servants,

> William Figg
> Richard Lambe
> Constables of the ancient Borough of Lewes

To Lt.-Col. Grahn

The Sussex County Magazine

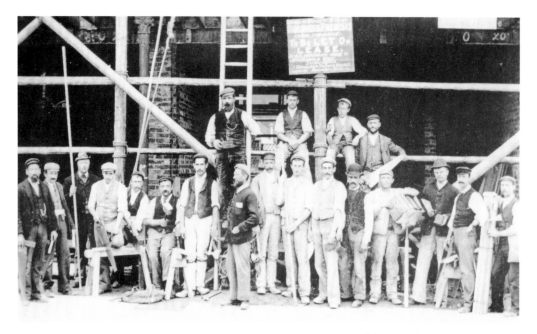

BUILDERS, BEXHILL-ON-SEA

THE CAVE

This important matter being disposed of there followed a brief silence, which was presently broken by Harlow.

'Funy name to call a 'ouse, ain't it?' he said. '"The Cave." I wonder what made 'em give it a name like that.'

'They calls 'em all sorts of outlandish names nowadays,' said old Jack Linden.

'There's generally some sort of meaning to it, though,' observed Payne. 'For instance, if a bloke backed a winner and made a pile, 'e might call 'is 'Ouse "Epsom Lodge" or "Newmarket Villa".'

'Or sometimes there's a hoak tree or a cherry tree in the garding,' said another man; 'then they calls it "Hoak Lodge" or "Cherry Cottage".'

'Well, there's a cave up at the end of this garden,' said Harlow with a grin, 'you know, the cesspool, what the drains of the 'ouse runs into; praps they called it after that.'

'Talking about the drains,' said old Jack Linden when the laughter produced by this elegant joke had ceased, 'Talking about the drains, I wonder what they're going to do about them; the 'ouse aint fit to live in as they are now, and as for that bloody cesspool it ought to be done away with.'

'So it is going to be,' replied Crass. 'There's going to be a new set of drains altogether, carried right out to the road and connected with the main.'

Crass really knew no more about what was going to be done in this matter than did Linden , but he felt certain that this course would be adopted. He never missed an opportunity of enhancing his own prestige with the men by insinuating that he was in the confidence of the firm.

'That's goin' to cost a good bit,' said Linden.

'Yes, I suppose it will,' replied Crass, 'but money ain't no object to old Sweater. 'E's got tons of it; you know 'e's got a large wholesale business in London and shops all over the bloody country, besides the one 'e's got 'ere.'

Eastoll was still reading the *Obscurer*: he was not able to understand exactly what the compiler of the figures was driving at—probably the latter never intended that anyone should understand—but he was conscious of a growing feeling of indignation and hatred against foreigners of every description, who were ruining this country, and he began to think that it was about time we did something to protect ourselves. Still, it was a very difficult question: to tell the truth, he himself could not make head or tail of it. At length he said aloud, addressing himself to Crass:

'Wot do you think of this 'ere fissical policy, Bob?'

'Aint thought Much about it,' replied Crass. 'I don't never worry my 'ed about politics.'

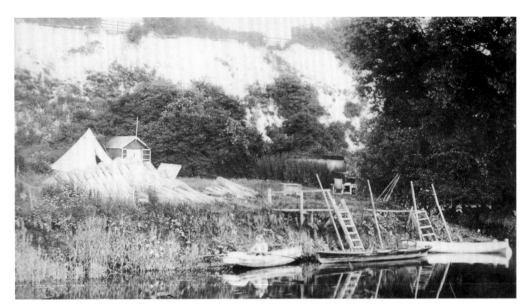

COLLECTING OSIERS, BURPHAM

'Much better left alone,' chimed in old Jack Linden sagely, 'argyfying about politics generally ends up with a bloody row an' does no good to nobody.'

At this there was a murmur of approval from several of the others. Most of them were averse from arguing or disputing about politics. If two or three men of similar opinions happened to be together they might discuss such things in a friendly and superficial way, but in a mixed company it was better left alone.

Robert Tressell

A PIECE OF CHALK

With my stick and my knife, my chalks and my brown paper, I went out on to the great downs. I crawled across those colossal contours that express the best quality of England, because they are at the same time soft and strong. The smoothness of them has the same meaning as the smoothness of great cart-horses, or the smoothness of the beech-tree; it declares in the teeth of our timid and cruel theories that the mighty are merciful. As my eye swept the landscape, the landscape was as kindly as any of its cottages, but for power it was like an earthquake. The villages in the immense valley were safe, one could see, for centuries; yet the lifting of the whole land was like the lifting of one enormous wave to wash them all away.

I crossed one swell of living turf after another, looking for a place to sit down and draw. Do not, for heaven's sake, imagine I was going to sketch from Nature. I was going to draw devils and seraphim, and blind old gods that men worshipped before the dawn of right, and saints in robes of angry crimson, and seas of strange green, and all the sacred or monstrous symbols that look so well in bright colours on brown paper. They are much better worth drawing than Nature; also they are much easier to draw. When a cow came slouching by in the field next to me, a mere artist might have drawn it; but I always get wrong in the hind legs of quadrupeds. So I drew the soul of the cow; which I saw there plainly walking before me in the sunlight; and the soul was all purple and silver, and had seven horns and the mystery that belongs to all the beasts. But though I could not with a crayon get the best out of the landscape, it does not follow that the landscape was not getting the best out of me. And this, I think, is the mistake that people make about the old poets who lived before Wordsworth, and were supposed not to care very much about Nature because they did not describe it much.

They preferred writing about great men to writing about great hills; but they sat on the great hills to write it. They gave out much less about Nature, but they drank in, perhaps, much more. They painted the white robes of their holy virgins with the blinding snow, at which they had stared all day. They blazoned the shields of their

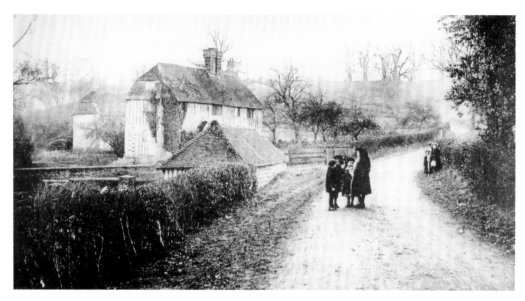

FONTHILL FARM, NEWICK

paladins with the purple and gold of many heraldic sunsets. The greenness of a thousand green leaves clustered into the live green figure of Robin Hood. The blueness of a score of forgotten skies became the blue robe of the Virgin. The inspiration went in like sunbeams and calm out like Apollo.

But I sat scrawling these silly figures on the brown paper, it began to dawn on me, to my great disgust, that I had left one chalk, and that a most exquisite and essential chalk, behind. I searched all my pockets, but I could not find any white chalk. Now, those who are acquainted with all the philosophy (nay, religion) which is typified in the art of drawing on brown paper, know that white is positive and essential. I cannot avoid remarking here upon a moral significance. One of the wise and awful truths which this brown-paper art reveals, is this, that white is a colour. It is not a mere absence of colour; it is a shining and affirmative thing, as fierce as red, as definite as black. When (so to speak) your pencil grows red-hot, it draws roses; when it grows white-hot, it draws stars. And one of the two or three defiant verities of the best religious morality, of real Christianity for example, is exactly this same thing; the chief assertion of religious morality is that white is a colour. Virtue is not the absence of vices or the avoidance of moral dangers; virtue is a vivid and separate thing, like pain or a particular smell. Mercy does not mean being cruel or sparing people revenge or punishment; it means a plain and positive thing like the sun, which one has either seen or not seen. Chastity does not meal abstention from sexual wrong; it means something flaming, like Joan of Arc. In a word, God paints in many colours; but He never paints so gorgeously, I had almost said so gaudily, as when He paints in white. In a sense our age has realized this fact, and expressed it in our sullen costume. For if it were really true that white was a blank and colourless thing, negative and non-committal, then white would he used instead of black and grey for the funeral dress of this pessimistic period. We should see city gentlemen in frock coats of spotless silver satin, with top hats as white as wonderful arum lilies. Which is not the case.

Meanwhile, I could not find my chalk.

I sat on the hill in a sort of despair. There was no town nearer than Chichester at which it was even remotely probable that there would be such a thing as an artist's colourman. And yet, without white, my absurd little pictures would be as pointless as the world would be if there were no good people in it. I stared stupidly round, racking my brain for expedients. Then I suddenly stood up and roared with laughter, again and again, so that the cows stared at me and called a committee. Imagine a man in the Sahara regretting that he had no sand for his hour-glass. Imagine a gentleman in mid-ocean wishing that he had brought some salt water with him for his chemical experiments. I was sitting on all immense warehouse of white chalk. The landscape was made entirely out of white chalk. White chalk was piled mere miles until it met the sky. I stooped and broke a piece off the rock I sat on: it did not mark so well as the shop chalks do; but it gave the effect. And I stood there in a trance

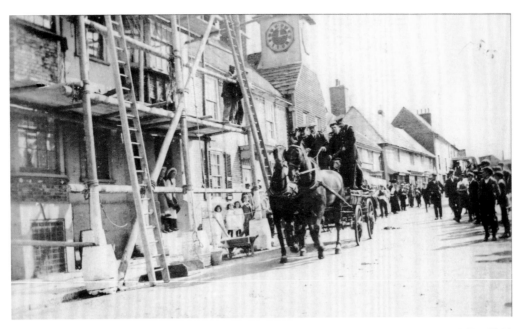

FIRE BRIGADE, STEYNING

of pleasure, realizing that this Southern England is not only a grand peninsula, and a tradition and a civilization; it is something even more admirable. It is a piece of chalk.

G. K. Chesterton

OLD TOM'S VIEWS

When I visited my friend the landlord of the Hare and Hounds last week, Old Tom was sitting in the bar having his lunch of 'bren-cheese' and beer. He greeted me with his usual touch of the fore-lock, and in answer to my

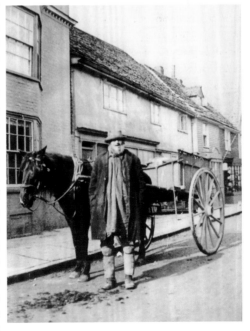

inquiry, 'What shall we have Tom?' he asked 'Who's goin' to pay?' I said 'Why I am, of course, Tom.' 'Well then let's have sumthin' good' he replied. After he had had 'sumthin' good', I told him it helped the world along to be sociable. To this Old Tom said:

'You baint no Sociarlist, master, for you shares out your own stuff. They only wants to share t'other people's You have 'eard me talk of Runagate Tom. Well, I rackon as how he wos a proper Sociarlist. He didn't do but very little work so hadn't got nothin' hisself but he was always sharing out anythin' that he could lay his 'ands on belonging to others. Caught 'im once I did with his old billy-cock hat full of Farmer Carter's eggs. Sed he 'ad collected 'em and wos a-takin' of 'em up to the farmer's house, but he wos goin a durned long way roun' to't, as I up and told 'im. He sed he didn't like to see poor children suffer, but he had no children hisself and Farmer Carter had six. He uster have a lot of fishy talk about boalter caplists and sed he wos labour and how we-no-ought to work only a few hours a day and have big money and share out everythin' ekal, and all be brothers like. He uster share other folks' beer till the

HIGH STREET, STEYNING

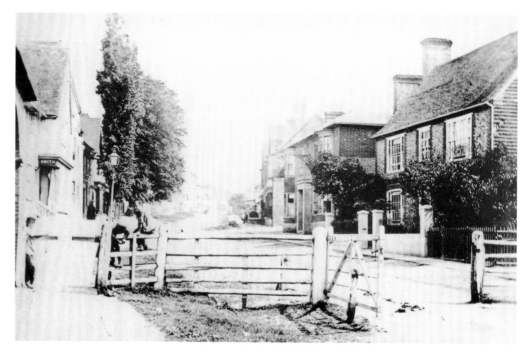

THE TOLL-GATE, LINDFIELD

landlord dosed a pot of beer with some hoss medcin and left it on the counter. Runagate Tom shared it out all to
hisself and then he cut his stick and we didn't see no more of 'im till next pig-killin' time. He sed he'd bin down in
the sheeres to collect sum rents. He had a tidy few in his old coat when he cum back and he had a gold watch wich
he had shared out from somebody. We told 'im 'twornt ekal for him to 'ave it and we only silver ones, but he only
sed we wos iggerant Sussex swede gnawers, forgittin' he 'ad jest called us "brothers". Otherwhile he would chipe
about there should be no fitin' 'cept revolverlutions, but he gen'rally started all the fites all-along-of his argifying,
so we interdooced 'im to Deaf Bob who always sed "No" to everythin'. He argified with old Bob for hover a 'our
afore he foun' out he wos deaf and hadn't eard nothin'. Young Dick, who wos whipper-in to the hounds and could
holler so as ye could hear 'im miles, once shouted his mightiest "Tally-ho" in Deaf Bob's ear, and nearly blowed
'im off his feet, but old Bob only clung on to the heave-geat, shook his 'ead a bit and sed "No". Little boy uster
strut up to old Bob and ask 'im if he would like a fite but he always sed "No".

'Then there wos old Two-at-a-time, as he was called. One bonfire nite in Steyning he kept feedin' the fire with a
prong, and a boy brought up two new faggots. Old Two-at-a-time looked at 'em and grinned and sed they looks
like sum of Squire Gorin's faggots. He tossed 'em on the fire and sed 'Bring 'em along, me boys, two at a time,
two at a time, never mind where they cums from'. He wos like a Sociarlist and didn't care, so long as they wos
sumbody else's faggots, but he raised the very old Harry wen he got home and foun' his new faggot stack wos
clean gone. The boys wos well brought up ye see and minded wot was sed to 'em.

''Tis this sort of folks as calls themselves Labour and has dances and all manner, but they don't know wot real
labour and dancin' is, I'll warrant. I once peeped in at one of their dances and see'd a lot of 'em shufflin' aroun'.
'What dance do ye call that?' I ses to the doorkeeper. He sed "Charles Stone". I uster know Charles Stone very
well in the old days but never dreamed anybody would copy his dancin'. Why he wos always afeared to lift his
feet on account of 'avin 'ad 'ousemaid's knee in his young days. We uster 'ave real labour and dancin' when I wos
a lad. We wornt afeared of twelve hours a day when hayin' or harvestin' wos on, and offen would do a dance in
the barn arterwards, too. It would froughten most of the youngun's now-a-days to 'ave seen us swappin' all day
long in the harvest field in the 'ot sun. My word, wot a merry clatter our hob-nails uster make when we danced
on the old barn floor! The rats would run and sit it out at the sides and git at the vittles, jest like human bein's.
There was young Tom Golds—he could foot it if ye like! Once when dancin' a waltz he kicked Long Jimmy under

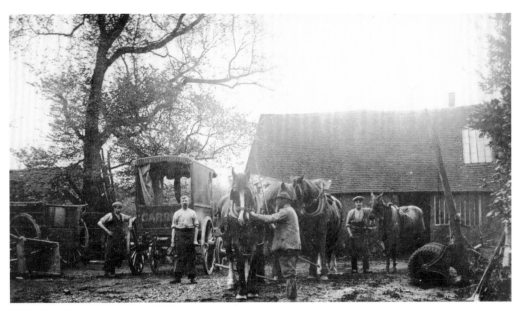

THE BLACKSMITH, ALBOURNE

the ear, and Jimmy was six foot seven. Joe Dale—whose aunt's sisters cum over with the Conkerer as I've been told—could dance a scotch-cheese on a wheat strike, and Big Tom Allen's dance would "bring the house down," as the sayin' goes, for he was over twenty stun and stout with it. He wos a prime lookin' man in his roun' frock. As for work there wosno never-sweat among us.

'The old Squire wornt no Sociarlist, but he uster share out a hem of a lot of beef, clothes, puddin's and all manner at Christmas in the big Hall. There was no grudginin' in them days but a good understandin' atween us all. The old gardener at the house, Muster Benjamin, was a man of gurt understandin' and I well minds the day when I 'eard young Crow Clements ask 'im if he could give 'im a pair of boots cos his father's feet had swelled up so as he couldn't wear no ornery size boot. Bein' a man of gurt understandin' ye see, and no Sociarlist, he give young Crow a pair of his own. I recomember 'im takin' a swarm of bees once. They flew rite out at old Dad Hillman when he wos abeatin' of a shovel and was settlin on 'im; there wos more b's in old Dad's lanwidge than there wos in the swarm but he dived thro' a hedge and left the bees in it. Muster Benjamin 'e cum out with his shirt sleeves turned up and took the bees in a skep jest as cool as ye like.

'Howsumdever, I rackon our Sussex lads won't let the old County doun but will still show the furriners we baint afeared of work and can dance and sing with the best of 'em, speshully while we call drink together of sumthin' good.'

Old Tom then took out a watch about the size of a small saucer and after glancing at it, winked at the landlady and took his departure.

I.P.M., The Sussex County Magazine

A RAW COUNTRY BOY

On leaving school at sixteen I returned home and, as my forefathers had done for centuries, I commenced to learn farming, which was quite a different thing in those days to what it is at the present time. And here I remained for twelve months, picking up a little knowledge of different soils, the different methods of cultivation, and various other matters connected with agriculture. I also learned something about domestic animals, and watched with great interest the manner in which the old herdsman managed his cattle. He kept them clean, their stall well ventilated and warm and free from draughts, with plenty of clean straw. He gained their confidence so that they were not alarmed at anything he did. He studied their dispositions, always putting al irritable or bad-tempered one in a quiet place. He fed them always at the same time, gauging their appetite so accurately that nothing

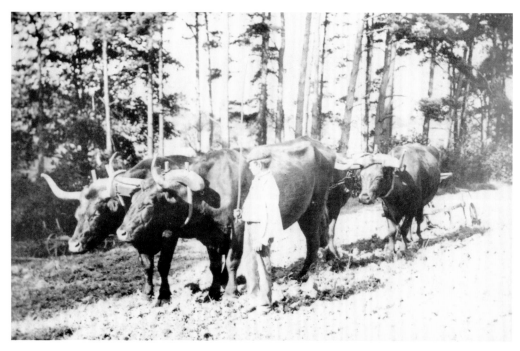

COUNTRY BOY

was ever left in their trough. The feeding over, he closed the door, so that nothing might disturb them during digestion. Could the most accomplished physician devise a better system than this? He could, in addition to this, do all ordinary agricultural work in all intelligent manner, and was in all respects a fair example of ordinary farm labourers, who are frequently looked on as ignorant and stupid. Does not the stupidity rather rest with those whose ignorance of the country and of the nature of plants and animals, prevents their seeing that these men are skilled labourers of the highest class?

I thoroughly enjoyed a country life, field sports in winter, and watching the ever varying appearance of the woods and fields as the changing seasons came round.

> Those who such simple joys have known,
> Are taught to prize them when they're gone.

And I look back with much pleasure to this twelve months, for I acquired a knowledge of the life-history of plants and animals, and I feel I also got a power of memory and observation which proved most useful in after life.

But the farmer's troubles are endless. Unfavourable weather may in a very short time destroy the work of a twelve-month, and disease a herd of cattle or a flock of sheep. There was at that time a great agricultural depression and the seasons were most unpropitious, so I determined to leave farming and enter the medical profession. It was a great wrench for me, a raw country boy, to leave the country life and country scenes in which I had been brought up, and in which all my tastes and pleasures were centred and plunge into the, to me, 'great unknown' of town life. I asked my father to try and place me as a pupil at the Sussex County Hospital.

N. P. Blaker

SUPERSTITIONS

In Richard Jefferies' essay, *The Country-side: Sussex* (in Field and Hedgerow), describing this district of the country, is an amusing passage touching superstitions of these parts, picked up during hopping:

'In and about the kiln I learned that if you smash a frog with a stone, no matter how hard you hit him, he cannot die till sunset. You must be careful not to put on any new article of clothing for the first time on a Saturday, or some severe punishment will ensue. One person put on his new boots on a Saturday, and on Monday

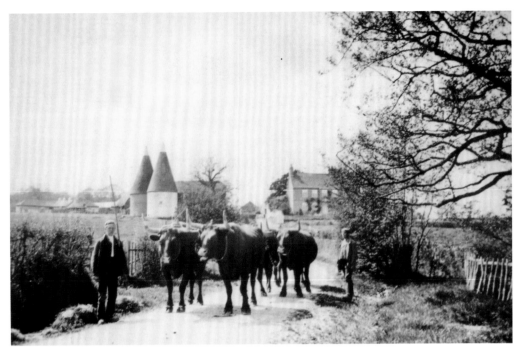

OLD COGHURST FARM, NEAR GUESTLING

broke his arm. Some still believe in herbs, and gather wood-betony for herb tea, or eat dandelion leaves between slices of dry toast. There is an old man living in one of the villages who has reached the age of a hundred and sixty years, and still goes hop-picking. Ever so many people had seen him, and knew all about him; an undoubted fact, a public fact; but I could not trace him to his lair. His exact whereabouts could not be fixed. I live in hopes of finding him in some obscure 'Hole' yet (many little hamlets are 'Holes', as Froghole, Foxhole). What an exhibit for London! Did he realise his own value, he would soon come forth. I joke, but the existence of this antique person is firmly believed in.'

E. V. Lucas

FULKING

During my first year, my father removed to Perching, in the parish of Edburton, and here I was brought up. As an only child, and with nothing but my immediately surroundings to occupy my attention, the events and scenes among which my childhood was passed have become vividly fixed on my memory, and it may be interesting to recall the appearance of a country village seventy years ago; and the parish of Edburton, with its hamlet of Fulking, presents, I think, a fair example of this. The population was almost entirely composed of agricultural labourers and their families, with the village shop-keeper, the village publican and one or two market gardeners. These labourers were a strong, hardy set of men, industrious, truthful and honest, with very few exceptions. Their dress was usually a dark smock frock, with elaborate pleating at the shoulders, knee breeches, leather gaiters and laced boots. On Sunday they wore a scrupulously white smock frock. Their food consisted of bread and cheese, vegetables, bacon and puddings, with fresh meat only occasionally. The roads at this time were very narrow, rough and muddy, and locomotion was very slow and difficult, consequently they rarely travelled far from home, some never going out of their own parish; indeed, it was a common saying that Sussex girls had such long legs because they stretched them by pulling them out of the mud in the roads. The late Mr Henry Holman, in his day a very excellent practitioner, who practised at Hurstpierpoint for nearly sixty years, and was one of the old-fashioned doctors who always did their round on horse-back, told me that when he left Edinburgh, where he was a student, he bought a horse and rode the whole distance thence, by easy stages, home to Hurstpierpoint, as

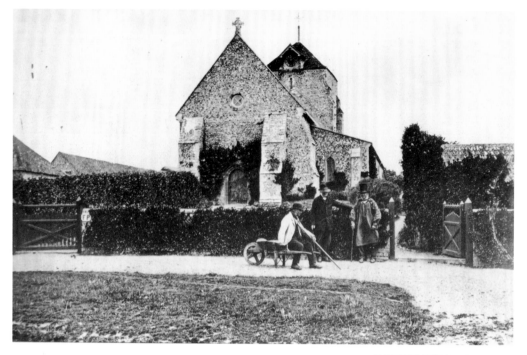

ROTTINGDEAN CHURCH

the easiest and cheapest way of accomplishing the journey, which took him, however, two or three weeks. The only ordinary means of communication between the village and the rest of the world was by an old woman with a donkey cart, who went to Brighton once, sometimes twice, a week and did most of the village shopping, etc., and the market-gardener, who went there with vegetables at suitable times.

It was not an unusual thing for men to work all their lives on one farm, and in it and all that belonged to it they took the deepest interest, regarding it almost as their own property and speaking always of 'our' cows, 'our' sheep, 'our' wheat; and their great object and ambition was to do their work, ploughing, mowing, etc., well, and to have the crops and animals under their care to look a little better than their neighbours'. They commenced their work at 6 a.m. and left off at 6 p.m. in summer, and from dawn till dark in winter, with intervals for lunch and dinner, so that

> Along the cool sequestered vale of life
> They kept the noiseless tenor of their way

with little variation. Indeed, sheep-shearing, harvest-supper and Christmas were in those country villages the three festivals of the year, and were looked forward to and remembered for days or weeks:

> A Christmas gambol oft could cheer
> The poor man's heart for half a year.

N. P. Blaker

ASSOCIATIONS OF THE PAST

It was a pleasing sight in years gone by to see the rustics of the parish assemble on a Sunday afternoon and hang about the church door ere they entered and took up their seats, all dressed in the smock-frock and hobnailed boots, and with hair cut straight across the forehead and all round as though a basin had been clapped on the head as a guide to the scissors of the homespun barber; and I well remember these same youths passing the reading-desk, with chin almost resting on the breast, 'demure and grave', many of them dropping the Curate a reverential bow as they followed each one on to his appointed place. Behaviour since that time has somewhat

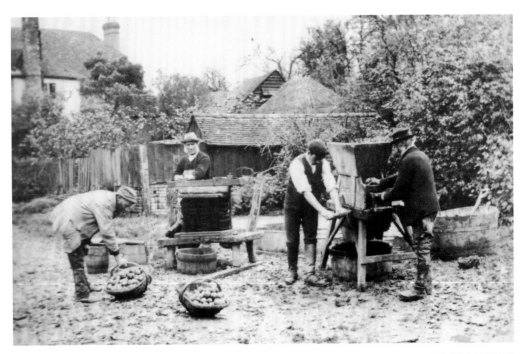

CIDER MAKING

changed, but reverence, if not so demonstrable, may be deeper. One thing is certain; the smock-frock and the hobnails are never now seen or heard within the portals of the church door. Fashion, following close upon the heels of progress and means, has banished the rustic garb. For dress 'tis hard now to know the maid from the mistress and the manservant from the master.

I pity the man, if any such there be, who can escape without emotion a visit to the shrines of our 'pious ancestors' as they lay embalmed in the dim religious light of our grand old cathedrals. The most rigid or rabid denominationalist, as he gazes upward to the centre of the high vaulted roof, is touched, and becomes mute in wonder and admiration, almost with love, as he treads the pillared aisle and hears the

> Pealing organ blow
> To the full voiced choir below.

And so in some degree it is with our rustic life in our own parish church. If veneration for the ritual is changing or passing away, there is no change in veneration for the building or for God's Acre. All this is sacred and hallowed. We may forget some living acquaintance, but here are friends we shall never forget. As I pass daily among the graves some occupants of the cold and lone home rises and stands before me—not shrouded nor ghostly, nor wan, nor weary. I see them, and hold converse with them as of old. We will walk the paths together, but talk on no new subject. Their present is my future. We touch not that mystery. It is some episode of the past that engages our thoughts and tongues for a few seconds: it may be the glimpse of a beloved child who has risen and is standing before me, or sister, brother, or parent who is awakening and tightening the cords of broken and almost forgotten love; it may be a mother's or a wife's caress, or it may be a father's rebuke. And so we people our brains with associations of the past. The reverie is salutary, and our loved ones retire to their cerements.

Thomas Geering

A GLASS OF CIDER

Some thirty years ago, in a rural God's acre, bordering on a great Sussex common, I made the acquaintance of a typical old Sussex sexton and parish clerk. He was brushing up the dead leaves, singing at his work in the churchyard. He was almost eighty years of age, and he earned his living, apart from his church duties, in a village

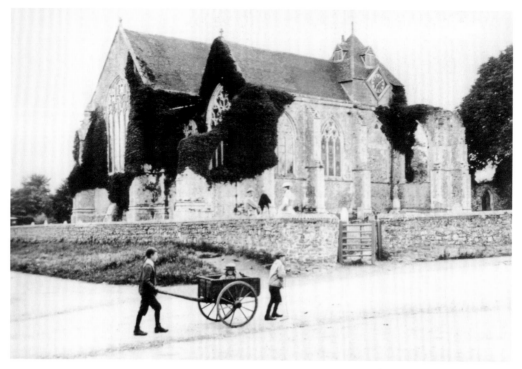

ST THOMAS À BECKET, WINCHELSEA

industry, and was the popular singer of rural songs at 'harvest homes' and choir suppers, or any other village festivity that came along. He was fond of a mug of ale, but his favourite tipple was a glass of cider. Not far from the village was a farmhouse noted for its home-made cider. It was akin to that Sussex farmhouse cider one glass of which made eyes sparkle and tongues loose, two glasses shook the confidence of men in their legs, three glasses sent them home to their wives under escort, or to a sound sleep in the barn. My old friend would make an excuse to visit this farmhouse, say soft things to the farmer's wife, and praise the farm's brand of cider. The farmer's wife, a buxom but sharp-tongued woman, would tell the old parish clerk what she thought of him—which was not always to his credit—but would fill a small glass with the cider, bid him drink it finally and begone. My old friend would admire the liquor, comment on its clarity, drink it, and remark, 'So much: so little!' He knew there was a goodly stock of the cider, and thought the farmer's wife a bit of a shrew, and stingy with the brew.

Wayfarer Snr, The Sussex County Magazine

A ROD IN PICKLE

There has been, perhaps, no change in our social life and customs during the last half century more marked than in the management and bringing up of children. I call well recollect when very little regard was paid to children's wishes and inclinations, they were expected to conform to what was thought best for them and to do what they were told. Truthfulness, obedience and respect to their parents were the objects chiefly aimed at, and 'Spare the rod and spoil the child' was the motto constantly in use and acted on. The instruments of punishment were the birch, cane and slipper, though sometimes a whip or leather strap was used. I well recollect being taken to a small dinner party at Pangdean where my uncle lived. In those days the dinner hour was usually about 3 p.m. Four ladies who had young families were present, one of them being the grandmother of one of our most distinguished Generals. After dinner, when the gentlemen had gone out, these ladies began talking about their children, and among other things they discussed was how, when and by whom they ought to be whipped. I was sitting terrified and almost forgotten under the table. In those days the birch was very freely used, and one was frequently to be seen resting on two hooks above the mantel-shelf in the nursery. It was generally administered by Mamma,

WASTE NOT, WANT NOT

though sometimes by Papa. It was the custom of some Mammas to keep a new rod in salt and water for some days before using it. In country places it was put into the brine in the tubs containing the pickled pork, the twigs thus salted absorbed moisture from the atmosphere, which rendered them more flexible and caused them to sting more, and also prevented them becoming brittle and breaking off in dry weather. This probably gave rise to a common expression, 'A rod in pickle.'

A lie in those days was always considered a terrible offence in a child, and was almost always followed by a whipping. A lady who had a little boy of about my own age lived about a mile from our house and our Mammas occasionally had tea together, and we children had a romp. One day my mother took me to have tea as usual with this lady, but instead of being sent to play I was told to sit on a low seat, and there I remained. At last the lady said, 'Little Willy has told a story and has been whipped and sent to bed, but you must just come and see him.' We went into the room, accompanied by a female relative, who suddenly turned down the bedclothes to show me the marks of the whipping. 'In terrorem!' It was quite effectual! Obedience was most strongly insisted on; any disobedience was severely punished, and children were very frequently made to assist in their own punishment. It was quite a common occurrence to make them fetch the rod or cane. A trained nurse, with whose family I am connected, told me that, when a child, she was sometimes told to go to a certain room and get ready to be whipped. This consisted of divesting herself of any impeding garments and getting the whip from a drawer and placing it on the table. When the lady who had charge of her arrived, she was made to put the whip into her hand and put herself into a proper position to receive the whipping which was always severe.

A distant relative of mine belonging to a generation preceding my own told me that, when a child, she was sent for a change from Brighton to Henfield, and stayed with her governess at the George Hotel. One day she transgressed in some way and her governess made a high fool's cap with white paper and wrote on it in large letters: 'This is a very naughty little girl,' and made her walk up and down in front of the Hotel for a considerable

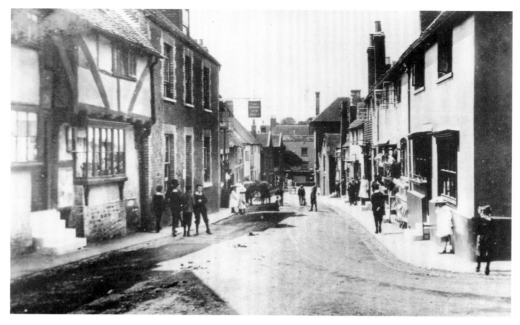

HIGH STREET, PETWORTH

time. When she related this incident to me, I told her I knew all about it, for a gentleman who saw her had told me of it years before.

N. P. Blaker

BEE-WASSAILING SONG

God made man. Man made money.
God made bees and bees made honey.
God made big man to plough and to sow.
God made little boys to frighten the crows.
God made woman to brew and to bake.
God made little girls to eat up the cake,
Then blow the horn.

Rhoda Leigh

OLD JOHNNY

'Playz de Wynchelsee'—are taken abundantly in the sea near here. Winchelsea is a very healthy spot, though so near the ague-bringing marshes. The shepherds of the plain call the ague 'Old Johnny' and wear a charm against it—a three-cornered piece of paper, suspended round the neck, and inscribed,

Ague, I thee defy:
Three days shiver,
Three days shake,
Make me well for Jesu' sake.

There are many charming walks in the high ground near Winchelsea, and the artist will find it a most attractive resting-place, and delight in the peculiar character of the place, the unexpected bits of ruin cropping up here and there, the strong relief of the foregrounds, the exquisite delicacy of the distances, and the picturesqueness of twilight in such unusual scenery.

Augustus Hare

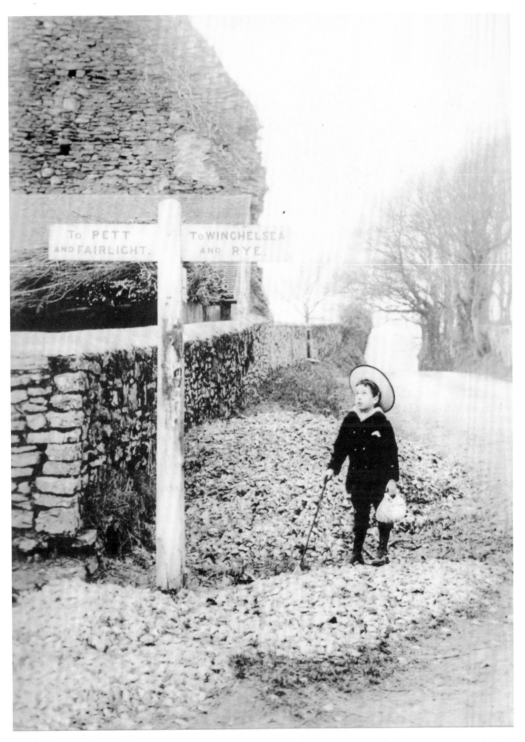

CHOICES

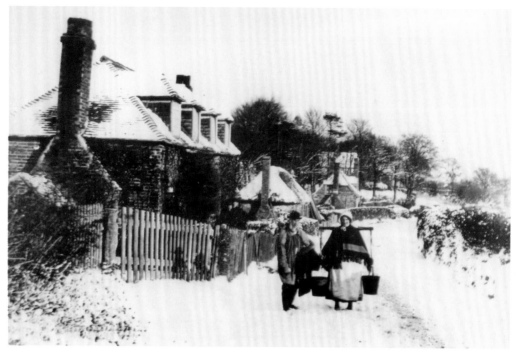

THE WATER CARRIER

HONEST LABOUR

These old homes, standing away in the fields, lead us to think about the inmates and their lives—the lives of the farm labourers. How distinguishing a term is labour!—if not the first, the second cause whence all our good things flow. Without it, barrenness and want; with it there should be plenty and contentment. Sad is the lot of the man who has 'nothing to do'. Such is the fate of many of the younger sons of our aristocracy and our country squires, born never to know the privilege of being independent. Not so with the too-often despised farm labourer—the man bred to work. The tenth son is on a level with the first, and the lesser is equal to the greater. There are no exemptions nor privileges in this family. To the first and the last the fortune is equal, and all the intermediates have a like share in the. heritage, to work to obtain the necessities of life; and happy—ah! happiest—is the man who has a willing heart and able hands to do so.

> He that will not live by toil,
> Has no right on English soil.

What more dignified than honest labour! The toiling, plodding, earnest man of the fields, tied by never flagging affinities to the spot on which he was born, has never roamed, and never perhaps sighed for change, though it has been but scant fare with him all his days. He was one of many sons, and took his lesson early at the plough, where he whistled, it may be, for want of thought, his boyish days away. He is an old man now, and has become the father of many boys and girls, and the table has been too often but scantily supplied. The mother has had her 'hands full' keeping the children tidy and clean, and the goddess of health has rewarded her by painting their glowing, laughing cheeks a ruddy hue. See the father in the village on a Saturday evening, clean-shaved and robed in the last new round-frock, with his basket by his side shopping; and see him as he returns up or down the street with the good things for the coming week—bacon, cheese, butter, and it may be a bit of tobacco; and he may also call at the tavern and wet his lips with a pint of beer, but never more, and only on shopping nights. Somehow, I suppose, he learned the notion from his father. He has considerable faith in the virtue of beer, but he wisely says, 'You must not take too much'; and a pint is his limit. See such a man, I say (and I am thankful I have known a few such), and you see one of the happiest men in the universe—never in debt and never in fear.

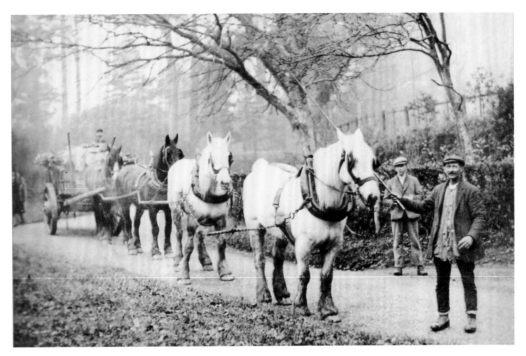

A SUSSEX LANE

Tomorrow is Sunday; he reveres the day, and goes to church or to chapel. Probably he is a Dissenter (Baptist, Calvinist, or Methodist). His faith is strong, and his hope equal to the future. The morrow rinds him refreshed, and ready again for the coming six days' toil. The master salutes him in the morning at his work, and the man, with no averted eye, freely returns the salutation.

Thomas Geering

SOCIAL HABITS

Owing to the conditions surrounding them, the mode of life and habits of thought of the people were very different from those of the present day. The well-to-do farmers and men of that class usually got up at 6, had breakfast about 7, dinner about 1 or 1.30, tea at 5, supper at 9, and went to bed about 10. Their social habits were much like those of the colonists of the present day. If a person, at a distance from home, chanced to be near a friend's house, he usually called in and was always asked to partake of the next meal or sat down with the rest as a matter of course. Dances took place very occasionally and were considered great events. Dinner parties were common but not frequent, the guests having to drive sometimes eight or ten miles in an open conveyance on bad roads. These dinners were much like the present ones, except that they took place in the afternoon, about 3 or 4 o'clock, that mild beer was drunk as well as wine, sometimes home-made; a champagne glass of very strong old ale with the cheese, and, after the ladies retired, the gentlemen drank punch and smoked long clay pipes.

But the most important events were the hunt dinners. Of course, only gentlemen were present, and so soon as the cloth was removed, pipes and tobacco were brought in, the punch was brewed, songs—chiefly hunting songs—were sung, and the festivities were kept up till morning.

I recollect asking a nonagenarian, the late Mr New, of Southwick, who had ridden on horseback not less than sixteen or seventeen miles in the morning of the day on which I sat next him at dinner, what he had done to be so well and strong at his age? The answer was 'I was always very careful, I never drank much wine. Five or six glasses at dinner, and the same after dinner, but I used to drink punch from six o'clock at night to six o'clock next morning.' But he forgot to mention that, in the intervals between these orgies, he was most abstemious and lived in the open air.

N. P. Blaker

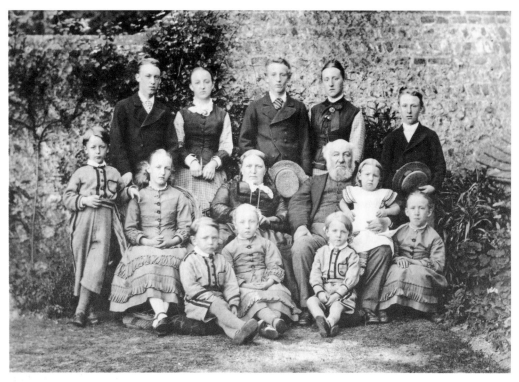

NEWINGTON FAMILY GROUP, GLYNDEBOURNE FARM

THE BARBER

So among the many notables of 'Our Sussex Parish' the barber Must not be forgotten. How subdued his tone, how civil his manner, how clean his napkin, in which he wraps you; how soft his fingers, how delicate his touch as he seizes your nose, and in five minutes rids you of your trouble. Listen to his razor as it travels beneath the snowy surface—white as Hecla, warm at Etna, soft as Venus. Do you hear the rattle of the bristles?—platoon firing right, left, and centre! The fight is soon over, the foe is vanquished, the victory is complete, and the man, shorn of his beard, is himself again. Let the unrazored deride; let him pride himself on his strength, vaunt in the street, gibe as he passes by, and, if he will, dip his beard in his cup or sail it in his soup-plate; let him be proud as he may be. My delight is in a recurring shave and a clean chin. And oh! that again my locks could be clustering and my pate well covered. Then, when seated in his chair and folded in the ample cloth, then had I pleasure. Closing my eyes, care fled from me, envy was banished, the whole world lay at my feet; then was I in a land flowing with milk and honey. Every moment was hallowed. This was my millennium, when sitting under the mesmeric touch of the barber, hearing and feeling the click of the scissors. It was then I sighed, when I had to make way for the next patron, and he, perhaps, hating the operation, cursing the barber if he dallied, and on some occasions rushing out of the shop—as our eccentric man Mr M. Slye, would do, with a half-cropped cranium, shouting, 'I'll pay next time,' and trotting away.

Thomas Geering

THE COT BY THE WAYSIDE

The appreciation of cottage-building is a plant of recent growth, a newly found truth, and, therefore, precious. The cottage has a beauty that is all its own, a directness, a simplicity, a variety and an inevitable quality. The intimate way in which cottages ally themselves with the soil and blend with the ever-varied and exquisite landscape, the delicate harmonies that grow from their gentle relationship with their surroundings, the modulation from man's handiwork to God's enveloping world that binds one to the other without discord or dissonance—all this is a

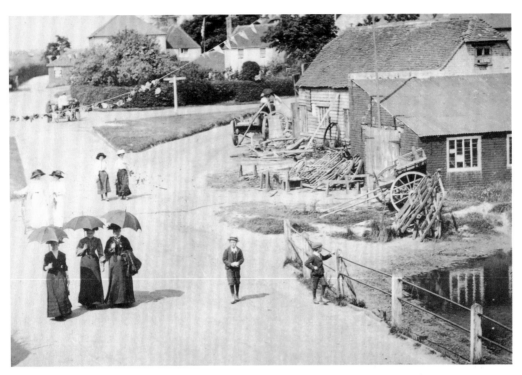

LITTLE COMMON VILLAGE

revelation to eyes unaccustomed to seek out the secrets of art and nature. 'It is only a cottage,' people say, without realising the importance which it really occupies in the story of English building, apart from the fact that they are very picturesque and very beautiful. They are that—at least we think so now, when we are delivered from the old regime of artificiality and false standards passed away in the last century, and new ideals, which were really a revival of the old, taught us sounder principles of taste. It would be hard to exaggerate the value of these little English cottages from this aspect of beauty alone.

P. H. Ditchfield

REARING CHILDREN

I was once struck by a mother who once had got children of all ages about her, and to whom, as she was not strong, I had happened to say,

'I am afraid all these children are a good deal of trouble to you.'

'Oh no, sir,' she said, 'children aren't trouble; they're only fatigue.'

The distinction seemed to me not an unreasonable one, reserving, as it apparently did, the deeper sense of trouble for that brought home too often by sons and daughters no longer children.

Hints on the rearing of children I often get, though not uncommonly on the principle of how not to do it. When I think of the conditions under which many of our poorer children are brought up, I often wonder how they turn out half as well as they do. Given one not over large living-room—the only refuge except the open air for all the various tempers and passions of a father and mother, and six or seven children of all ages and dispositions; given two bedrooms, from each of which every sound of a crying child or a groaning sick person passes through the thin partition into the next room, and often through the unceiled floor into the living-room; given even the ordinary worries and irritations of life, aggravated now and then by a little beer, and less money, on Saturday night; given the not over-soothing effect of an occasional lecture from a clergyman or district visitor, who, judging of things from a cleaner, airier, and more generally comfortable point of view, speaks accordingly; given all these drawbacks, and many more, and who can be surprised if some poor cottages are not exactly schools of patience,

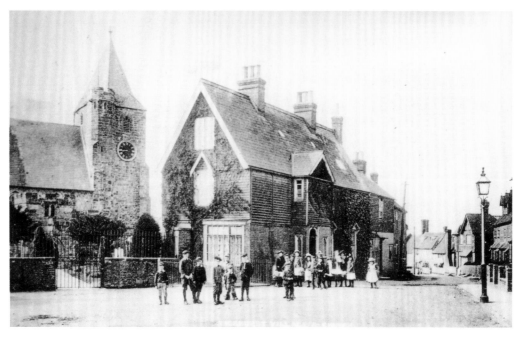

TICEHURST VILLAGE CHURCH

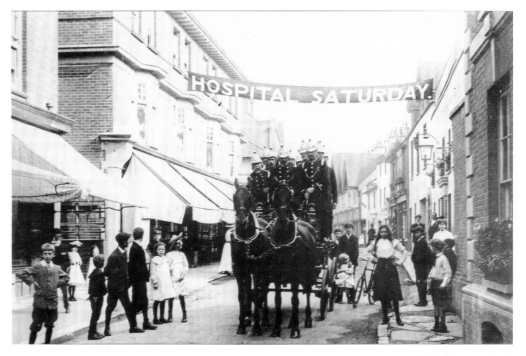

HURSTPIERPOINT

MAYFIELD

resignation, good temper and refinement? A word and a blow are a very ready discipline in an area in which no one of its occupants can be very much more than an arm's length from another, and a large part of many children's time is probably spent in simply calculating how often they can do what they like, against orders, after the word, before the blow comes. It must have been a sense of this common experience which made a woman once say to me, speaking of the superior system of which she herself had been brought up,

 'Ah, sir, I'd as good a mother as ever a child need to have. Whatever she promised me I was sure to get it, whether it was a bull's eye or a hiding.'

John Coker Egerton

THE PILLION

Among other things that have passed away in our parish is the pillion. Sixty years ago, we had our pillion in use. Then the old farmer, dressed in his white smock-frock, with his wife behind him, rode up to church on the back of the old horse, 'Dobbin'. The owner was Henry Hicks, yeoman, living on his own small estate near Otham Quarter. The highway leading to his house was known as 'Hick's Drove', and the drove in summer was one of our sweetest and prettiest old lanes, with a wide marsh ditch on either side. The way was garnished the whole distance with hawthorns of every shape, height, and bulk. There was no trimming nor training; Nature had formed them after her own fashion. They had grown high out of reach of the lowing cattle who sought shade beneath the clustering branches from the rays of the summer sun. The painted blossoms pleased the eye and pleasantly scented the air as you passed on a May morning between their thorny ranks. Grass to the ankle bedded your feet, and the walk was clean and pleasant. The saucy blackbird, chirping as he flew from bush to bush, with the more modest thrush, round here a home all the year round. There was beauty and security in summer and plenty with the hips and haws in winter. The sly magpie and the shy pigeon deigned to make the place the abode of love, and nested here. The moorhen and the water-rat among the flags, the water-lilies, the rushes, and beneath the shelter of the overhanging bushes, held undisputed sway and possession. Such was, and is now, somewhat the Drove in summer.

HIGH STREET, HARTFIELD

But see the place in winter, after a frost! For pedestrians it is impassable; the wheel-ruts are up to the axle; no cart, save the heavy-horsed miller's cart, ventures that way. The butcher's boy, with basket on his arm, makes the journey once a week on the old pony, picking and choosing as he goes the best footing. The mud is more than ankle deep; the flats are covered with water; the herbage is swept off; the bramble to the hardest tree is leafless; the decaying ash has no shelter for its naked limbs; the few Stunted oaks moan as you pass by, drooping their heads eastward. All is desolate and chilling save the shining haws, tempting the fieldfare and redwing to join our home birds in their repast. If you venture Lip the lane, a snipe may spring up at your feet, and the heron will be watching as he thrusts his head only just enough above the bank of the watercourse in which he is fishing for his cold meal.

Such is no exaggerated description of the lane, as it was fifty years ago, whence Master and Mrs Hicks emerged on the saddle and pillion on their errands to town shopping, or on their journey to church. I saw them but once as they dismounted on the block in the 'George' yard on a Sunday afternoon; and this, too, was the only time I ever saw the pillion. It was said, perhaps maliciously, that upon one Journey, when the old gentleman had arrived in the inn yard and was about to dismount, very much to his surprise and chagrin he found himself alone on the horse. He and his wife had started together properly seated, but at the end of the Journey the pillion was naked and bare. The lady was not in her place behind her husband; she had been, by a lurch of the horse, thrown from her seat and left in the lane in the mud. The old man being deaf, had not heard her cry for help. He held on his way, little dreaming that his dear old partner was floundering about in the mire of the Drove. Luckily no serious damage was done. The surface of the ground was softer than her pillion, and if her dignity had been offended and her Sunday clothes spoiled, no bones were broken. The lady outlived the misadventure many a year.

Thomas Geering

SNIPPET

> 'Eh knowed ow tud be, ven en seed ow 'twas.'
> 'I know how it would be, when I saw how it was.'

said an old farm labourer who had stood watching a badly driven waggon till it overturned.

N. P. Blaker

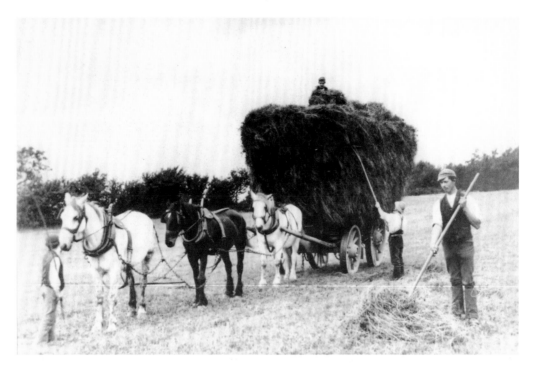

HAYMAKING

THE TITHEMAN

A glimpse of the old Sussex field routine, not greatly changed in the remote districts today was given to Mr Gordon thirty years ago by an aged labourer. This was the day:

'Out in the morning at four o'clock. Mouthful of bread and cheese and pint of ale. Then off to the harvest field. Rippin and moen (reaping and mowing) till eight. Then morning brakfast and small beer. Brakfast—a piece of fat pork as thick as your hat [a broad-brimmed wideawake] is wide. Then work till ten o'clock: then a mouthful of bread and cheese and a pint of strong beer. ("farnooner," i.e. forenooner; "farnooner's-lunch," we called it). Work till twelve. Then at dinner in the farm-house; sometimes a leg of mutton, sometimes a piece of ham and plum pudding. Then work till five, then a *nunch* and a quart of ale. Nunch was cheese, 'twas skimmed cheese though. Then work till sunset, then home and have supper and a pint of ale. I never knew a man drunk in the harvest field in my life. Could drink six quarts, and believe that a man might drink two gallons in a day. All of us were in the house (i.e. the usual hired servants, and those specially engaged for the harvest): the yearly servants used to go with the monthly ones.

'There were two thrashers, and the head thrasher used always to go before the reapers. A man could cut according to the goodness of the job, half-all-acre a day. The terms of wages were £3 10s. to 50s. for the month.

'When the hay was in cock or the wheat in shock, then the Titheman come; you didn't dare take up a field without you let him know. If the Titheman didn't come at the time, you tithed yourself. He marked his sheaves with a bough or bush. You couldn't get over the Titheman. If you began at a hedge and made the tenth cock smaller than the rest, the Titheman might begin in the middle just where he liked. The Titheman at Harting, old John Blackmore, lived at Mundy's [South Harting Street]. His grandson is blacksmith at Harting now. All the tithing was quiet. You didn't dare even set your eggs till the Titheman had been and ta'en his tithe. The usual day's work was from 7 to 5.'

E. V. Lucas

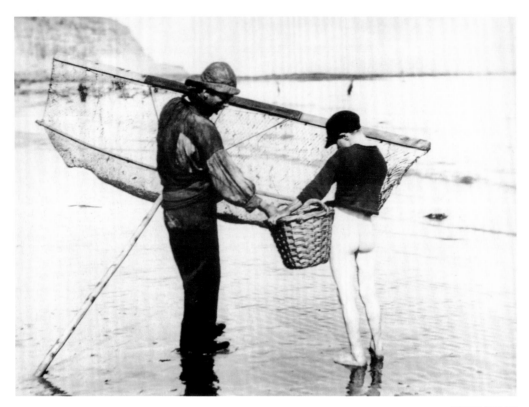

SHRIMPING

THE RIGHTS OF THE POOR

The laws of England are such that no person is allowed to starve, yet it is known that want of food ends the existence of many who from pride or ignorance neglect to bring themselves in connection with the national machinery. So it is in regard to sickness, doubtless, the poverty-stricken frequently die when medical aid given at the right time would have saved life. Any person in distress has a legitimate right to claim the services of the poor law medical man. It is evident the poor do not realise this fact as they should do. Of course there is a little red-tape business before the medical officer arrives, but it is very slight, merely an application to the relieving officer for an order upon the doctor. We make these remarks in consequence of what was revealed in the evidence at an inquest held last week upon a poor fellow residing at Ore. Suddenly taken ill, but with no means to pay for a doctor, the wife did her best till matters became desperate and then she went for the doctor resident in Ore. Quite within his rights this gentleman declined to take the case unless his fee was guaranteed. The kind-hearted Vicar of Christ Church, Ore (the Revd Chas. Ough), was then applied to—and it was after midnight—by the distracted woman and he immediately gave directions that 'whether the man was out of work or not he would be responsible.' Armed with this surety the woman obtained the doctor and ere he could be at the man's side she was a widow! In this case a post-mortem examination showed that had the medical aid arrived earlier the man's life could not have been saved, but the circumstances might have been different. The destitute poor should know that they are entitled to medical attention, and that it is their duty to see that they get it.

Hastings & St Leonards News 1900

COTTAGE HOUSEHOLD MANAGEMENT

I have learnt many a lesson of good management in our cottages, which might satisfy the most careful Scot. One thoroughly good manager I prevailed upon some years ago to give me details as nearly as she could of the weekly spending of a weekly income of 15s. 6d. It took the following form:—

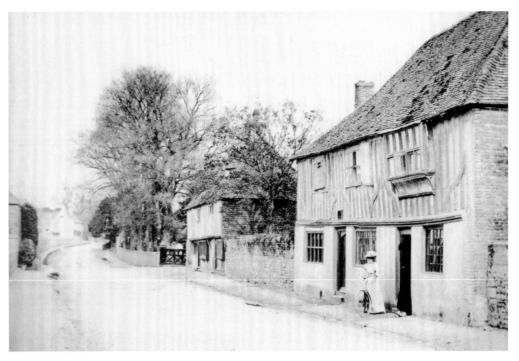

WESTHAM

	s.	d.
Rent	2.	0
7 gallons of flour	7.	0
—		
2 lb of Dutch cheese	1.	3
1 lb of butter	1.	4
½ lb of soap	0.	2
Soda ½d. blue ½d.	0.	1
Salt and pepper	0.	0½
1½ lb of candles	0	10½
2 oz of tea	0.	4
2 lb of sugar	0.	7
Schooling	0.	7
Cotton 1d., mustard, etc. 2d.	0.	3
Milk per week, viz. ¼ of a pint of skim daily	0.	3½
Mangling	0.	1
Total	14.	10½

Outgoings for wood, clothing, boots, shoes, and other items not included in the above balance-sheet, are defrayed from extra earnings by piecework, wood-cutting, mowing, harvest, hopping, and hop-drying.

The good management lay in getting out of these materials more comfort for a family consisting of husband, wife and six children, the eldest aged fourteen, than many housekeepers would get out of nearly double the income. One great difficulty is, so to manage that the living shall be about the same on Friday and Saturday as it is on Sunday and Monday. 'A feast and a fast,' as our folk say, is not an uncommon system with bad managers, whereas forethought and a clear head will naturally greatly lessen this evil. I have tried, but in vain, to persuade my informant to write down for me from time to time the various little recipes by which she gives variety and piquancy to the simple substances on which she has to feed the family. If I could only remember the devices that

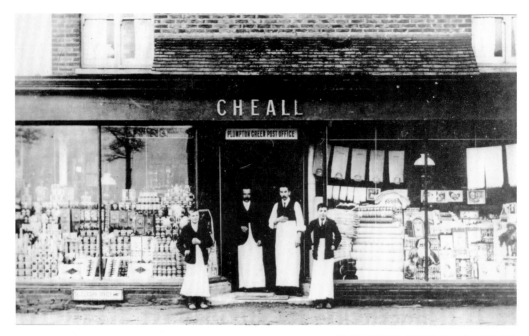

PLUMPTON GREEN POST OFFICE

have frequently surprised me by their ingenuity, I should be able to compile a little handbook of cottage economy, for which the authorities at South Kensington would, I believe, thank me.

The failures of well-meant attempts on the part of amateur economists to assist the poor in the art of management once met with a rebuke which amused our people when it happened long ago, and which is not yet forgotten. A lady, whose earnest desire to do good was well known in this neighbourhood, had persuaded an undoubtedly bad manager to let her have for once the laying out of the week's money. Having carefully considered what was most needed for the family, she went to the shop, and having returned, laid forth upon the cottage table the things she had bought, giving the woman at the same time some trifling change, and saying—

'There, friend, I think you will allow that I have spent your money to rather better advantage than you sometimes do yourself.'

'Oh, thank you, ma'am,' said the woman; 'but where's the grist?'

All the money had gone in 'shop things,' and the largest item of outlay, viz, the flour, the good lady had utterly overlooked.

It was just such a manager as the one this lady tried to help, of whom one of our shopkeepers told me, after she had gone with her family to America, that he had lost at any rate a steady customer, for that she regularly came or sent for a quarter of an ounce of penny tea, that is a fathing's worth, four times a day. When I asked what her reason could be for not giving an order for at least a whole pennyworth at once, he said that she had no doubt noticed that he did not weigh out the quarter of an ounce, but guessed it, and that so probably she had calculated on getting a little more by taking an ounce at four times than if she had taken it all at once.

Had I been set to guess her reason I should have been a long time guessing this, but I make little question that it was the right one. While I am on the subject of domestic management I may quote a recipe for avoiding family quarrels, which I think may fairly claim credit for good sense. It was given me by an old man as invented and practised by a couple whom he used to know, down 'Chidding-lye' way.

'You see, sir,' he said, 'they'd agreed between themselves that whenever he came home a little "contrary," and out of temper, he wore his hat on the back of his head, and then she never said a word; and if she came in a little "crass" and crooked, she threw her shawl over her left shoulder, and then he never said a word.'

If similarly wise danger-signals could be pretty largely used, how many unnecessary collisions would be avoided, and how many a long train of evil consequences would be safely shunted till the line was clear again!

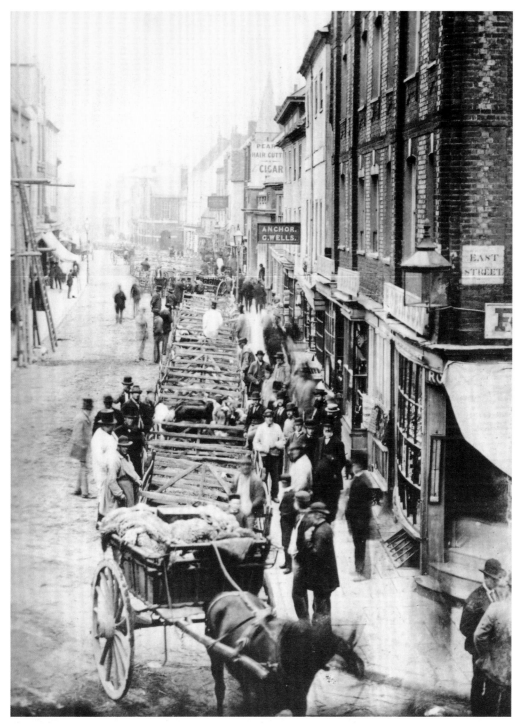

CHICHESTER, 1880

This self-denying reticence stands, however, I fear, in singular contrast with the 'hot supper' which often awaits the husband whose coming home depends more upon 'turning-out time'—the time, that is, when our public houses are cleared and closed—than upon care for the peace and quiet of his family.

John Coker Egerton

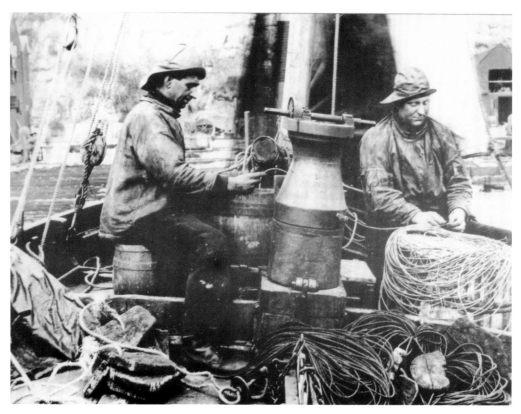

FISHERMEN, HASTINGS

THE STADE

The Stade, with its clusters of tall, quaint, irregular, black huts, sheds and 'deezes' [sheds for drying herrings] is one of the most picturesque features of Hastings. On the beach are the fishing-boats, the capstans (alluded to in a corporation decree of 1537) by which they are hauled up, nets, tackle and all the oddments of a fishing village. Although the Hastings men have long since ceased to fish as far afield as Yarmouth, local waters afford them plenty of employment, and the fish-market in the early hours of the morning is a busy scene, interesting not only to prospective purchasers but also to students of dialect, as the fishermen still speak a jargon of their own, containing a certain amount of corrupt French and a certain amount of obsolete Saxon. In 1803 there were 97 fishing-boats here, mostly small craft of from 4 to 7 tons, and in 1903 the number employed was 103. The value of the fish caught at Hastings in 1905 was returned as rather over £19,000—Brighton, the only Sussex fishing port worth consideration as a rival, standing at £16,000. This sum, which represents some 1500 tons of fish, included mackerel, caught from May to October, herring, from October to Christmas, sprats, from November to March, and all the usual miscellaneous assortment of plaice, whiting, cod, skate, etc., as well as 'that delicious shell-fish the escalop' and shrimps, locally known as 'pandles'. Many of the boats employed are built locally, and the Hastings yards have also had a reputation for pleasure craft and racing yachts, a notable example being the lugger-yacht *New Moon*, which in 1886 was considered to be 'the ablest sea boat of her class and tonnage in the world.'

Schemes for building a harbour at Hastings in 1837 having, like those of the seventeenth century, come to nothing, attempts were made on a more modest scale in 1893 to provide shelter for the fishing-boats by means of a mole, the broken remains of which may still be seen.

L. F. Salzman

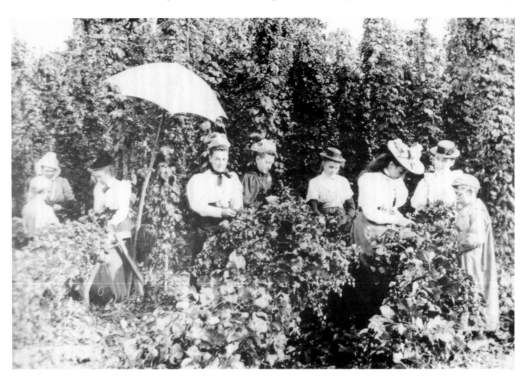

HOP PICKERS

HOP PICKERS

The train puffed out of the little country station after unloading its freight of hop pickers. With cares left behind in old London, they climbed into the large blue wagons with their miscellaneous luggage—yellow tin boxes, bundles tied with rope, Lizzie's new hat in a paper bag, small enough to be carefully nursed on her lap. Sambo the cat in an old hamper—he couldn't be left behind no-how—fowls and rabbits which must come, saucepans, plates, kettles and pots. The clothes worn by the pickers matched their luggage in variety. There were gaudy velveteen dresses, gay jumpers, velvet toques and bright-coloured close-fitting hats, plush coats adorning the proud owners of coral necklaces long enough to wind twice round the throat; striped pink and white dresses that made fair-haired children look daintily neat; faded patched frocks and shabby straw hats covering the brunette complexions and beautiful brown eyes of their wearers. Grey jerseys were worn by boys with alert faces and sharp eyes to detect ripening nuts on the hazels and blackberries among the brambles. The caravans came next, their occupants stopping to water their horses at the wayside pond. With them was Mickey Slater, a noted picker in his caravan, with its quaint roof to which was fixed a chimney made from an inverted bucket with a hole made in the bottom for the smoke to escape.

Following these came the pickers on foot, who had started early in the spring, doing odd jobs along the way, digging, planting, and helping with the fruit picking. Their luggage packed in clean sacking, was piled on perambulators and push-carts. The pickers waved friendly greetings as they passed along the road, cheering when they reached Hoppers Street—a long shed divided into compartments with a brick fireplace in the centre for cooking. This shed serves as a home for many of the pickers, others are accommodated in hoppers' huts, while some live in their caravans.

In the old days the pickers were so rough that their arrival was dreaded and the gardens avoided by the curious. Today the scene may be visited without apprehension. A beautiful fresh morning is ideal for a visit.

Edith R. Case, The Sussex County Magazine

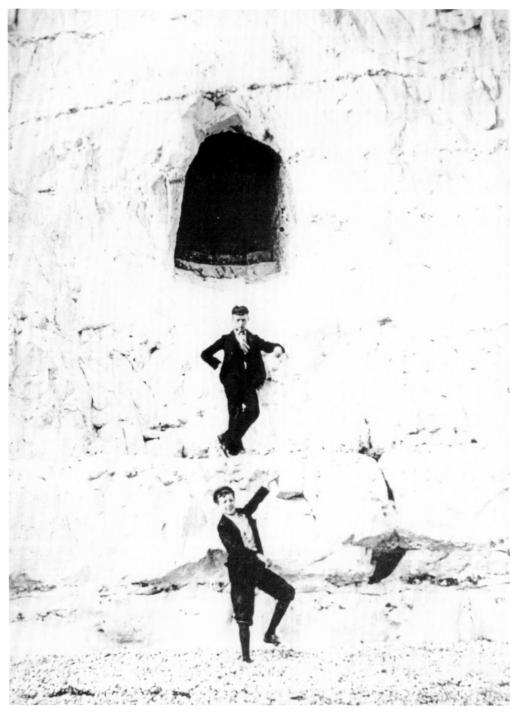

PARSON DARBY'S HOLE

PARSON DARBY'S HOLE

The old lighthouse on Beachy Head, the Belle Tout, which first flung its beams abroad in 1831, has just been superseded by the new lighthouse built on the shore under the cliff. Near the new lighthouse is Parson Darby's Hole—a cavern in the cliff said to have been hewed out by the Revd Jonathan Darby of East Dean as a refuge from the tongue of Mrs Darby. Another account credits the parson with the wish to provide a sanctuary for

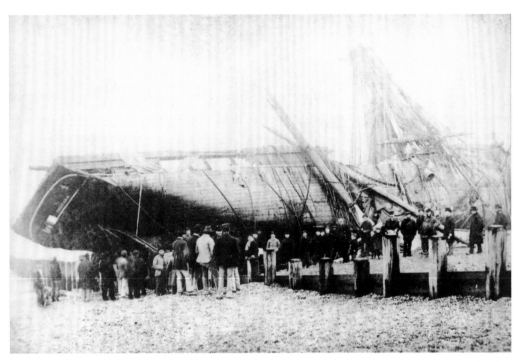

SHIPWRCK OF THE *TALLY HO*, 1886

shipwrecked sailors, whom he guided thither on stormy nights by torches. In a recent Sussex story by Mr Horace Hutchinson, called 'A Friend of Nelson', we find the cave in the hands of a powerful smuggler, mysterious and accomplished as Lavengro, some years after Darby's death.

E. V. Lucas

HENFIELD

Eh be givene t' Henvul t'mor ter look at dem dere hogs. Dey sey deirm be better dun overn, en sey dey beant. Ouern be a good tot o' shuts an dey be middlin lusty. De travlin's purty bad, and de brooks be out, but b'ou-t-will we shall goo, regn en shall git dere somehow.

 I am going to Henfield tomorrow to look at them there hogs. They say theirs are better than ours, I say they are not. Ours are a good lot of shuts (half-grown pigs) and middling fat. The travelling is pretty bad, and the brooks are out, but be it how it will I shall go. I reckon I shall get there somehow.

N. P. Blaker

TOASTS

The following toasts were given at harvest home suppers and other merrymakings:

> Here's to the bee that stung Adam and set all the world a-jogging.
> A shady lane, a gravel walk, a pretty girl and time to talk.
> Here's a health to the Queen (Victoria), and may we always have her golden likeness in our pockets.
> May the soldier that loses one eye in the service of his county never see distress with the other.
> Here's to the flea that jumped over me and bit my brother.

The Sussex County Magazine

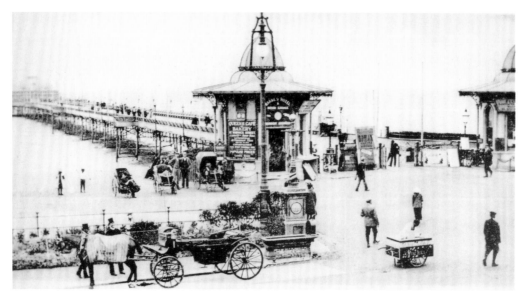

WORTHING PIER

TYPHOID-STRICKEN WORTHING

Considering the terrible gravity of the long-continued epidemic of typhoid fever with which the town of Worthing has been visited, very little reliable information on the subject has reached the London press. At first the authorities were naturally reticent, though to attempt even to minimise the seriousness of the situation was worse than useless. The visitation divides itself into two distinct periods, and though there is now good reason to hope that the sway of the disease is effectually broken, still fresh cases are being daily reported, while the clergy and ministers of all denominations view with the utmost sorrow and concern the prospects of distress among the poor for the winter. It is not alone that visitors have shunned the town completely, but that all the well-to-do residents who could possibly leave have gone away, and I was told as typical of the loss to trade that a leading local draper's entire takings for one day last week were tenpence halfpenny! At Brighton station, where one changes from the Pullman car express, guards and porters look at one as a curiosity when one asks to be directed to the Worthing train; while at Worthing itself one is eagerly offered the services of at least three railway servants to carry a hand camera, a mackintosh, and newspapers.

Streets, Esplanade, and Beach

The town itself is as depressing as a city of the dead. Pretty villas have their shutters up and gates padlocked, while the grass grows rank and coarse over what should be well-kept lawns. There is often not a vehicle to be seen, unless it be the municipal watercart, labelled on all sides, in heavy black-printed strips, 'Drinking Water'. At intervals, large galvanised cisterns bearing the same inscription have been set up, and to these may be seen coming maid servants and working men, with cans and buckets, or boys and girls with jugs and tins, to convey home the necessary supplies. As to the unfortunate lodging and boarding-house keepers, no words are too strong to describe their disappointment. I counted fourteen consecutive houses on the Esplanade on which the notice that there were apartments to be let appeared; then came two or three obviously private houses, closely shuttered, and the dreary notices of vacant rooms began again. In the hotel at which I lunched there was not a single entry in the visitors' book since June 30th, and I was informed that only one suite of apartments upon the Esplanade was let, the intrepid occupants of this being, it was reported, the relatives of a convalescent who was not at present sufficiently strong to be moved. The disappointment is all the keener as the Worthing seasons for a year or two past have been only moderately prosperous, and there was every reason to believe that with the fine summer, and the cholera scare on the Continent, this year would have been one of unexampled popularity for the town. Certain it was that many sets of lodgings had been booked early in the spring, but of course these

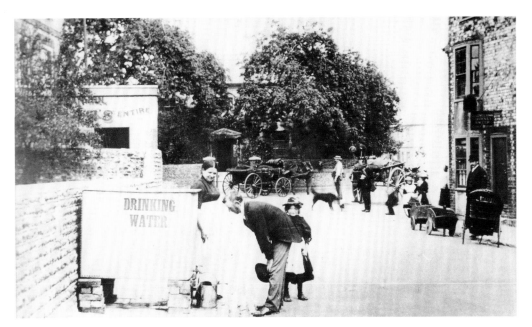

DRAWING WATER

were thrown up at the first hints of the scourge upon the place. Nothing perhaps impresses one more strongly with the absolute stillness and desertion which rules there than the utter solitude of the Esplanade and beach. On the former, a nurse in her neat outdoor uniform occasionally steps briskly along to get a breath of fresh air during her off-duty hours; a bath-chair, in which is seated some slowly-recovering patient, moves slowly by, or now and again there may be seen some on evidently on business intent. On the pier I secured between three and four o'clock an instantaneous photograph of its entire perspective, showing two figures, one of whom was a nurse. Down on the beach bathing machines were drawn up high and dry, boats literally by the score lay dusty and unused under the bright sunshine, and all the life and movement within view were a solitary boatman with a pot of paint, and two little children aimlessly paddling.

How the Epidemic Arose

To those beyond the immediate neighbourhood the first intimation of the plague which had fallen upon the place was a letter which appeared in several of the London daily papers dated July 11th, stating that some six weeks previously the town had been attacked by typhoid fever, and some thirty lives had been lost. In the light of subsequent knowledge this outbreak can be clearly traced to its source and in order to understand it it must be borne in mind that what was popularly known as 'the new well' was sunk some twelve years ago, when the necessity for increasing the water supply of the town became evident. Previously to boring for this, a supply of water, far beyond the powers of the machinery then at the command of the Local Board to cope with, had been struck, and was abandoned owing to its unmanageable volume. The 'new well' in due course was connected by a cutting through the chalk in a south-westerly direction with a second well, which was cased with brick, and between the two a good though insufficient reservoir was formed. When the last well was added to this series, various considerations led the authorities to take advantage of a long disused triple pipe sewage main, which it was believed had been effectually disconnected from the more modern drainage system of the town. The need, however, for a further extension of the water supply became apparent in the early spring, and the local authorities naturally turned to the great supply known to exist at a few yards distance. An experienced well engineer was brought from the North, and hardly had he begun his work before a subsidence took place. This was not regarded as indicative of anything unusual in the soil round; the defect was made good and tunnelling was continued up to precisely the point where it was expected that water would be struck. It came in with greater force than had been anticipated and the workmen barely escaped with their lives, leaving their tools behind them. Though there was no perceptible

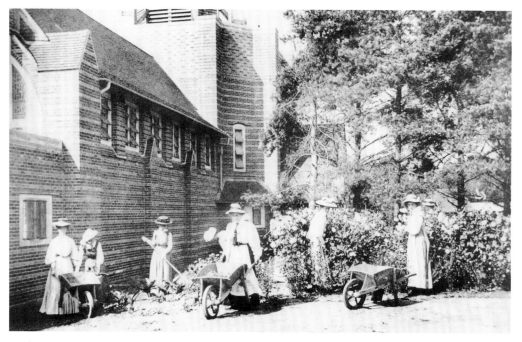

GARDENING AT KING EDWARD VII SANATORIUM, MIDHURST

taste or smell to this water it was noticed that it was slightly brown, which was supposed to indicate the presence of oxide of iron. When the first cases of typhoid arose, shortly after the water of the enlarged system came into use, no suspicion seems at first to have existed as to the cause, and it was not until the epidemic assumed really serious proportions in its first outbreak that any investigation took place. Then it was discovered that the drain-pipes and so-called blocking had been appallingly defective, and that drainage from the town was entering the water mains. When some thirty deaths had occurred, the Corporation seems to have grasped the terrible nature of the situation, and drains were flushed, people boiled all their milk and water, and by the end of June the malady abated, water was officially pronounced pure, and precautions were relaxed. Unfortunately things were not as safe as they seemed, and in a week or so the second outbreak, far worse than the first, was raging.

The Spread of the Disease

Up to Tuesday the deaths from typhoid had numbered, since the first outbreak in May, 154 in all. In that time something over 2,000 cases have been under medical treatment, the greatest mortality occurring, I am assured, among strong and healthy people of between eighteen and thirty years of age. One of the nurses—a lady of great experience in fever cases—to whom I was talking on the subject, said that the disease had been of a particularly malignant character, and those who had survived it had a terribly long and tedious period of convalescence yet to face. The town clerk kindly furnished me with some of the returns which had been made up as to the progress of the disease, and in the week ending July 8th, 184 cases had been reported. The highest total was touched during the week ending July 15th, when there were 253, and from that date onwards there has been a gradual diminution, the other figures being: July 22nd, 157; July 29th, 84; August 3rd, 56; while in the five days previous to my visit this week to the town, only 21 cases had been reported, four of these having been notified that morning.

Hospitals and Relief for the Poor

Though Worthing under ordinary circumstances is well supplied with hospital accommodation, it was totally inadequate to meet the unprecedented strain thrown upon it, and no fewer than six special institutions had to be requisitioned for the sick. The ministers of religion came nobly forward, and St George's Mission Room was at once converted into a temporary hospital with beds for thirty-seven sufferers, of which Miss Freeman, with a staff of highly qualified nurses, took charge. The Primitive Methodist Chapel in Lyndhurst Road was similarly

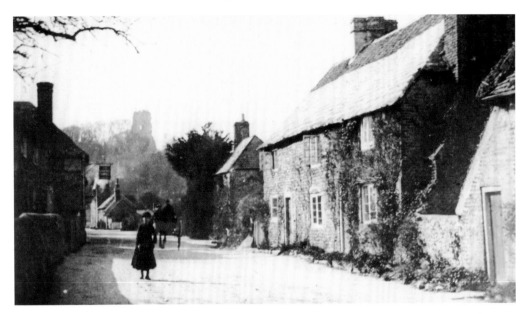

BRAMBER

employed, the Girls' Training Home and the Home for Waifs and Strays provided accommodation for many more, while the 'Travellers' Rest', a house founded and fitted up by Mrs Fooks, for mission work among the tramps who pass through the town, was also give over by her for a temporary infirmary. A very large staff of district nurses, too, have been working right nobly in the town tending the sufferers in their own homes, while for the relief of the poor a fund has been raised by the mayor to supply them with such nourishing foods as are of especial importance to typhoid patients. The soup kitchen formed a good nucleus for this, and enormous quantities of beef tea, meat extract, wine, brandy and milk have been distributed without fuss or delay to those who brought an order signed by any of the medical men or district nurses.

Daily Graphic

THE PARSON'S PRIORITY

A young newly-married couple started off on Sunday morning to attend their parish church, in the year 1800. As they turned a corner in their gig, they were hailed by someone who called out, 'Where are you going this morning?' 'To church, of course,' was the reply. 'Do not trouble, there will be no church today.' The voice was that of the vicar. Astounded, the farmer said, 'What do you mean, vicar?' 'Simply this, I learnt last night that twelve miles from where I live a calf was killed yesterday. It was too late then to go so far, so I started off at daybreak, and found the farmer had not disposed of my favourite portion, the head. It was an opportunity too good to miss. I have it here.' And he held up his purchase, wrapped in a blue handkerchief, saying, 'Now I am not going to allow my old housekeeper to spoil in the cooking what has cost me twenty-four miles' riding. I am going back to superintend it's being properly cooked, so you see it is quite impossible for me to have any service today.'

Alice Catherine Day, The Countryman

LEGEND OF A SUSSEX SAINT

<div align="center">

Saynt Dunstan, as ye story goes
Caught old Sathanas by ye nose;
He tugged so hard and made hym roar,
That he was heard three miles and more.

</div>

The Sussex County Magazine

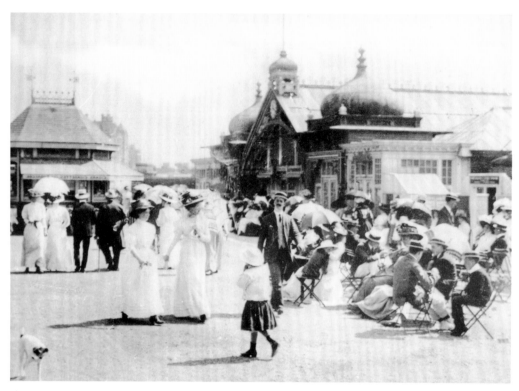

THE KURSAAL, BEXHILL-ON-SEA

FISHERMEN'S WORDS

The counting of the catch, when a herring boat comes in at Hastings is interesting both for the way in which it is done and the quaint terms still in use as they were on the same spot centuries ago.

The fish are thrown out on the beach before counting, the man who does the latter being known as the 'teller'. Taking the herrings up four at a time (two in each hand), this number being described as a 'warp', he throws them into baskets holding a bushel each and known as 'prickles'. Each warp thrown into the basket is counted 'one, two, three,' 'one and twenty,' 'two and twenty,' and so on up to sixty-six when the 'teller' calls out 'score'.

The 'scorer' (another man) repeats 'score', at the same time making an upright chalk mark upon the bow, or some other part of the boat, which is drawn up on the beach alongside. Until a few years ago the ancient method of cutting a notch in a piece of wood, or 'tally', for each score recorded, was used.

The sixty-six 'warps' or 264 herrings, are counted as two hundred. When 1,000 is reached the scorer draws a line from the top of the fourth stroke to the bottom of the first. The fish are sold by the 'last', understood to be 10,000 fish but actually over 13,000, so the buyer gets a good many thrown in. All reckoning is done in 'warps'—i.e. four fish.

The weather terms used by the fishermen are also very curious, and as old as the ancient town itself.

Salty weather with a heaving, oily sea is called 'swallocky' and is generally known to presage a storm, but a dead calm with close moist air is described as 'planety' weather. A scattered mass of cirrus cloud in the form of a loop is given the quaint name of 'eddenbite,' whose derivation is hard to guess. Other white clouds blown by the wind are 'windogs' and 'messengers'. Small low clouds in an otherwise clear sky are 'port-boys.'

A mock sun, always taken as an ominous portent, is described as 'smither diddles', and two kinds of hail are recognised, possibly ordinary hail and sleet, the latter being given the comical name of 'egger-nogger'. Changeable, unsettled weather is described as 'shucky', and what the ordinary seaman would call real 'dirty' weather the Hastings fisherman will call 'truggy'.

Eva Bretherton, The Sussex County Magazine

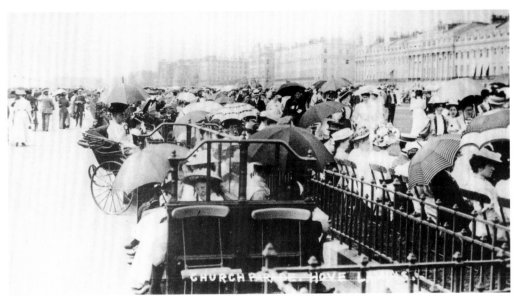

CHURCH PARADE, HOVE

SOLDIERS AND THE CHURCH

To the Editor of the Observer

Sir—In your letter of the 21st ult. The President of the Soldiers' and Sailors' Families Association is reported to have said 'the greater part of our soldiers are Churchmen.' Similarly some member of the Board of Guardians recently declared that the majority of the 'inmates' are Churchmen. The same statement is also made about our prisoners. To know Mrs Harkness whether in private or public life, is to hold her in profound respect, and to know that she prefers accuracy. Is it not a fact that in the Army and the Navy, and in public institutions, the practice is to put down as Churchmen every man who does not declare himself to be in membership of some other denomination?

 Yours truly,

 (Sgd.) J. Macer Wright

Hastings & St Leonards Observer

VOCAL FLIGHTS

I cannot say that the Sussexians have more musical voices than the people of any other part of the kingdom, but their speech is pleasant, more so than in most counties, and they are certainly fond of singing. The people of the downs have in my experience the nicest voices in speaking. And here as in other places you will occasionally find a voice of the purest, most beautiful quality. I would go more miles to hear a voice of that description speaking simple words, than I would go yards to listen to the most wonderful vocal flights of the greatest diva on earth. Not that the mere pleasure to the sense would not be vastly greater in the latter case; but in the other the voice, though but of a peasant saying some simple thing, would also say something to the mind, and would live and re-live in the mind, to be heard again and often, even after years; and with the other similar voices it would serve to nourish and keep alive a dream. And after all a dream may be a man's best possession-, though it be but of an immeasurably remote future—a time when these tentative growths, called art, and valued as the highest good attainable—the bright consummate flower of intellect—shall have withered, and, like tendrils no longer needed, dropped forgotten from-the human plant.

One such voice I heard to my great delight in or near a hamlet not many miles from Singleton in the West Sussex Downs. Sauntering along the path in a quiet green very pretty place, I spied a girl pushing a perambulator with a baby in it before her, using one hand, while in the other hand she held an apple, which she was just beginning to eat. It was a very big apple, all of the purest apple green colour except where she had bitten into it, and there

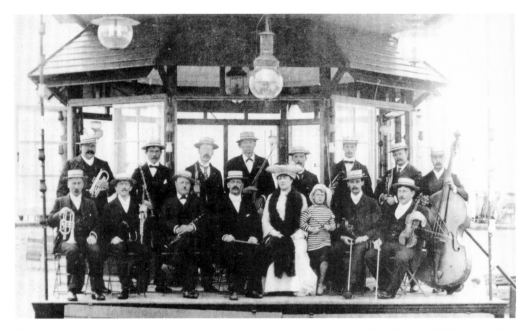

SEASIDE ORCHESTRA, LITTLEHAMPTON

it was snowy white. She was a slim, gracefully-formed girl of about fifteen, with the Sussex round face and fine features, but with a different colour, for her skin was a clear dark one, her eyes soft deep blue, and her unbound hair, which was very abundant and very fine, was black, but showing chestnut brown where the wind had fluffed it about her face. Perhaps her mouth, with its delicately moulded lips, was her finest feature; and it was very pretty, as she came up to where I stood waiting for her, to see her small, even sharp pearly teeth cut into the polished green apple. But though she was so lovely to look at, if I had allowed her to pass by without speaking the probability is that her image would have soon faded out of memory. We see and straightway forget many a pretty face. But when I spoke to her and she answered in a musical voice of so beautiful a quality, that was like a blackbird's voice and a willow wren's, yet better than either, the rare sweet sound registered itself in my brain, and with it the face, too, became unforgettable. When she had given me her answer I thought of other things to ask—the name of the next village (which I knew) and the next, and the distance to each, with many other unnecessary inquiries, and still every time she spoke it was more to me than a 'melody sweetly played in tune,' and it was at last with the greatest reluctance that I was compelled to thank her and let her go.

As to the singing of the Sussex peasants, I must confess that it has amused rather than delighted me, but at the same time it is interesting. You can best hear it in the village ale-house or inn in the evening, especially on a Saturday, when a pleasant break in the week has come with rest from toil, and money has been paid for wages, and life has a more smiling aspect than on most days. Beer, too, of which unusually large quantities are consumed at such times, makes glad the Sussexian heart, and song is with him the natural expression of the feeling. Willum, asked for a song, without much demur sings it with all his heart; he is followed by Tummas, who scarcely waits to be asked; and then Gaarge, who began clearing his throat and moistening his lips when Tummas was in the fourteenth and last stanza, bursts out with his rollicking song with a chorus in which all join. Then follow Sammel and Bill (to distinguish him from Willum), and finally John Birkenshaw, the silent man, who has been occupied all the evening drinking beer and saying nothing, gives by general request his celebrated murder ballad in twenty-three stanzas. Before it is quite finished, when he is pointing the moral of his gruesome tale, warning all fond mothers to look well after their daughters dear, and not foolishly allow them to go out walking with young men of doubtful reputation, the listeners begin to yawn and look drowsy; but they praise his performance when it is happily over, and John wipes his forehead, drinks his beer, and says good-night.

W. H. Hudson

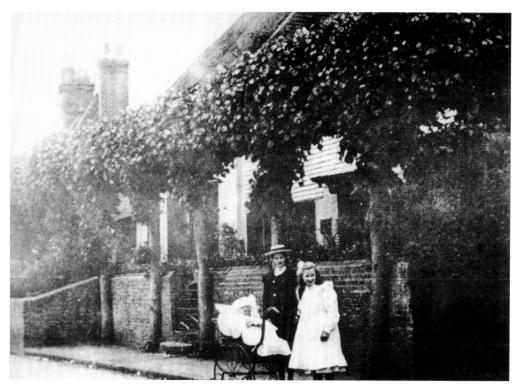

NORTH BRIDGE STREET, ROBERTSBRIDGE

ASHBURNHAM PLACE

Extracts from letters written by Bertram, the 5th Earl of Ashburnham to his Mother, the Dowager Countess, between 1884 and 1886.

Ashburnham Place,
Ashburnham April 1884

On Monday I return to attend Lady Brassey's fancy dress ball. The ball was to commemorate two events, or rather to celebrate the double event of her son's coming of age, and of her daughter's engagement to young Mr Egerton of Mountfield who has I fancy done a good thing for himself in securing the early affections of this young lady who is but a child and was to have 'come out' at this ball. I always destined her for one of my brothers though why I should trouble myself to disturb their tranquility I do not quite know....

Writing later in the month:

There is not much to tell you beyond that it was a successful though slightly ridiculous affair, there were many pretty people, and very pretty costumes. There were very few people who I knew, and I had some difficulty in even recognising them in their various disguises. The beauty of the evening to my thinking was Sir Anchitel's second daughter, her dress became her admirably but I cannot say whether in ordinary clothes she would look so pretty. I went in uniform, and a good many other people did the same. The ridiculous side of the business consisted in Sir Thomas Brassey acting as master of ceremonies, and shouting out directions to every one in a stentorian voice as if he had been on board of his yacht in a tempest. There was also a very ludicrous attempt at a sort of polonaise or procession to the sound of music headed by Sir Thomas and the Duchess of Cleveland, followed by Lady Brassey and me. We went down several passages but were always stopped by locked doors or some other obstacles, so it came to nothing. On the whole it must be said that the whole performance has been a piece of purse-proud tomfoolery or tombrassery, for though they are rich, they are not sufficiently territorial to make the majority of their son a county event and I feel sure most of their guests must have laughed at them. I forgot to tell you that my Lady B. had a *throne* in the ball-room, upon a dias!

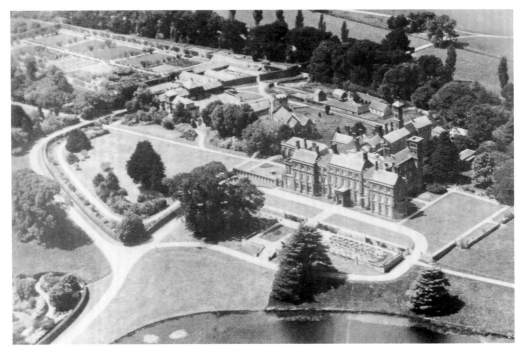

ASHBURNHAM PLACE

April 1885

There is no news except that poor old Morris is half paralysed and not likely ever to recover, and that old Ransom, whom you may recollect as a beater, has committed suicide by cutting his throat. . .

The place is in great beauty with uncommonly brilliant autumnal tints, and Jones is painting another picture. The news of the day is that old Mrs John Winchester has run away to join the Mormons; carrying with her £300 of her husband's savings. Mr Whistler (the encumbant at Ashburnham) told me that another woman came to ask him for a loan of £40 to go out to Utah, which is curious as shewing that she regarded it as quite a proper thing to do.

It is satisfactory to know that a labourer can save money in this way, and it is credible to Winchester, who at one time spent most of his earnings on drink, to have achieved such a success, but it cannot be said that his virtue has been rewarded. . .

6 November 1885

I have nothing more to tell you, except that we are expecting to have quite the worst audit ever yet known next week. . .

My principal object in writing today is to ask you whether it would be convenient to you to give me the great pleasure of seeing you here at any time between next Monday and the 7th December. I am inviting a few people for the latter day in order to get the tame pheasants shot early, I do this to save expense in feeding and also because it is feared that there will be many people out of work this winter, and consequently much poaching. . .

New Year 1886

We have had here, with the exception of one day, a most enjoyable climate, and for the last three days such warmth as one would be glad to welcome in June. The sport has been on the whole miserable as to the amount of game killed, and I calculate that the whole estate has not furnished, during the whole season, so many pheasants as were bred and brought up by hand. . .

July 1886

I have no news to give to you except that old Mr Hodgson has gone off to Wales and that old John Winchester is going to Join his wife in Utah, or at least he is going to Utah, for I do not suppose that they will be necessarily reunited. . .

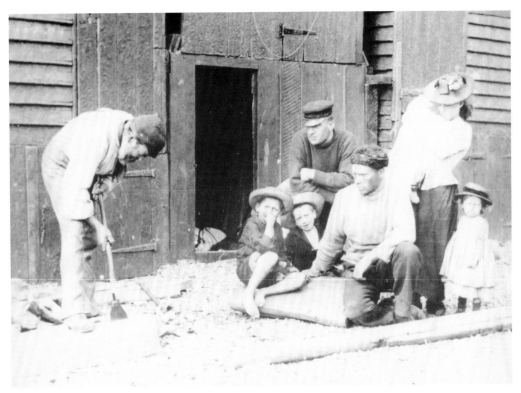

REPAIRING A BOAT

'BENDING IN'

In early Victorian days (about 1850) a very curious custom obtained among Sussex fishermen, the 'Bending In' ceremony, which generally took place in April when the luggers were preparing for the North Sea fishing.

It was a pretty sight on a sunny morning to see the wives and children seated in a wide semi-circle on the beach, with their faces to the sea; and the luggers in groups of two and three, with their bows washed by the incoming tide, the greased planks put ready and hawsers attached to the capstans, by which were sturdy horses waiting to play out the hawser, and the grandfather fishermen standing by in groups, ready at the appointed time to propel the lugger over the greasy planks, and steady the round, brown, unwieldy tubs as they tumbled and curtseyed into the sea.

Before this happened the priest of the nearby church Joined the throng. He stood in surplice before the circle of women and their little ones, and asked a blessing upon the fishing and the fishers, his lifted hand, palm down, over the assembled crowd, and asked God to keep these husbands, fathers and sons in the hollow of His hand, and return them safely to the anxious souls who could only stand and wait.

The fishermen stood coyly by at the priest's back. Nothing Would induce them to join in the simple prayer. They could tell you, if they ever communicated upon the subject 'that prayers when they were goin' off made 'em too soft, and they warn't agoin' to sea like jelly fishes.'

The priest, good man, knew his men and did not approach them personally. He also knew that if that ceremony had not been held over their women folk and little ones the men would have gone to sea disconsolate and resentful, feeling defrauded of what they considered the rights of their women and children. When they stood by during the blessing they considered that they had 'done their bit' in seeing fair play on the priest's part, and went to their boats satisfied that they had been, as it were, consecrated and commended to their God whom they were going forth to meet in the deep water perils.

I believe the simple souls imagined that there were two kinds of God—the priest's God in white robes and embroidered chasuble, and their God whom they imagined as a sleeping Christ lying in their boat ready to

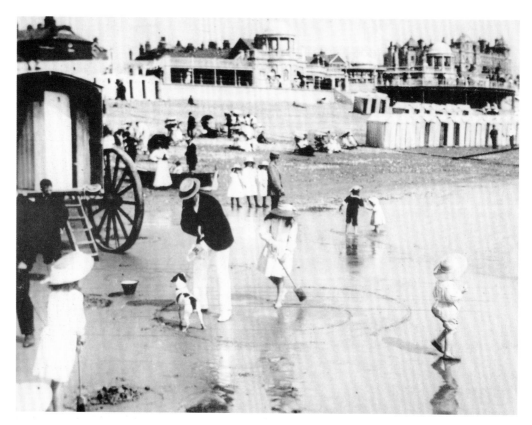

BEXHILL-ON-SEA

succour them in danger. Perhaps they were right.

Later, the priest coming to the water's edge, removed his biretta, and stood with bared head in silent prayer, what time the fishermen lifted the two ends of a net which lay gathered in long rows by the boat's side, and with the help of the captain and mate, who were standing at bow and stern within the boat, laid down the net in the midst in careful folds and 'bent it in' to the boat to the accompaniment of a musical chant with words sound like:

Holly haunch ho-o-o-o-o

All the boats began and ended this ritual at the same time. The priest lowered his hands and turned towards the crowd around deep baskets containing bread and cheese, flanked by huge stone bottles of beer. The men, shy of the priest no longer, left the boats and joined in the picnic with the priest (generally the donor of the feast). Then followed a scene of feasting and good wishes, good-byes, much lifting of toddlers in stalwart arms (with much objection on the toddlers' part to scrubby beards), kisses and looking backwards. Many young souls parting lingeringly and promises were given anent fidelity, and frequent messages to be sent home by 'boats that passed in the night.'

At length a great cry of 'Holly haunch ho-o-o-o-o' from the grandfathers who stood in rows on either side of the boats, their bodies bent and feet firmly planted in the sand and shingle, arms behind, their hands firmly clutching the boat side, reiterating the aforesaid chant every time the boat moved nearer the water's edge, shouting a final 'Hi!' as the unwieldy monster wobbled into the surf.

They soon appeared again and got busy with big brown sails. All ran to the water's edge and screamed final words to father concerning what gifts he was to bring home for them, as the boat caught in an obliging wave and curtseyed out to sea.

Ida St John, The Sussex County Magazine

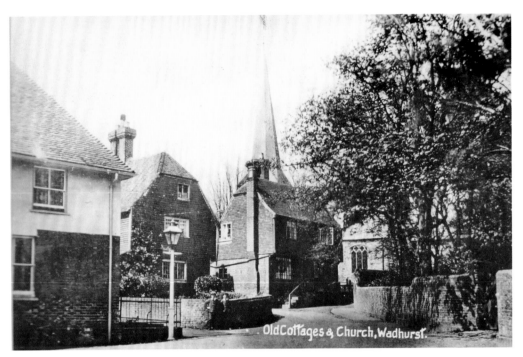

OldCottages & Church, Wadhurst.

WADHURST

MRS MARY NORMAN

At the Mark Cross Petty Sessions, on Tuesday, Thomas Humphrey and Louisa Humphrey, his wife, of Wadhurst, were charged with neglecting their children, so as to cause them unnecessary suffering. Mr Fred J. Whiteley, of Tunbridge Wells, prosecuted on behalf of the National Society for the Prevention of Cruelty to Children, and said the case was a very serious one. Defendants had six children, the charge being taken in respect of five of them, one of whom was the illegitimate child of the female defendant, the others being the children of both defendants. The male defendant was a man able to earn good wages, but drank. Some time ago the woman and children went into Ticehurst Union. They came out again in February, 1896, when the male defendant took them to his mother's. His mother told him that she had no room for them at her house, but took them in for the night. They had remained there ever since, the man never attempting to do any work. The house contained six rooms, and, two of the bedrooms being occupied by other relations, the defendant's mother took her daughter-in-law to sleep with her while the male defendant and four children slept on the floor in the living room. Their bedding was sacks and the clothing the clothes they had worn during the day. The poor little illegitimate child slept out in the wash-house on a sack. They slept like that all through the winter. The children were badly fed, while their condition could only be described as beastly. They were filthy to a degree, and their heads were so covered with vermin that the schoolmistress had to raise their hair with a pointer, being unable to touch it. The sacking upon which they slept, got, as might be expected, in a filthy condition, and the moral surroundings were such as to have done them great harm.

Albert Carroll, Inspector of the NSPCC, said that he had paid some visits to the school which the children attended, and also to the place where they were staying. He described the condition of the children, saying they were in a most filthy state.

The mother of the male defendant was called, but fainted on going into the witness box, and had to be taken out of court. Mr Whiteley next called 'Mrs Mary Norman', and this led to an amusing incident. A lady stepped into the box and seized the Testament in a manner which caused the prosecuting solicitor not a little embarrassment. The lady was the first to find her tongue, and then declared in emphatic tones, 'I don't know nothing about this case.' Mr Whiteley: 'I don't want you.' (Laughter)—The woman: 'What did you call me for?' (Laughter)—Mr

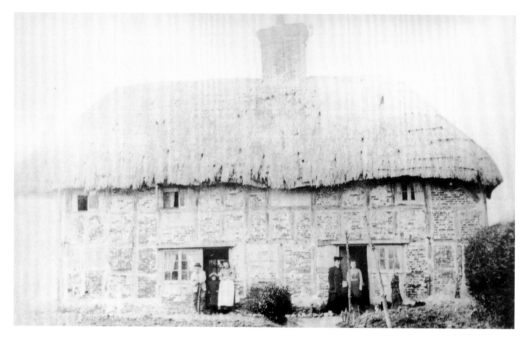

THATCHED COTTAGES, RACTON

Whiteley: 'I called "Mrs Mary Norman",'- The woman: 'Well, I'm Mrs Mary Norman. (Loud laughter). I don't know nothing about this case.'—Eventually it transpired that there were two ladies bearing the name of Mrs Mary Norman in court. The one necessary to the case then gave evidence upon the filthy condition of the children, and also stated that she had given them food upon many occasions.

Hannah Watson, head mistress of the girls' school at Wadhurst, said three of the children in question attended her school. She had to keep them apart from the other scholars owing to their filthy condition, and she had sent them home for the same reason. The children at the school often gave defendants' children food.

The female defendant protested that it was the fault of her husband. She had got three homes together, but he did not work, and never gave her any money.

The male defendant—'You're telling lies, Loo, but I won't go against you.'

The mother of the female defendant said she had seen the children quite clean. Her daughter tried to do her best.

Mr Whiteley here intimated that he did not wish to press the case against the woman.

Elizabeth Pollington also gave the woman a good character.

James Beany, the father of the female defendant, said he was sorry to say he knew too much about the matter. The family had come to him for food and shelter several times. His daughter's husband had behaved very badly, and had neglected the children very much. Witness added that he was thankful that there was a Society to protect the poor children.

The Bench sentenced the male defendant to four months hard labour and the woman to one month. The man threatened to make some of the witnesses 'sit up' when he came out of gaol.

Bexhill Observer

ROMAN REMAINS

In some respects there is no more interesting spot in Sussex than the mangold field on Mr Tupper's farm that contains the Roman pavements. Approaching this scene of alien treasure one observes nothing but the mangolds; here and there a rough shed as if for cattle; and Mr Tupper, the grandson of the discoverer of the mosaics, at work with his hoe. This he lays on one side on the arrival of a visitor, taking in his hand instead a large key. So far, we are in Sussex pure and simple; mangolds all around, cattle sheds in front, a Sussex farmer for a companion,

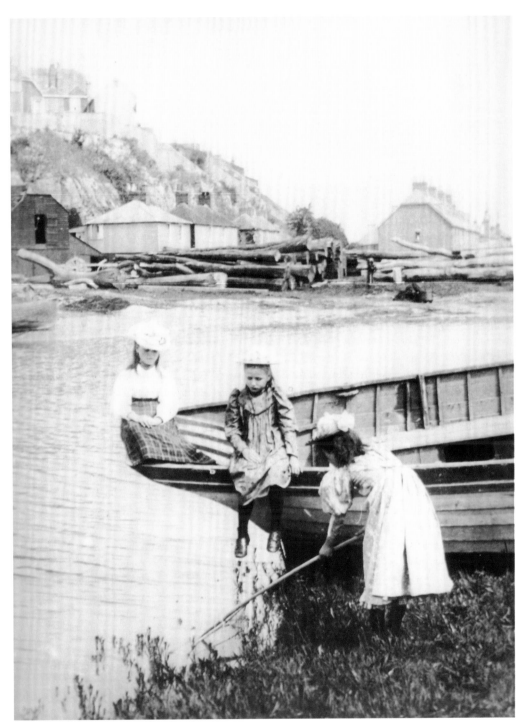

CHILDREN PLAYING

the sky of Sussex over all, and the twentieth century in her nonage. Mr Tupper turns the key, throws open the creaking door—and nearly two thousand years roll away. We are no longer in Sussex but in the province of the Regni; no longer at Bignor but Ad Decimum, or ten miles from Regnum (or Chichester) on Stane Street, the direct road to Londinium, in the residence of a Roman Colonial governor of immense wealth, probably supreme in command of the province.

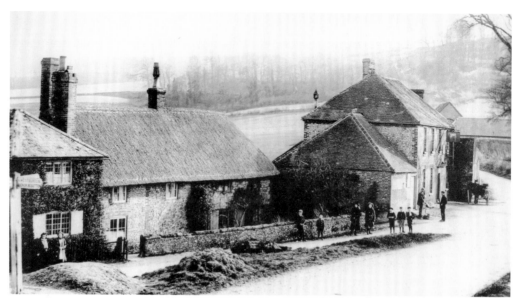

SIGNPOST TO BIGNOR, BURY

The fragments of pavement that have been preserved are mere indications of the splendour and extent of the building, which must have covered some acres—a welcome and imposing sight as one descended Bignor Hill by Stane Street, with its white walls and columns rising from the dark Weald. The pavement in the first shed which Mr Tupper unlocks has the figure of Ganymede in one of its circular compartments; and here the hot-air pipes, by which the villa was heated, may be seen where the floor has given way. A head of Winter in another of the sheds is very fine; but it is rather for what these relics stand for, than any intrinsic beauty, that they are interesting. They are perfect symbols of a power that has passed away. Nothing else so brings back the Roman occupation of Sussex, when on still nights the clanking of armour in the camp on the hill-top could be heard by the trembling Briton in the Weald beneath; or by day the ordered sounds of marching would smite upon his ears, and, looking fearfully upwards, he would see a steady file of warriors descending the slope. I never see a Sussex hill crowned by a camp, as at Wolstonbury, without seeing also in imagination a flash of steel. Perhaps one never realises the new terror which the Romans must have brought into the life of the Sussex peasant—a terror which utterly changed the Downs from ramparts of peace into coigns of minatory advantage, and transformed the gaze of security, with which their grassy contours had once been contemplated, into anxious glances of dismay and trepidation—one never so realises this terror as when one descends Ditchling Beacon by the sunken path which the Romans dug to allow a string of soldiers to drop unperceived into the Weald below. That semi-subterranean passage and the Bignor pavements are to me the most vivid tokens of the Roman rule that England possesses.

E. V. Lucas

GLORY OF RYE

There is a wealth of colouring in this southern front of Rye with its varied shades and tones and the sunshine streaming full upon it, that almost persuades me to forswear myself and suggest something of a continental parallel, illusive though it be. All about this waterside trail too, with its stacks of timber and litter of immense tree trunks, hauled down from Sussex woods, lies the flotsam and jetsam of the sea, those far-flung and promiscuous relics of forgotten voyages, and forgotten men, of rotted and abandoned craft.

Why the broken figurehead, or the rusty anchor of a long vanished vessel, the water-logged ribs of a defunct smack, the steam of a ship's boat with its faded name still partly legible, should thus move one is not far to seek. That these inconsequent fragments touch a cord left quite unstirred by the abandoned skeleton of a carrier's cart, or a prehistoric railway carriage transformed into a bathing shed is a question which the mystery of the great deep

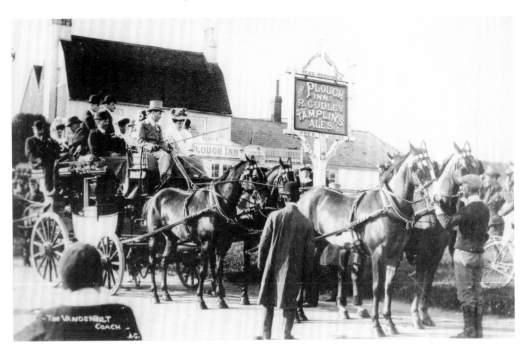

THE VANDERBILT COACH AT PYECOMBE

sufficiently answers. Perhaps upon this particular spot they may also seem emblematical of the vanished maritime glories of Rye, and assume additional pathos thereby. If such be the case, I do not know whether a still surviving shipyard just around the bend, with a half-built vessel probably on the stocks, may serve to modify or to emphasize these sombre reflections, purely academic though they be. For Rye still builds on an average one ship of about fifty tons and sometimes a sailing barge or two of larger tonnage every year. The former is launched in normal times with some ceremony. The Mayoress breaks a bottle over the stern and the assembled youth of Rye raise a cheer as the great ship glides down into the muddy but historic stream. To such a pass have things come where once were built and manned fleets to fight the French and Spaniards, and privateers in the Napoleonic wars, and even pirates in earlier days when a good opportunity occurred. At any rate neither Winchelsea, nor Romney, nor I think Hythe nor Sandwich turns out even one ship per annum, for the best of reasons not of their making.

It is to the glory of Rye, however, as I have always been assured by those who ought to know best, that this solitary contribution to the British mercantile marine, whether smack or coasting trader, is built as is no other vessel in the whole kingdom in these hurried days. There are still ships' craftsmen in Rye, having the pride of other days within them, who would rather hurl their tools into the harbour than hustle over or scamp the smallest fragment of their work. Lowestoft and Yarmouth and Hull are fully conscious of this unique characteristic that has apparently no longer any place among themselves, and if a small vessel of extra stamina is required they send all the way to sleepy old Rye for it.

A. G. Bradley

OLD GOATCHER

Sheep-farming is not an industry belonging to our side of the hill, but on the southern slopes large flocks are kept, and even imported from Kent for the summer grazing.

Old Goatcher, shepherd for the farmer on the southern side, seldom slept in his bed during the lambing season. He would possibly leave his dog on guard at the shed and hurry to his cottage for a hasty meal, but his nights were spent tending sick ewes by the light of a lantern, or dozing on a heap of straw, ready to spring up immediately if his assistance was required. The imported sheep he regarded as interlopers, stealing the luscious

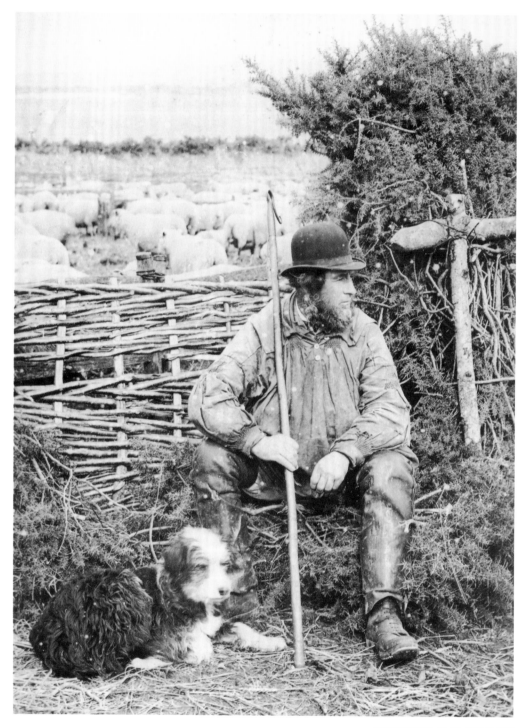

SHEPHERD AND HIS DOG

feed from his precious charges. In spite of himself he admired the heavier bodies and sturdy legs of the visitors. Illness, and an accident, smote down the shepherd, and he took to his bed never to rise again. We went to see him one day in a cottage in the village, to which he had been taken by the doctor's advice. His fringe of beard was limp, his weather-beaten face a sickly brown. He was terribly home-sick. Fields, sheep, and his dog were the things he knew and understood. He did not speak, and we thought he slept. As we tiptoed away he opened his

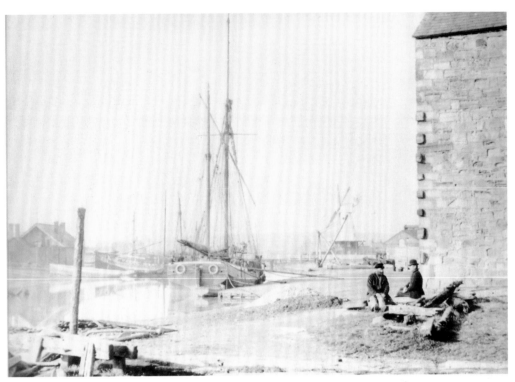

STRAND QUAY, RYE

eyes, and we caught a husky whisper: 'Be those old Kents up in top field agen?'

After he had passed away we almost regretted that the custom followed in a distant part of the country was not preserved in this neighbourhood. When a shepherd dies in a certain part of mid-Sussex, it is the custom to pin a lock of fleece to his breast as he lies in his coffin. This, so that the angels may know he was a Sussex shepherd with little time to spare for regular church attendance, but a devout man notwithstanding.

We all regard the behaviour of a flock of sheep as a sure barometer, and it is worth while rising early to note this. If at sunrise the animals are lying down comfortably asleep, or meditating, fine weather is certain. If, however, they are scattered and restless, rain is coming.

Rhoda Leigh

RED VELVET

Georgie went into his sitting-room next door, where there was a big mirror over the fireplace, and turned on all the electric lights. He got up on a chair, so that he could get a more comprehensive view of himself, and revolved slowly in the brilliant light. He was so absorbed in his Narcissism that he did not hear Lucia come out of her bedroom. The door was ajar, and she peeped in. She gave a strangled scream at the sight of a large man in a glaring red suit standing on a chair with his back to her. It was unusual. Georgie whisked round at her cry.

'Look!' he said. 'Your delicious present. There it was when I came from my bath. Isn't it lovely?'

Lucia recovered from her shock.

'Positively Venetian, Georgie,' she said. 'Real Titian.'

'I think it's adorable,' said Georgie, getting down. 'Won't Tilling be excited? Thank you a thousand times.'

'And a thousand congratulations, Georgino,' she said. 'Oh, and my discovery! I am a genius, dear. There'll be a high table across the room at my banquet with two tables joining it at the corners going down the room. Me, of course, in the centre of the high table. We shall sit only on one side of these tables. And you can sit all by yourself exactly opposite me. Facing me. No official position, neither above or below the others. Just the Mayor's

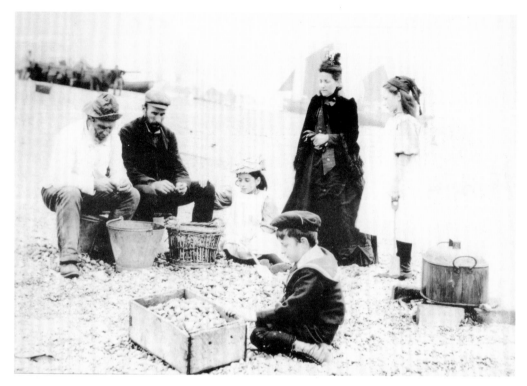

HASTINGS BEACH

husband close to her materially, but officially in the air, so to speak.'

From below came the merry sound of little bells that announced dinner. Grosvenor, the other parlour-maid, was playing quite a sweet tune on them tonight, which showed she was pleased with life. When she was cross she made a snappy jangled discord.

'That solves everything!' said Georgie. 'Brilliant. How clever of you! I *did* feel a little hurt at the thought of not being there. Listen: Grosvenor's happy, too. We're all pleased.'

He offered her his beautiful velvet arm, and they went downstairs.

'And my garnet solitaire,' he said, 'Doesn't it go well with my clothes? I must tuck my napkin in securely. It would be frightful if I spilt anything. I am glad about the banquet.

'So am I, dear. It would have been horrid not to have had you there. But I had to reconcile the feelings of private life with the etiquette of public life. We must expect problems of the sort to arise while I'm Mayor—'

'Such good fish,' said Georgie, trying to divert her from the eternal subject.

Quite useless.

'Excellent, isn't it,' said Lucia. 'In the time of Queen Elizabeth, Georgie, the Mayor of Tilling was charged with supplying fish for the Court. A train of pack-mules was despatched to London twice a week. What a wonderful thing if I could get that custom restored! Such an impetus to the fishermen here.'

'The Court must have been rather partial to putrid fish,' said Georgie. 'I shouldn't care to eat a whiting that had been carried on a mule to London in hot weather, or in cold, for that matter.'

'Ah, I should not mean to go back to the mules,' said Lucia, 'though how picturesque to see them loaded at the river-bank, and starting on their Royal errand. One would use the railway. I wonder if it could be managed. The Royal Fish Express.'

'Do you propose a special train full of soles and lobsters twice a week for Buckingham Palace or Royal Lodge?' he asked.

'A refrigerating van would be sufficient. I daresay if I searched in the archives I should find that Tilling had the monopoly of supplying the Royal table, and that the right has never been revoked. If so, I should think a petition

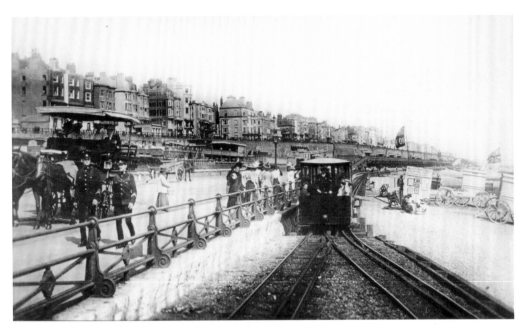

ELECTRIC RAILWAY, BRIGHTON

to the King: "Your Majesty's loyal subjects of Tilling humbly pray that this privilege be restored to them." Or perhaps some preliminary enquiries from the Directors of the Southern Railway first. Such prestige. And a steady demand would be a wonderful thing for the fishing industry.'

'It's got enough demand already,' said Georgie. 'There isn't too much fish for us here as it is.'

'Georgie! Where's your political economy? Demand invariably leads to supply. There would be more fishing-smacks built, more men would follow the sea. Unemployment would diminish. Think of Yarmouth and its immense trade. How I should like to capture some of it for our Tilling! I mustn't lose sight of that among all the schemes. I ponder over so constantly. . . But I've had a busy day: let us relax a little and make music in the garden-room.'

She rose, and her voice assumed a careless lightness.

'I saw today,' she said, 'in one of my old bound-up volumes of duets, an arrangement for four hands of Glazonov's *Bacchanal*. It looked rather attractive. We might run through it.'

Georgie had seen it, too, a week ago, and though most of Lucia's music was familiar, he felt sure they had never tried this. He had had a bad cold in the head, and, not being up to their usual walk for a day or two, he had played over the bass part several times while Lucia was out taking her exercise: some day it might come in useful. Then this very afternoon, busy in the garden, he had heard a long-continued soft-pedalled tinkle, and rightly conjectured that Lucia was stealing a march on him in the treble part. . . Out they went to the garden-room, and Lucia found the *Bacchanal*. His new suit made him feel very kindly disposed.

'You must take the treble, then,' he said. 'I could never read that.'

'How lazy of you, dear,' she said, instantly sitting down. 'Well, I'll try if you insist, but you mustn't scold me if I make a mess of it.'

It went beautifully. Odd trains of thought coursed through the heads of both. 'Why is she such a hypocrite?' he wondered. 'She was practising it half the afternoon.'. . . Simultaneously Lucia was saying to herself, 'Georgie can't be reading it. He must have tried it before.' At the end were mutual congratulations: each thought that the other had read it wonderfully well. Then bed-time. She kissed her hand to him as she closed her bedroom door, and Georgie made a few revolutions in front of his mirror before divesting himself of the new suit. By a touching transference of emotions, Lucia had vivid dreams of heaving seas of ruby-coloured velvet, and Georgie of the new Cunard liner, *Queen Mary*, running aground in the river on a monstrous shoal of whiting and lobsters.

E. F. Benson

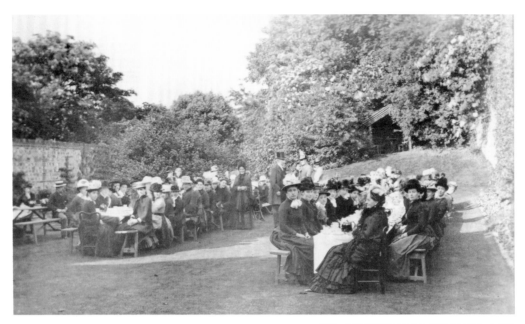

GIRLS FRIENDLY SOCIETY TEA, RIPE

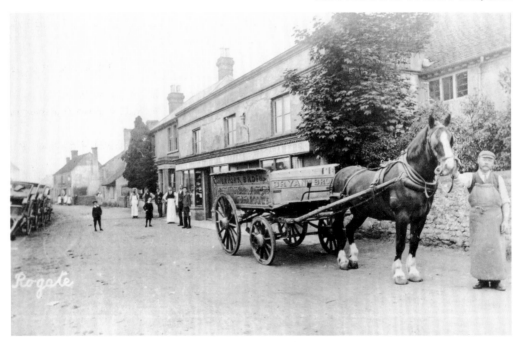

ROGATE VILLAGE STORE

A DAINTY LASSIE

A child came along—a dainty lassie, neatly dressed as today cottage children nearly always are. She was returning to school and carried in her hand a bunch of bee orchids; far too many I thought of a flower so choice and infrequent.

'My dear,' I said 'those are quite interesting flowers. Where did you find them?'

'I know where they grow, but I won't tell you. Teacher said that when we found beautiful and rare flowers we were not to tell everybody.'

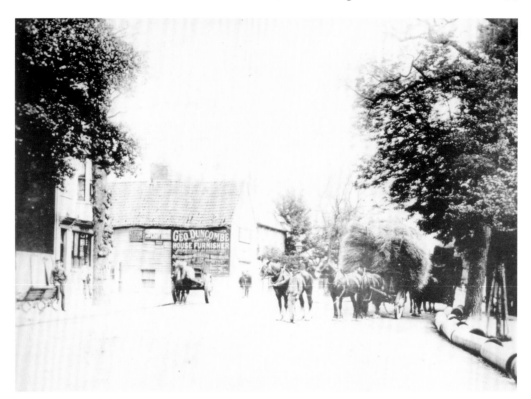

PRESTON VILLAGE

'I am not everybody, but your teacher is I can see a wise woman. But, why did you pick so many?'

My damsel was silent at this. Then she said just what I expected her to say; 'If I had not picked them someone else would. I got there first.'

That is just the sort of answer you get from hosts of unthinking people who go out and gather with wastefulness the treasure of wood and field.

'I think I will go and see your teacher and say "I consider your children are gathering far too many precious little flowers; just look at that girl with the bunch of bee orchids!"'

Then the child behaved artfully and prettily. 'Don't do that and I will give you a nice little buttonhole.'

At once she made a spray of three orchids and set them off with a sprig of wood sorrel and then pinned them on my jacket flap. So I was appeased and I further learned that Mother Eve has some wise little daughters in the world.

Thus adorned I went on my way.

A.A. Evans

SNIPPET

Some of the villages have their own proverbs and customs, but there are few of general use in Sussex, Brand's 'Popular Antiquities' says: 'In West Sussex there is a curious belief that when an infant dies, it communicates the fact itself by a visit, as if in the body, to some near relative.'

Augustus Hare

DOWNLAND DOGS

I have described the sweetest, most musical voice heard in Sussex as that of a young girl in the downs; another downland girl's voice was one of the acutest carrying voices I ever heard in my life. She was shepherding (a rare thing for a girl to do) on the very high downs between Stanmer and Westmeston; and for two or three days during

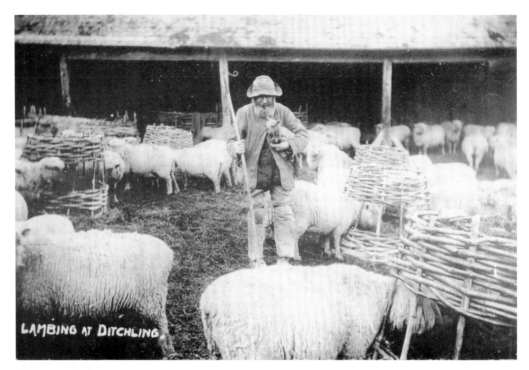

LAMBING AT DITCHLING.

SHEPHERD

my rambles among the hills in that neighbourhood I constantly heard her oft-repeated calls and long piercing cries sounding wonderfully loud and distinct even at a distance of two miles and more away. It was like the shrill echoing cries of some clear-voiced big bird—some great forest fowl, or eagle, or giant ibis, or rail, or courlan, in some far land where great birds with glorious voices have not all been extirpated.

It was nice to hear, but it surprised me that all that outcry, heard over an area of seven or eight square miles, was necessary. At a distance of a mile I watched her, and saw that she had no dog, that her flock, numbering time hundred, travelled a good deal, being much distressed by thirst, as all the dew ponds in that part of the downs were dry. When her far sounding cries failed to make them turn then she had to go after them, and her activity and fleetness of foot were not less remarkable than her ringing voice; but I pitied her doing a man and dog's work in that burning weather, and towards evening on my way home I paid her a visit. She was a rather lean but wiry-looking girl, just over fifteen years old, with an eager animated face, dark skin and blackish fuzzy hair and dark eyes. She was glad to talk and explain it all, and had a high-pitched but singularly agreeable voice and spoke rapidly and well. The shepherd had been called away, and no shepherd boy could be found to take his place; all the men were harvesting, and the flock had been given into her charge. The shepherd had left his dog, but he would not obey her: she had taken him out several days, leading him by a cord, but no sooner would she release him than he would run home, and so she had given up trying.

I advised her to try again, and the next day I spent some time watching her, the dog at her side, calling and crying her loudest, flying over the wide hill side after the sheep; but the dog cared not where they went, and sullenly refused to obey her. Here is a dog, thought I, with good old-fashioned conservative ideas about the employment of women: he is not going to help them make themselves shepherdesses on the South Downs. A probably truer explanation of the animal's rebellious behaviour was given by a young shepherd of my acquaintance. The dog, he said, refused to do what he was told because the girl was not his master's daughter, nor of his house. The sheepdog's attachment to the family is always very strong, and he will gladly work for any member of it; but for no person outside. 'My dog,' he added, 'will work as willingly and as well for any one of my sisters, when I leave the flock to their care, as he will for me; but he would not stir a foot for any person, man or woman, not of the family.' He said too, that this was the common temper of the Sussex sheep-dog; faithful above all dogs to their

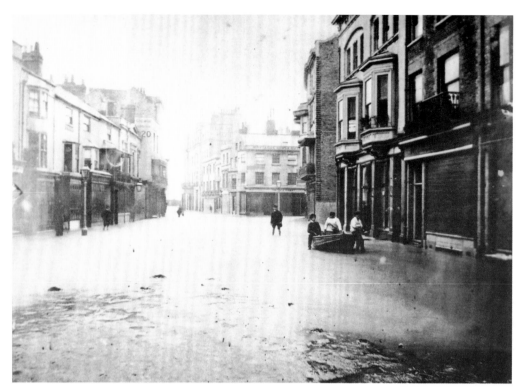

WORTHING

own people but suspicious of all strangers and likely at any time to bite the stranger's hand that caresses them.

I daresay he was right: I have made the acquaintance of some scores of these downland dogs, and greatly admired them, especially their brown eyes, which are more eloquent and human in their expression than any other dog's eyes known to me; yet it has frequently happened that after I had established as I imagined a firm friendship with one, he has suddenly snapped or growled at me.

W. H. Hudson

FLOOD

Terrible Gale—On Monday we had one of the most disastrous gales that has ever visited this part of the Coast. Fortunately this town, of late years, has been more protected by its defences than formerly it used to be; and much of the mischief now caused might have been averted had the Local Board taken proper precautions after the last spring tides, and also prohibited the wholesale removal of the beach which has been going on for months past. The sea on Monday morning dashed over the pier-head, tearing up part of the flooring and doing considerable damage throughout the length of the structure. It flowed over the parade, flooded the Marine-road, and ran up the whole distance of Bath-place and half way up South-street. Many of the shop-keepers were totally unprepared for such a visitation, and the water was knee-deep in several of their establishments. Not a few of the principal shops were entirely closed for some hours in the middle of the day. In one instance a proprietor went out to make the necesary purchases for dinner, but was unable to return, owing to the flood, till long past his usual dinner hour. The inhabitants of Bath-place must have suffered sadly, as the waters rose above their kitchen windows, and poured in in streams through every crack and cranny of the lower part of their dwellings. Some half-a-dozen boats, plying for hire, did an active business for an hour or so in South-street and the Marine-road. Frequently passengers went by boat to the post-office, to leave and obtain letters, etc. The damage done to the sea-front has not yet been ascertained, but it must be very considerable. The beach at Warwick-buildings alone will, we should say, cost a hundred or two to repair. At Navarino corner, the destruction is lamentable, and as you go further east the havoc

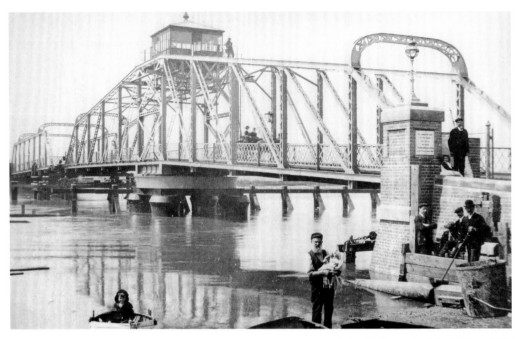

TOLL-BRIDGE, LITTLEHAMPTON

played by the waves is still more disastrous. Higher tides, it is anticipated, are yet to come, and much alarm is expressed at the probable consequences should the wind increase to another gale similar to that just experienced.

West Sussex Gazette

'AS MERRY AS A GRIG'

Occasionally in his conversations with me ol' Martin Malpass, my gardener, makes use of some quaint proverbial saying that is a remnant of the rustic philosophy current in the days of his youth. Sussex proverbial sayings are no longer extant as the small change of conversation; and the morals which they might point, as well as the tales they might adorn are, in these days, presented without such ornaments.

Malpass was relating to me the tergiversations of Baldy's boy. It appears that on a recent day the youth was told off to give him assistance in 'Mucking out the squire's hog pond.' Baldy's boy, however, was disinclined for work; probably he had contempt for Martin's overseership. The old man completed his recital of his assistant's shortcomings by saying, 'He's as saucy as Hinds; he would make a loiter pin to wind down the sun.'

From the context I gather that by this expression Malpass meant that Baldy's boy was not only impudent, but that he was a dawdler as well. I had never before heard the term 'loiter pin', and I asked Martin what it meant.

'Can't say disackly, sir; it's one o' them words we folkses used to say when I was a young man.'

Nor since Martin made use of the term have I been able to track it down. It is in no dictionary I have consulted; nor have my questionings brought me a solution, even from mechanicians who, I thought, might be expected to know it. Martin's complete phrase I have had authenticated by other old Sussex folk, but none have explained 'loiter pin.'*

I have noted down a number of Sussex proverbial saving collected from Martin Malpass and other old Sussexians during a number of years; and I have spent an hour in making a selection from my store. These I present to the reader for the furtherance of his own wisdom.

If you tell me a piece of news that is already known to everybody, I may comment in the Sussex way by saying, 'My Lord Baldwin's dead,' though I should be unable to tell you who Lord Baldwin was. If you are unfortunate you may have 'the Devil's own luck, and your own too.' You may know a 'brewer of mischief who deserves to be drowned in his own mash tub.' If you desire ill for your enemy wish him 'short shoes and long corns.' Do not forget

* The phrase may refer to a delaying pin for the windlass to let down the sun by degrees.

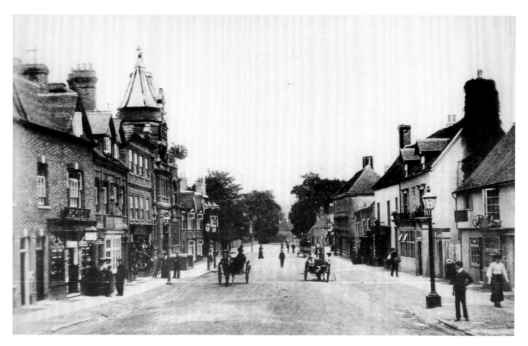

NORTH STREET, MIDHURST

that appearances are sometimes deceptive, for a thing may be 'all glitter, like a brass button in a sweep's eye.'

'If you won't work in the heat you may have to go hungry when the frostes come.' You may, however, be a very worthy fellow. If so I could wish that you may have to 'put up with no worse yoke than that of an egg.' Beware of gluttony, for you may 'eat enough to sink a barge, and drink enough to float it again.' Beware,

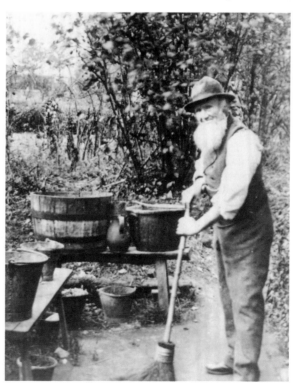

also, of the man who exaggerates for 'he would canter nine miles round a cabbage.' He who has his affairs well in hand is to be commended for 'he has got the fore-horse by the head.'

If you are a hairy man, you may be said to be a 'happy man; a hairy woman is a witch.' 'When a woman wears the breeches you may know that they don't fit the man,' which proves that he is not master in his own house.

You are instructed to beware of the flatterer in the term 'don't trust him who gives you brass love and copper compliments.' If you are one who attempts to achieve the impossible I remind you that 'you can't whistle and eat flour.' If you have a fit of idleness you may know that 'old Lawrence has got hold of you,' though who 'old Lawrence' is I am unable to say.

If you are a true friend you are a 'bread and cheese friend.' If I wish you good I shall 'hope that you'll live till you die, and that every hair of your head will become a wax

SWEEPING LEAVES

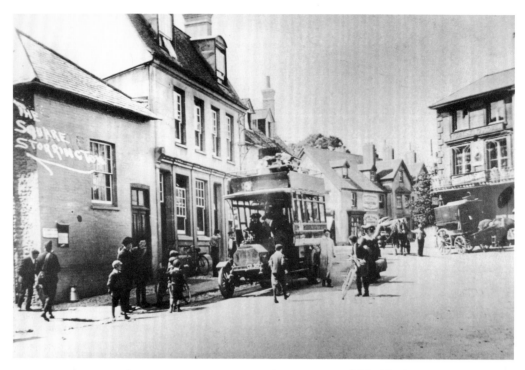

THE SQUARE, STORRINGTON

candle to light you to glory'; or I may hope that your 'big toe may never stare you in the face for want of shoe leather.' You may mean well: 'Well, if you mean well so let you fare well.' As for our nation's enemies, 'I'd have their skin turned into parchment, and our rights written on it.' So 'God bless us all, and the Devil take the rest.'

A chatterbox may be reminded that 'every baa loses a bite'; one may be as 'pert as a tom-tit,' or 'poor and pert like a rat-catcher's dog.' If you are one who makes much fuss over small matters you 'puff and pant like a broken winded robin.' You may be 'as sharp as a rat-catcher's dog at a sink hole'; and a woman with many mischief-loving children must have 'eyes in her elbows to see what's going on behind her.' A cheerful person is 'as merry as a grig' (frog), even though his garden crops are slow to mature, for 'parsley seed always goes nine times to the Devil before it comes up.'

That poverty always has its resources is illustrated by "Tis a poor common where a goose cannot get a bite.' One who suffers extreme poverty may be described as having to 'eat shorn bugs for dinner.' The shorn-bug is a beetle. An evilly disposed person is described as being 'as black as a habbern,' a 'habbern' I believe, being the back of a firegrate. One may be 'as deaf as a bittle,' which is simply a wooden bowl. More cryptic is the saying, 'One shoulder of mutton gets down two,' which probably means you can't have one shoulder off a sheep, but must kill it and take both even if you only want one.

'Nobody likes working for a dead horse'; that is for wages already received. If you hear that a man 'died under the gallows' the phrase must not be misinterpreted, for it means merely that he died of overwork. A vice may be 'like a lawyer: if once it lays hold of you, you don't easily get shut an't' (rid of it). A 'lawyer' in this case means the branch of a bramble bush; though I understand that there are members of the legal profession to whom that proverb might equally well be applied.

A misfortune which affects all alike, and which none can avoid, is called 'neighbours' fare'. Too much of a good thing is 'a faggot above a load': as I do call it a faggot above a load to have to turn out again after my hard day's work. 'One boy is a boy; two boys is half a boy; three boys is no boy at all' is more subtle than is at first apparent.

A person may be 'as hard as a beggar-boy's heart', or 'as hard as a skim-dick,' which means that he may be as

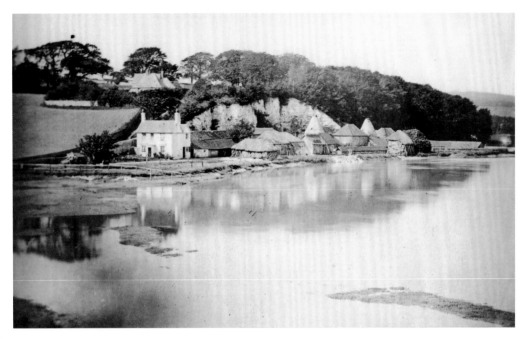

PIDDINGHOE

hard-hearted as the Sussex cheese known as 'skim-dick'—so-called because it is (or was) made from skim milk.

The married woman should remember that

> If you rock the cradle empty,
> Then you shall have babies plenty

and that is the reason why the well-dowered mother avoids the cradle when the baby does not occupy it. An economical cottage wife 'cannot refuse to make little feet fit old shoes,' and if she has contempt for poverty she may wish it 'in a ditch, and the Devil throwing stones at it.'

'If you go nutting on Sunday, Satan will be sure to come and hold the boughs down for you,' was a phrase, I imagine, coined to frighten naughty children.

The saying that 'ill-gotten money does not last' is translated in Sussex by the phrase, 'what is got over the sow's back is mostly spent under her belly.' 'Smugglers gold does not wear' was a variation of this proverb, which was current in the days of 'free trade.' Another traditional saying, applied to one who quickly earns and spends money, is ''Tain't no good to pour in 'at the bung-hole so long as it runs out at the spicket' (spigot).

One of the best Sussex proverbs is applied to a person whose intentions are suspect: 'We've wintered un an' summered un, an' wintered un agen, an' now it doan't sim as if we can trust un.'

An old bachelor is an object of contempt. 'I don't believe in old bachelors; they ought to lie on a bed of nettles, sit on a wooden stool, eat alone from a wooden trencher, and be their own kitchen maids.'

In East Sussex there was a saying, in humorous contempt of the inhabitants of the little village of Piddinghoe, in the valley of the Sussex Ouse, who were said to 'shoe their magpies.' The saying has puzzled many an inquirer, but I think that if we remember that the magpie is mischievous and inquisitive, for 'shoe' understand 'shoo' the puzzle is solved.

Another witticism relating to Piddinghoe declares that the villagers 'hang up their ponds to dry.' A Sussex writer suggests that this saying arises from the fact that whiting was there made from chalk ground in water. After the water had been drained off the sediment was placed on shelves, under pent-houses, to dry.

And again of the same villagers, with reference to their peace-loving habits:

> Englishmen fight, Frenchmen too;
> We doant—we live Pidd'nhoo!

Arthur Becket, The Sussex County Magazine

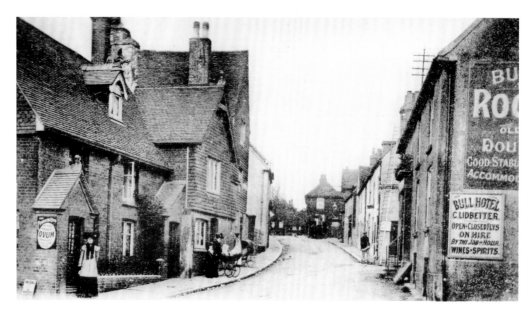

DITCHLING

BUSTLING DITCHLING

Ditchling is a quiet little village on high ground, where Alfred the Great once had a park. The Church is a very interesting and graceful specimen of early English architecture, dating from the 13th century. A hundred and more years ago water from a chalybeate spring on the common was drunk by Sussex people for rheumatism and other ills; but the spring has lost its fame. The village could not well be more out of the movement, yet an old lady living in the neighbourhood who, when about to visit London for the first time, was asked what she expected to find, replied, 'Well, I can't exactly tell, but I suppose something like the more bustling part of Ditchling.'

E. V. Lucas

FOR A BULLOCK THAT HATH A WHIFFING COFF

One ounce of Turmerick, one ounce of vine-crick, one handfull of ye Lungs of an Oak, a quarter of a pound of Lent Figs and Shreed them all small. Boyl them in two Quarts of mild Beer. Then strain it off and give it at four Times.

Rhoda Leigh

WASSAILING

'Hope it don't snow Boxing Day,' observed Mr Swift, munching mince pie.

'Fer why? Yer don't go wassailing now?' asked his wife.

'Well, I did think as I would this year,' he replied sheepishly. 'Our trees ain't 'ad 'alf as many apples since us guv it up, an' Greenfield an' Chris Crapper sez as they'll , come too.'

Just then the dance ended with applause and some guffaws under the mistletoe.

'By the by,' remarked my friend, handing round full glasses, 'you never guessed the answer to my riddle, Mrs Swift—what key is it that unlocks a man's tongue?'

There was silence for a moment, then her husband looked up. 'Whusky, I reckon.'

'Right,' said my friend amid much applause. 'Must you really go now?'

The babies awoke as their mothers rose to their feet. Overcoats and mufflers were fetched. A sleepy child burst out laughing suddenly. 'Bob Wilton 'as got Tommy's hat on.'

This remedied and the lanterns lighted, Mr Swift made a speech. 'A merry Christmas an' thank you one an' all. Us will wassail your trees come Boxing Day, Miss.'

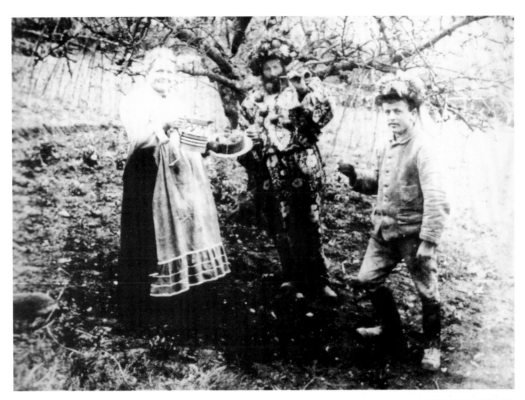

APPLE HOWLING

The lights went bobbing up the hill, a few flakes of snow were falling; the party was over.

Snow covered the garden to the depth of six inches on Boxing Day. Strange marks showed the progress of a fox. Along the road came the wassailing party. Mr Swift carried the horn, contrived by his grandfather from the property of a defunct bullock. Old Greenfield had no business to be out of doors, but there he was, with a red muffler wrapped round his old throat, and enormous snow-shoes impeding his movements. Chris Crapper looked sheepish but had induced Ben Eede to come too. They marched into the garden, stopped at the first apple tree and sang, solemnly blew the horn and moved on to the next tree. After the last had been wassailed we invited the singers indoors to drink hot elderberry wine. Greenfield became reminiscent. 'Everyone what 'ad a tree did get the wassailers in Boxing Day years ago.'

'Gone out it has,' lamented Mr Swift. 'Why, even Tom the postman don't do it now. Says the village holds 'tis just foolishness.'

'Us ain't village though,' argued Chris, suddenly finding his tongue. 'An' I hopes as we'll get more apples up here this year. Since Dad guv it up we ain't had near as many, so now we've tried again maybe we'll get more.'

I am bound to say the prospect of our apple crop is excellent.

Wassailing Song

Here stands a good old tree,
Stands fast root, bear well top.
Every little twig bear apple big.
Every little bough bear apple now.
Hats full, laps full,
Three or four sacks full,
Holloa, boys, holloa, and blow the horn.

Here stands another, good as his brother,
Stand fast root, bear well top.
Every little twig bear apple big.
Every little bough bear apple now.
Hats full, laps full,
Three or four sacks full,
Holloa, boys, holloa, and blow the horn.

Rhoda Leigh

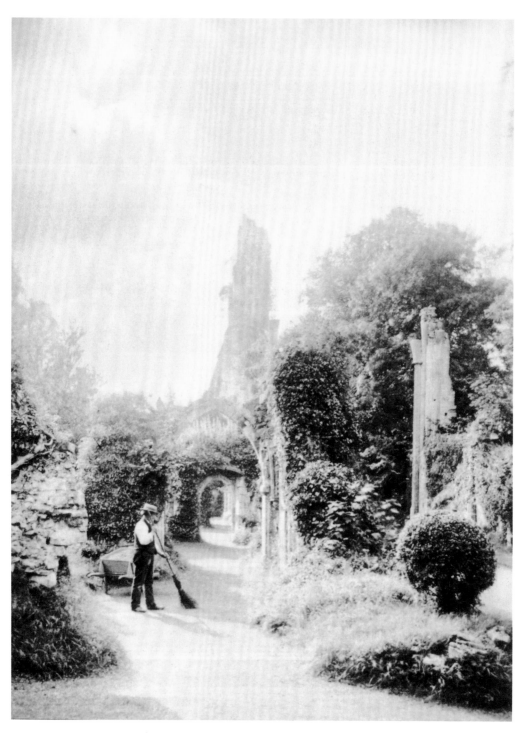

BAYHAM ABBEY

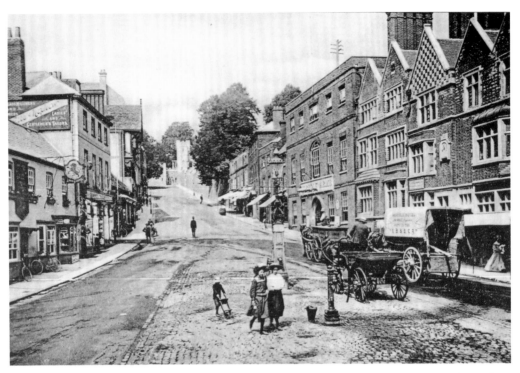

HIGH STREET, ARUNDEL

BAYHAM ABBEY

I wonder how many of my readers know the ruins of Bayham Abbey. It dwells in one of the backwaters of Sussex and is still as remote as when in the 13th century some pious wanderers discovered it, '*quae dicitur Beuliu*', 'a beautiful place'. We sometimes recognise beauty by its contrasts. We all know that dwellers in towns see a loveliness in downs, woods, and fields to which the rustic is insensible. And that tells the story, or in large part, of the Premonstratensian Abbey of Bayham. About the year 1180 Ralph de Dene and his sister—or was it his niece, the cartularies are not clear—for the welfare of their souls and those of father and mother and all good Christians, gave a bit of ground with chapel on it at Otham, just at the edge of Pevensey Marsh, and there some monks—the 'White Canons'—settled, built a small abbey and began to say their prayers. The place was dedicated to St Lawrence, the gridiron martyr, and well they had cause to remember their patron saint. Pevensey Marsh was then little else than a swamp, and these holy men in their retirement were tortured with almost chronic agues and marsh fever. There was too much baking on the gridiron, and Jordan, the abbot, with his monks begged Ela de Sackville for a place where they could serve the Lord less distracted by the devils of the marsh. So, soon after the foundation in 1205, they migrated to Bayham, by contrast a '*Beuliu*'. Otham became only a grange served by two or three of the brethren. Bayham is on the banks of a stream which separates the county from Kent, and there arose a building, in its time one of the fairest in Sussex, and today perhaps its most charming of ruins. The stones give the date: the reader will see the mouldings of the capitals, deeply undercut, of the early 13th century, and there is a graceful, trefoil-headed piscina showing additions of a later date.

Bayham Abbey began to fall into decay, its buildings and its discipline, some time before its suppression. The fact is, monastic life was going out of fashion some years before the end came. Men's sympathies, and the benefactions of the wealthy, began to flow into other channels, especially those with educational purposes, and before the Reformation, Wolsey seized its endowments and used them with others from a like source to rear the noble pile of Cardinal's College at Oxford. So Bayham and Otham live on in a sense among the begowned youth of Wolsey's great College of Christ Church.

A. A. Evans, The Sussex County Magazine

GATHERING FLOWERS

A NEW BARN

'Please, Ma'am,' said an old farmer who had called on my mother, 'will you be good enough to build me a new barn? Mine seems as if it would go to pieces.'

'No,' my mother replied, I am quite unable to lay out so much money.' A pause.

'Well, Ma'am, have you seen my barnyard gate lately?'

'No, what is the matter?,

'It is so broken that the hinges are worn out. In fact, I can hardly open or shut it.'

'I think I can promise you a new gate.'

'Thank'ee, Ma'am, that is all I wanted, but thought maybe if I spoke first about the barn I might get the gate.'

Alice Catharine Day, The Countryman

HUMBLE BEES

This bank we are passing is a favourite winter retreat for female humble bees. Early in the autumn they begin to scoop out a little tunnel in this grassy slope, and when it is deep enough to protect them from the frost they retire into it, and pushing up the earth behind them close up the entrance of the hole, and there lie dormant until the warmth of spring tempts them to come out. Then they may be found in great numbers on the early sallow, and other tree-blossoms, recruiting their strength, while they seek a place in some hedgebank wherein to found a new Colony.

The Carder bee forms its nest on the ground and makes a roof of interwoven moss, from which it takes its lame. I once gathered the moss from such a nest by chance and saw the little masss of cells with honey in them. I went away meaning to examine it more closely on my return, but a crow in the apple-tree overhead chanced to spy the nest and made off with it in his beak before I could rescue the honey store of the poor little bees I had so unwittingly injured.

Mrs Eliza Brightwen

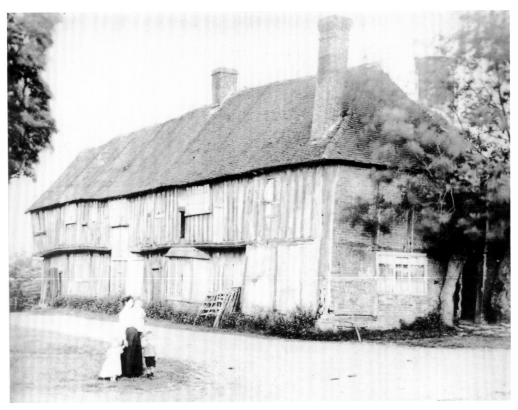

COURT LODGE, UDIMORE

LINES AFFIXED TO AN OLD SUSSEX MILL POST

The windmill is a Couris thing
Completely built by art of man,
To grind the corn for Man and beast
That they alike may have a feast
The mill she is built of wood, iron,
and stone,
Therefore she cannot go aloan;
Therefore, to make the mill to go,
The wind from some part she must blow.
The motion of the mill is swift,
The miller must be very thrift,
To jump about and get things ready
Or else the mill will soon run empty.

Discovered by M. Lower

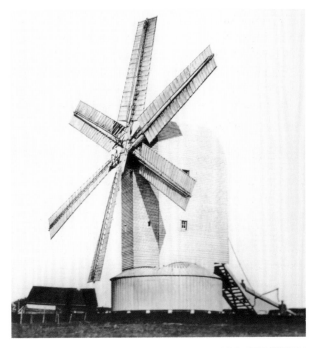

ASHCOMBE MILL, KINGSTON

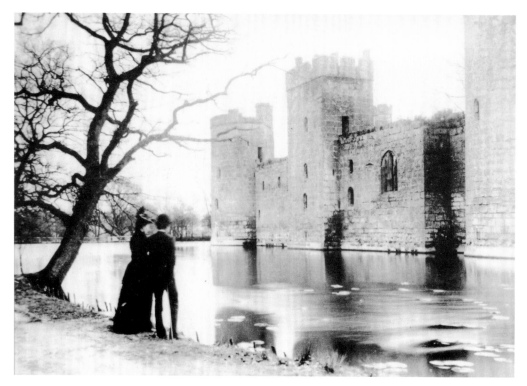

BODIAM CASTLE

BODIAM CASTLE

Bodiam Castle is an immense edifice, scarcely to be called a ruin; for it wants little but re-roofing and re-flooring to be made habitable. It rises on all sides sheer from the water of a little lake—not a moat. There are ten towers, each between seventy and eighty feet high; and, as you approach it from any direction, it has the appearance of a huge mediaeval fortress in perfect readiness for war. If you visit the place, even on a fine summer day, the chances are that you may eat your luncheon on the bank of the lake or in the courtyard in perfect solitude. The few persons who visit the place do so from Hastings—a hilly and tiring drive there and back of twenty-four miles; but the proper way of seeing it is either from Rye or from the Robertsbridge Station on the South-Eastern line. From this station it is only four miles by the marsh; the walk is a beautiful one, nearly all the way on the banks of the Rother. I recommend any one who may take this walk on a hot day to eat his sandwiches on the bank of the Bodiam lake, and not in the courtyard as most people do. The interior of the castle on a still day is a cauldron of unwholesome marsh-air. I was laid up once with a sharp attack of marsh-fever, after enjoying a couple of hours' doze in the chill and refreshing shade; and a medical man who attended me told me that four people out of a picnic party of twenty-six—of whom he was one—had been similarly inconvenienced. The open marshes are not at all unwholesome except at sunset; and there are few places returning so low a death-rate as the little towns on the rocky islets surrounded by these still seas of pasture. A feature of Bodiam Castle which the visitor should not overlook is the great jousting-field, under view from the walls. It is in form and size exactly like that described by Sir Walter Scott in his description of the tournament at Ashby-de-la-Zouche.

Coventry Patmore

THE WEDDING

Hond Sir,—

I takes the libbaty to write these few lines hopping they will leave you quite well as they finds me at present, to tell you 'bout dis here gurt weddin and todo up at Furrel, for I thort as you'd like to have a pertickler and kract

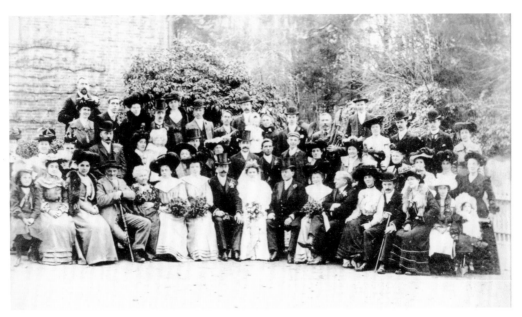

WEDDING OF MAGGIE AND SID DUNSCOMBE

account ont all, to put into de peaper a Saddaday.

'Twas one of my lord's grandarters as was to be married, but I can't spell her name nohows in de wurreld.

Dey do say as she be a gurt favrite of my lord's and no wonder nother, for she's a honaccountable plessan peart young laddy surelye, and tarks to any one jes as free, and as for the rheumatticks!! Lar bless ye! 'Twould make you forgit ye'ed ever had 'em to hear her larf.

Wall, dere was to be over three hunderd people had in to dinner up at the ridin' school; 'twas de cheldern, and de laybrers, and all as was 'bove sixty yeeres of age.

So 'twas over a wick agoo, de passon he comed down our house, and ast me whedder I was 'bove sixty yeeres of age.

'Wall, sir, I sez, 'I doan't jesly know how old I be, but I noos I be 'bove sixty yeeres of age, for ye see I went to work when I was somewheres 'bout nine yeeres old (dat was in old Mus Ridge's time) and I kep on till I was sumwheres 'bout fower and twenty, and den a young woman got me into trouble, and I was force to goo away to sea, but I diddun hold to that no much 'bove six or seven yeeres, and den I come home and got drawed for de meleshia and sarved ten yeeres, and den volunteered for a sodger and served my time fefteen yeeres, and den I come back to de farm, and dere I've worked for fower and forty yeer, till I got quite entirely eat up wid de rheumatticks, and now I ain't done naun for dese las' ten yeeres and sometimes dey be better dan what dey be othersome. So I noos I be 'bove sixty yeeres of age.

But howsomever, I must be gittin on, for de womenfolk, 'ul be wautin to read all 'bout dis weddin.

And, fuss of all, I mus tell you dat I've had a very gurt misfortin, all through along on account of losin a hog; and she jes wos a purty hog tew. I bought her when she warn't but seven wicks old, off old Master Chawbery, time he lived down de street, up agin de church.

Supprisin gurt hog she growed tew be sure!

Dere was a man come from Uckful one day and looked at her; and dere was a man from Lunnon, he see her, and dey both allowed as dey'd never seed sich a hog all dere lives. And she hadn't had naun but three bushels of pollard nother.

Ah, you'd have been pleased to see her, I know. Dere was a many used to come down of a Sunday and looked at her; and old Master Chawbery and me, we'ev stood over de poun whiles people was in church, and rackoned her up and looked her over for hours together; and we both guv it in as she wouldn'd weigh no less than seventy stun.

And she hadn'd had naun but three bushels of pollard nother.

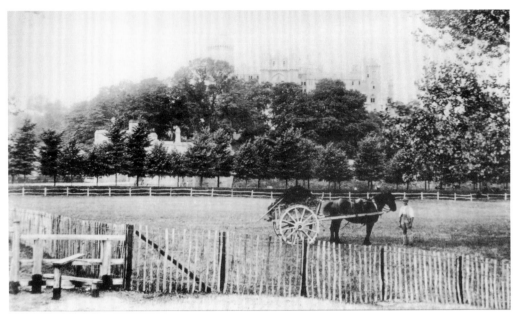

ARUNDEL CASTLE

Wall, one marnin, 'bout three wicks agoo ('twas of a Saddaday) I was gwine ra-ound by de pa-ound, and I looks over, and dere was de hog, seemingly 'bout as common, and pensley I looks round agun, and dere she was all stratched out and gaspin for breath.

So I goos indoors and ses 'Mestress,' I ses, 'de hog be countable ornary.'

'Wall,' ses she, 'dere ail't no call for yew to come spannelin' 'bout my clean ketchen naun de moor for dat,' she ses.

'Ah,' ses I, 'but she be countable had, mestress,' I ses, 'and I dunno but what she be gwine to die.'

'Massy pon me,' ses she, 'gwine to die! Never! Surelye.'

'Yew come ra'ound and look at her, den,' I ses.

Soon as ever she seen her, she ses to me, she ses, 'Why doant ye give her somethin,' she ses, 'standin here!'

So I got down a gurt bottle of stuff what I had from de doctor time my leg was so bad, and took and mixed it ill with some skim-milk and a liddle pollard and give it her, jes lew warm.

But it didn't seem as she was anyways de better for it, and all nex day she kep on getting wus, and she died de Monday night as she was took de Saddaday. And it seemed jes a though 'twas to be, for naun as we could give her didn't do her no good whatsumdever.

Dere was a dunnamany people come and looked at her. And we had her opened, and Master Chawbery he allowed as she was took wid de information.

John Coker Egerton

RESTLESS MAIDENS

A labouring man, out of work and hungry, went one morning into the surgery of a neighbouring parish doctor, sat down, and asked to have one of his teeth taken out. The doctor opened the man's mouth and looked at his teeth, but seeing nothing amiss, said—

'Which is the tooth, friend?'

'Oh, e'er a one you like, sir,' said the man. 'I've got nothin' for 'em to do, so I thought I might as well get rid an em.

The good doctor did not charge his patient anything for looking into his mouth, but gave him a shilling, and told him to go and get his teeth a job for one day at all events.

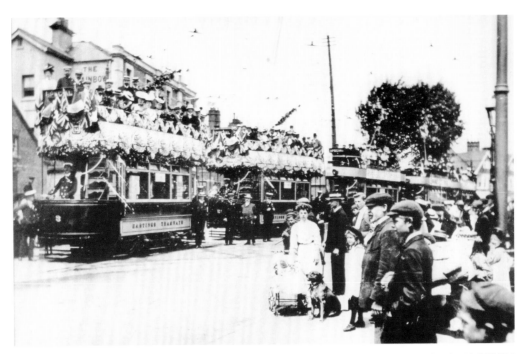

DECORATED TRAMS, HASTINGS

Concerning teeth, not of men, but of dogs, my good friend the medical man of the next parish to my own, tells me that some time ago, as he was calling at a house, the door was opened by a genuine, simple, somewhat uncouth Sussex maiden, past whom rushed out two dogs, which began to snarl uncomfortably near his heels. Not quite liking their ways, he said to the girl—

'I hope your dogs don't bite?'

'I reckon they wouldn't make out much if they didn't,' was the only reply.

It was not all at once that the full meaning of the answer revealed itself to the doctor's mind, but on reflection it struck him that dogs that couldn't bite their food would 'make out' badly in feeding, and he was reassured.

Our native domestics have at times done their share in unconsciously amusing us. A clever young cook who I once knew in this part of the county, used frequently to mention among the advantages she had had, the special one of being for a time kitchen-maid under a religious cook. I chanced one day to inquire the point of view from which this fact was regarded as so beneficial, and the answer I found was this, that the cook being religious had a class in a Sunday school, and that in consequence all the Sunday cooking fell to the lot of the kitchen-maid, whose experience was thereby greatly enlarged.

In former years I knew well a Sussex curate of an uncomplaining turn of mind, whose landlady one morning apologized to him for the charcoal-like condition of his toast, on the ground that the servant had 'cooked it too rash', that is, had toasted it in such a hurry that she had burnt it to a cinder. The mistress had said to the girl—

'Surely you are never going to take that in to the gentleman; why, a dog wouldn't eat it,' or words to that effect.

'Oh, I lay he will,' was the reply, and in the toast had come.

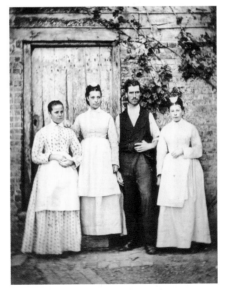

SERVANTS AT GLYNDEBOURNE FARM

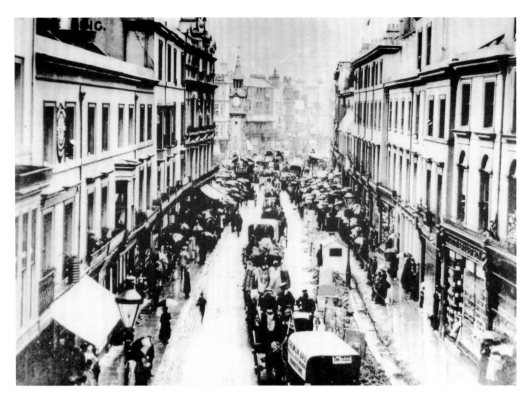

ROBERTSON STREET, HASTINGS

Greater consideration, however, for an employer was, I confess, shown by a young East Sussex cook, who, when on entering upon her new situation she saw the state in which the saucepans had been left by her predecessor, said most feelingly—

'I grieved over them as if they had been my own mothers.'

The doctrine that the present is a restless age, and that the members of a household feel that they need frequent change, is one which, in my own experience at least, is, I am thankful to say, by no means borne out by facts. Still we have some restless maidens, no doubt, as a lady who formerly lived in the parish, and who happened to be in want of a parlour-maid, could testify. She told me that, among other applicants for the place was an uncultivated damsel who did not look much more than sixteen or seventeen years of age. She added—

'I naturally remarked, "You are rather young for such a situation, are you not?" '

'"Oh," said the girl, "I am ever so much older than I look. "

'"But," I inquired, "have you ever had a situation before?"

'"Oh yes, lots!" was the prompt reply.'

The girl was not accepted. Much of the changing of situations, however, among our younger girls is not to be wondered at. They go for their first place to the seaside lodging-houses, where the work is too much for them, and they are obliged to leave.

John Coker Egerton

FILTHY LUCRE

To the Editor of the Observer

Sir,—I have just received your issue of January 4th in which the opinions to the contemplated tram scheme are expressed at such length. Knowing both Hastings and St Leonards and living now at Margate, one is able to compare the advantages or reverse of a town fitted with this mode of locomotion with one that is not, and a few of the disadvantages may well be noted before the irrevocable is brought about.

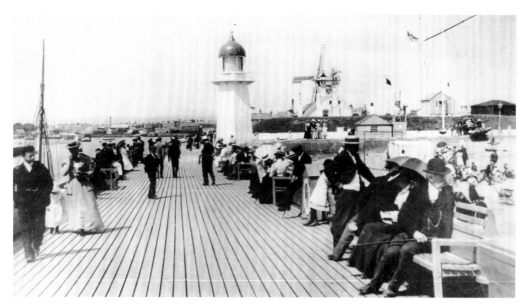

LITTLEHAMPTON PIER

1. – Along the lines house upon house is being vacated, no reduction in rent being apparently sufficient to induce anyone to live within ear-shot of the intolerable noise, which seems a necessary and inseparable evil pertaining to the running of trams. To people in ordinary health it is intolerable, while to invalids the effect is disastrous.

2. – In comparison with St Leonards, Margate is a level plain. It boasts of one hill only. On this several accidents have already occurred, people being injured and property destroyed.

3. – In the main, the roads here are much broader than those at St Leonards, yet carriage accidents are frequent and all pleasure in driving is being destroyed. In a place where the most desirable of the visitors bring their own carriages this consideration is no light one.

Looking at things at Hastings and St Leonards from an impartial standpoint, it would appear that the powers that be in this, one of the Queens of watering places and health and favoured resorts, are ready to sacrifice her beauty and attraction for the sake of a few thousand pounds in hand, regardless of the certain disastrous result. Surely this one of our Cinque Ports is above such a consideration as the acquiring of 'filthy lucre' at such a cost.

Yours truly

EXPERIENTIA
Margate

Hastings & St Leonards Observer

SUSSEX COUNCIL

A local (Littlehampton) proverb says that if you eat winkles in March it is as good as a dose of medicine; which reminds me that Sussex has many wise sayings of its own. Here is a piece of Sussex council in connection with the roaring month:

> If from fleas you would be free
> On the first of March let all your windows closed be.

I quote two other rhymes:

If you wish your bees to thrive	The first butterfly you see,
Gold must be paid for every hive;	Cut off his head across your Knee,
For when they're bought with other money	Bury the head under a stone
There will be neither swarm nor honey.	And a lot of money will be your own.

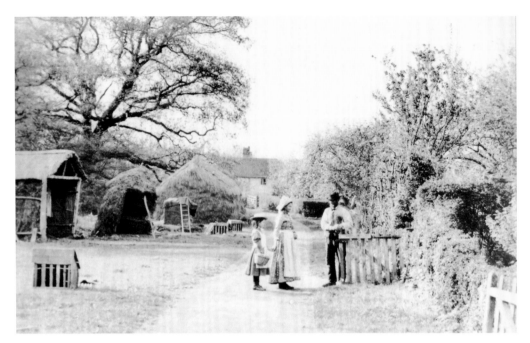

FARM NEAR ASHBURNHAM

On Whit Sunday the devout Sussex man eats roast veal and gooseberry pudding. A Sussex child born on Sunday can neither be hanged nor drowned.

E. V. Lucas

PLATNIX

Selina would never forget the first time she had seen Platnix. It had been years ago, when she was only four, and Moira was only two, and still occasionally called 'Baby'. For a long time she had been wondering when they would get there. Father had said it was only five miles from Hastings, but it seemed as if they must have driven twenty miles at least. She was beginning to feel tired of sitting in the carriage, squeezed between Father and Nurse—for in those days she was too little to sit on the back seat by herself. Moira had fallen asleep on Nurse's lap, and the horses had that strange hot smell that came from them when they plodded up the hills. Selina hated the slowing down of the horses to walk up hill; she would have liked them always to be trotting, with a gay sound of creaking harness and bowling wheels. Father generally told her stories when the hills were long, but already she knew most of them by heart, and no story, however interesting or new, was as lice as going fast.

They came to an old, old cottage with a thatched roof and walls that seemed to lean. She was suddenly afraid that it might be Platnix.

'Oh, father, that's not Platnix, is it?'

'No, indeed it's not. We've another mile to go.'

Another mile. . . she could hardly believe. Yet she was glad that the old, old cottage was not Platnix. She would have been afraid to live in it.

'Father, does anybody live there?'

'Lots of people, I expect.'

'But won't it fall down quite soon?'

'Oh, no, I should think it would stand up another twenty years.'

'Oh. . .' Again Selina was surprised. Then she saw a lovely red-brick house, standing up tall and straight in a field, as pretty as a dolls' house, with a pink roof and a pink porch to match.

'Oh, Father—is that Platnix?'

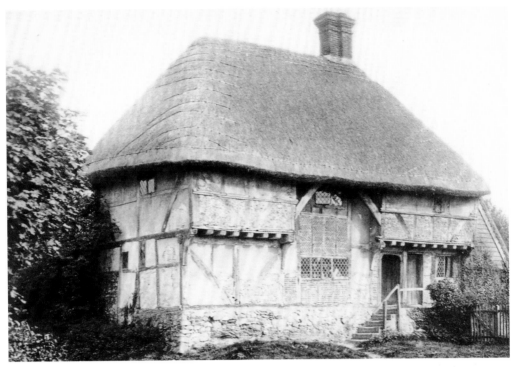

VILLAGE STORE, BIGNOR

No, it was not; and this time she was sorry—it looked so bright and safe. They drove on and on and on, then the carriage turned off the road and went down a lane between high hedges, then through a gate and past some outhouses. And suddenly Platnix appeared, and to her horror Selina saw that it was very old. The roof was all crinkled, waving up and down, and the tiles were covered with patches of green moss and yellow mould.

'Oh, Father, don't let's go in.'

'Why, not Pet?'

'Because it looks so old, and it's sure to fall down.'

At this Nurse said: 'Don't be a silly little girl,' and if Mother had been there she would probably have scolded, but all Father said was:

'Oh, no it won't. It's not really such a very old house. Besides, the part you're going to live in is quite new'- and he showed her that a piece had been added on, with much bigger windows and a new, smooth roof. That was where Nurse and Moira and Selina were to live while Father and Mother went abroad. They would have a bedroom and a sitting-room, and need never go into the old part if they didn't want to.

'And if the old part falls down it won't hurt us?'

'Not in the very least,' said Father cheerfully.

After that she felt brave enough to go in and meet Mrs Huggett, the farmer's wife, who led them into the parlour. It was full of sunshine and in the middle of it was a table laid with blue and white cups for tea. On the mantelpiece were two vases with long branches of apple-blossom. . . and here Selina's first memory of Platnix faded, she could remember no more of that first day. The apple-blossom seemed to end it.

Sheila Kaye-Smith

BIGNOR'S GLORY

Admirers of yew trees should make a point of visiting Bignor churchyard. The village has also what is probably the quaintest grocer's shop in England; certainly the completest contrast that imagination could devise to the modern grocer's shop of the town, plate-glassed, illumined and stored to repletion. It is close to the yew-

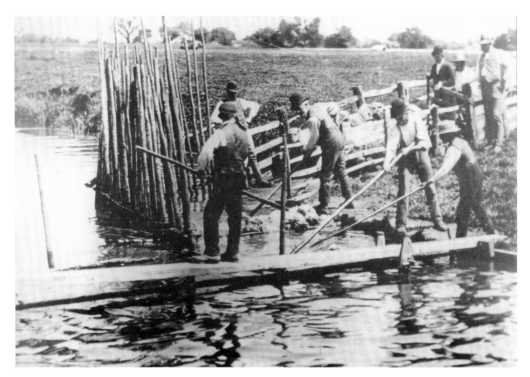

SHEEP DIPPING

shadowed church, and is gained by a flight of steps. I should not have noticed it as a shop at all, but rather as a very curious survival of a kindly and attractive form of architecture, had not a boy, when asked the way to the Roman pavement, which is Bignor's glory, mentioned ,the grocer's' as one of the landmarks. One's connotation of 'grocer' excluding diamond panes, oak timbers, difficult steps, and reverend antiquity, I was like to lose the way in earnest, had not a customer emerged opportunely from the crazy doorway with a basket of goods. It was natural for the boy, whose pennies had gone in oranges and sweets, to lay the emphasis on the grocery; but the house externally is the only one of its kind within miles.

E. V. Lucas

SHEEP WASHING

The water in a little stream at Merston, near Chichester, had been carefully dammed to give a proper depth, and pens had been arranged in which the main portion of the flock were penned ready to be let in to the 'catching pen', which would hold about a dozen neat little Southdown ewes or tegs. Once in this pen the shepherd's assistant caught one of the sheep, and carefully lowered it into the water to where the head shepherd was standing in a barrel moored in the stream. 'Shep' caught the sheep, struggling in the water, gave it a thoroughly good rubbing over the back and loins, turned it over, rubbed the wool growing underneath, then with a shove immersed its head beneath the stream, and letting go, allowed it to swim away.

On the animal's way down stream a man armed with a long wooden pole, to which was affixed an iron arm, guided it towards the landing place, and if it showed a tendency to sink from the weight of water in its wool, the arm was inserted beneath the chin, and the animal was prevented from going to the bottom.

Towards the end of the wash the water became shallow, and the sheep was able to scramble out, and when once on dry land again, it would give a series of mighty shakes to get rid of the moisture, throwing off a cloud of spray. Then it would run bleating to join its companions who were grazing on the sweet grass.

Flockmasters prefer their sheep to emerge from the wash on to grass, for thus they do not instantly become muddy again, as they would do if they came out into a fold on arable land.

SHOE-SHINER

Beer is always provided, and is done ample justice to by those who are engaged in washing, and although we did not hear the 'Froth Blowers' Anthem', we heard many expressions of satisfaction. In the days when all flocks were washed it was well known that the hill flocks required less scouring than those kept all the year round within hurdles on the heavier land of the Weald. The chalky mud quickly dissolved in the water, but the heavier mud would not dissolve so speedily, and thus the sheep were subjected to more of the scrubbing process.

When the flocks reached home again they would be kept off the arable land as much as possible for at least a fortnight. This gave time for the 'yolk' or 'grease' to begin rising in the wool again, and this made shearing easier.

E. Walford Lloyd, The Sussex County Magazine

OLD IRON

The county of Sussex has always been very dear to me. For years I lived near its western border, and later on after Mr Nevill's death in 1878, I went to live in East Sussex, not very far from Heathfield, then still a remote old-world district, which seemed to have been wrapped in slumber ever since the furnaces of the old Sussex iron-masters had been extinguished some hundred years before. In this part of the country a good deal of Sussex iron work, log tongs, fire dogs, rush holders and the like, was still to be obtained. The cottages, in many cases, had discarded such relics of the past, which were thrown out into the fields, or lay, covered with rust, on their garden rubbish heaps. Consequently, I added considerably to the collection which I had begun to form when living near the other side of the county, where I had purchased a

THE SPILLWAY, ASHBURNHAM

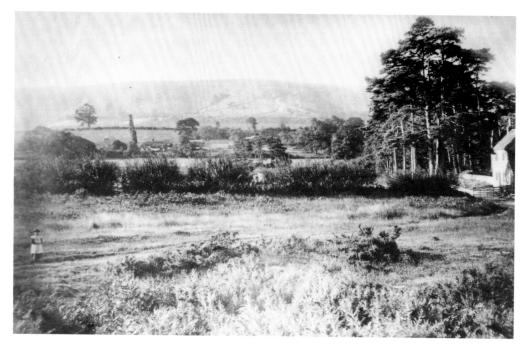

THE DOWNS

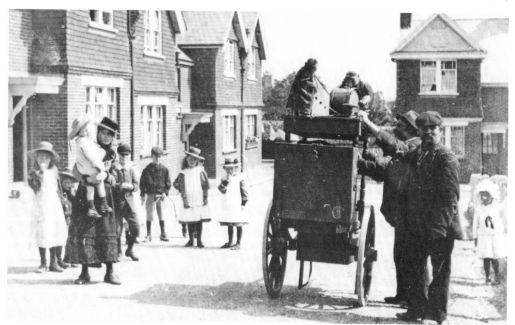

BARREL ORGAN, THE MEADS, EASTBOURNE

good deal of old iron work, principally from Newman of Chichester, a great character in his way, and a staunch believer in matrimony, who once told me that a man might as well do without mustard as without a wife.

People used to laugh at what they called my craze for old iron. However, my collection, now loaned to the Victoria and Albert Museum, has, I believe, become of some value.

The quite, peaceful Sussex of today, gradually alas! owing to the increase of villas, losing something of its sweet rural character, is very different from the county which furnished the guns and shot of the ships with which Drake, Hawkins, and Frobisher harried the invincible Armada of Spain.

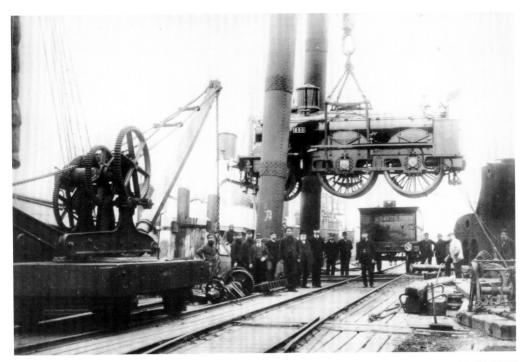

NEWHAVEN

The forty-two forges and iron mills which once sent forth culverins, falconets, firebacks, and irons, plough shares, spuds, and many other implements and ornaments, including the railings of St Paul's Cathedral, have now long ceased to work. With the close of the eighteenth century the Sussex iron-masters saw that the end of their industry was near. The growing scarcity of wood, and the opening of coal mines in Wales, and other parts of the Kingdom, where iron ore was in close proximity to them, were fatal to the Sussex works, which gradually grew fewer and fewer, until the last of them, at Ashburnham, was closed in 1809, the immediate cause of it being the failure of the foundry-men, through intoxication, to mix chalk with the ore, by reason of which it ceased to flow, and the blasting finally ended.

Lady Dorothy Nevill

LOCOMOTION

It would be difficult, or almost impossible. for people living in the early part of the twentieth century, and accustomed to the luxurious and rapid travelling, with all the means and appliances for comfort of the present day to realise that in the forties and even the fifties. of the nineteenth century, the ordinary rate of travelling was only from about six to ten, or at most. twelve miles an hour: that the roads, except the large thorough-fares along which coaches frequently ran, were so narrow that vehicles could only pass with considerable care, that they were mended with flints coarsely broken, it broken at all, and that these were put on in the autumn. and were ground in by the wheels of carts and other vehicles during the next winter, and that, if put on too late, or if the winter happened to be unusually dry, they remained loose all the next summer. Horses with broken knees were very common objects and the jolting of the vehicles, even with the best springs, was very tiring; a journey of any considerable distance was a matter of some importance, and preparations were made days beforehand. There was a common saying: 'A man must go to London once or else he will die a fool,' and going to London was looked on as a great event. My father used to relate that he started on his first visit to London from Selmeston, close to Berwick Station, with his father very early in the morning on horseback, dressed in a new suit of clothes and new top-boots. I can well recollect Queen Victoria coming from London to Brighton by road, and seeing

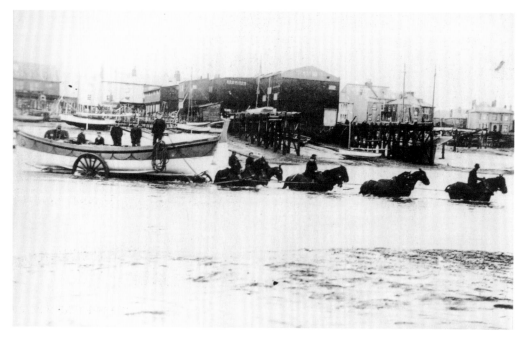

SHOREHAM LIFEBOAT

her in her carriage with her escort round her pass through Pyecombe; and I also recollect the coaches with their teams of splendid horses running between London and Brighton, and presenting a most imposing appearance especially at night when their approach was announced by the bugle and they were lighted up with a number of lamps, and seeming to bear down upon you like a big ball of fire. Horses on the road were frequently frightened by them and I well remember, when I was taken to Pyecombe to see my relations, being kept awake till 10 p.m. or later, because my father was afraid to start on his road home till the last coach had passed. I can also recollect seeing the horses in the windlasses drawing up the chalk from the entrance of Patcham tunnel for the new London and Brighton Railway, which was then being constructed and was looked upon almost as one of the wonders of the world. Owing to the bad condition of the roads, by far the greater part of travelling was done on horseback (the pillion had only just given way to wheeled conveyances for women) and the horse, especially the hackney, was a most useful and necessary animal, and among men, formed the usual and most interesting topic of conversation:—

> Of the good horse that bore him best,
> His shoulder, hoof, and arching crest.

Riding on a good horse through the beautiful lanes of Sussex, rough though they were, on a fine day was most enjoyable, and seemed to give a feeling of freedom and independence which was most exhilarating; and a ride on a fine summer night was, perhaps, even a greater pleasure. Horses always went well at night and seldom shied or stumbled, and to walk along with the rein loose on his neck in those lanes, overshadowed by trees, with all nature at rest, the stillness only broken by the flight and note of a night bird, the barking of a fox in the woods, the tinkling of a sheep-bell or some other occasional country sound was almost heavenly. But there was another side to the picture at times and to ride home ten or twelve miles on a night when it was almost pitch dark and raining hard and the wind blowing in your face, was quite another matter. To those who lived on, or in the country north of the South Downs, when coming from Brighton or any place along the coast, it was sometimes convenient or almost necessary, in order to save distance, to ride across the Downs at any hour of the night, which was very pleasant on a fine light night, but when the night was very dark it was not always an easy matter and required a good deal of experience and judgment. It was easy enough to ride towards any lights, such as the Brighton lamps, but quite impossible to make any use of such light when riding ill the opposite direction, or in hazy weather, when no lights

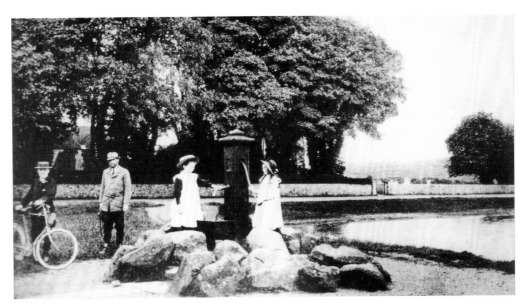

FALMER POND AND PUMP

of any sort could be seen: but by noting the direction of the wind, and keeping a current of air on a particular part of your face, by noting also the position of any familiar object, by a knowledge of the outline of the surrounding hills, and the fact that there is almost always a fringe of light on the edge of the hills, looking on to the Weald, and so defining their outline, it was not difficult to make out the direction in which you were going and to find the way, but on a very dark night, or a thick foggy atmosphere, it was most difficult to steer correctly. Your own ideas of locality seemed entirely to have left you, and if by chance you came across a familiar object, you either did not at first recognise it or it seemed, to your distorted imagination, not to be ill its right position.

N.P. Blaker

A SHEPHERD'S LIFE

The shepherd of the downs, out for the day in summer, has a provision against thirst in his can of water or cold tea, which is usually kept concealed in a furze-bush. To carry water is a precaution which I never take, because, for one reason, I love not to be encumbered with anything except my clothes. Even my glasses, which cannot be dispensed with, are a felt burden. Then too, I always expect to find a cottage or farm somewhere; and the water when obtained is all the more refreshing when really wanted; and finally the people I meet are interesting, and but for thirst I should never know them.

That ancient notion of the value of a cup of cold water, and the merit there is in giving it, is not nearly dead yet in spite of civilisation. Water is the one thing it is still more blessed to give than to receive; and if you approach any person wearing on your face the look of one about to ask for some benefit, and your request is for a drink of water, you are sure to make him happy. This is not said cynically: if by chance one of our millionaire dukes has ever in his life given a drink of water to some poor very thirsty man, he will secretly know that this action on his part gave him more happiness than it did to build a cathedral, or give a park to the public, or to win the blue ribbon of the turf, or even to be Prime Minister.

On one excessively sultry breathless morning, when I had foolishly gone out for a long ramble without my usual protection for the head, I all at once began about noon to suffer intolerably from both heat and thirst. I was probably below par on that day, for I had never felt more parched, even when travelling for twelve hours in the sun without a drink of water; and as to the heat, I experienced that most miserable sensation of a boiling brain—a feeling which associates itself in the mind with the image of a pot boiling on the fire, bubbling and puffing out jets of steam. The nearest inhabited place in sight was a small farmhouse on the crest of a hill about two and a half

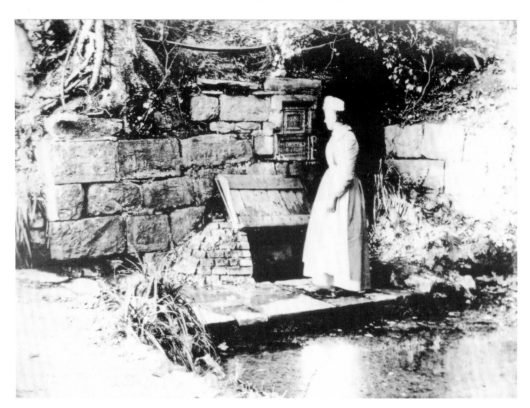

QUEEN ELIZABETH'S WELL, RYE

miles away, with deep hollows and hills to descend and ascend between. But down below me, at the bottom of the valley, not much more than half a mile from where I stood, there was a small, half-ruined, barn-like building, and not far from the building a shepherd was standing watching his flock. To him I went and asked if any water was to be had at that place. He shook his head. 'No well there?' I said, indicating the old stone building. 'Oh yes, there's an old well there; you can drag the stone off, but you can't get any water without a bottle and string.' The fellow's indifference irritated me, and turning my back on him I went and hunted for the well, and succeeded in dragging aside the heavy stone that covered it, to find that the water was not more than about seven feet below the surface. Twisting the band of my tweed hat in the crook of my stick handle, then lying so as to hang well over the edge, I managed to fish up a hatful of water, and drank the whole of it, much to the shepherd's amusement, who had followed me to watch operations. The water was delightfully cold and refreshing, and the well-soaked hat, when I put it on, kept my head cool for the rest of the day.

My hat of an unsuitable material had proved directly useful in that case. The straw hat is of course lighter and cooler than any other; but no person with any consideration for the feelings of a bird ill the matter would think of wearing it, any more than he would think of sporting white or light-coloured flannels. White and black are equally bad for those who go a-birding. There is nothing like tweeds of a greyish-brown indeterminate colour, with a tweed hat to match.

A second amusing adventure, which I had at a farm ill a deep hollow ill the midmost part of the South Down range, where it is broadest, remains to be told. The small grey old house, shaded by old trees, so far removed from the noise of the world ill that deep valley among the great hills, had enchanted me when I first beheld it, and hearing later that the people of the house sometimes took lodgers ill summer, I went to inquire. I left the village north of the downs where I was staying a little after seven o'clock ill the morning, and after being out on the hills for over six hours ill a great heat, visiting many furzy places ill my ramble, I went down to that shady peaceful spot where I hoped to find a home. Some old trees grew on the lawn, and on a chair ill the shade sat a grey-haired man ill broad-cloth clothes, his feet ill red carpet slippers, looking very pale and ill. He was I supposed a

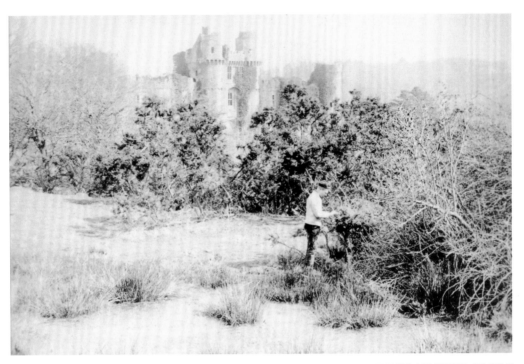

HURSTMONCEUX CASTLE

visitor or guest, and a town man; probably a prosperous tradesman out of health, too old to make any change in the solemn black respectable dress he had always worn on Sundays and holidays. Going on to the open front door I knocked, and after a time my summons was answered by the landlady, a person of a type to be met with occasionally not in Sussex only but all over the country, the very sight of which causes the heart to sink; a large, heavy-bodied, slowminded, and slow-moving middle-aged woman, without a gleam of intelligence or sympathy in her big expressionless face; a sort of rough-hewn preadamite lump of humanity, or gigantic land-tortoise in petticoats. When questioned, she said No, she could not take me in. Yes, she took lodgers and had a party now, they were going, but then another party had engaged to come. She never took but one party at a time—that was her way. Cross-questioned, she said that it didn't matter whether it was a single man who was out every day and all day long or a family of a dozen, so long as it was one party. She laid herself out to do for one party at a time, and had never taken more and couldn't think of taking two—it upset her.

Very well, that point was decided against me; it was now time to say that I had been out walking in the sun for over six hours and was hungry and thirsty and tired—Could she give me something to eat while I rested? No, she could not; it was hard to get anything in such an out-ofthe-way place and the provisions in the house were no more than were needed. Oh, never mind, I returned, some bread and cheese will do very well—I'm very hungry. But there was no bread and cheees to spare, she said. Then, I said, I must make a drink of milk do. There was no milk, said she, or so little that if she gave me any they would be short. Then, I said, getting cross, perhaps you will be so good as to give me a drink of water. She revolved this last request in her dull brain for a minute or so, then saying that she could do that, slowly went away to the kitchen to get the water.

During our colloquy another person, a well-dressed elderly woman, the wife of the man in broadcloth and slippers, had come into the hall and listened. She now dived into her rooms and in a very few moments returned with as much bread and cheese as a hungry man could eat on a plate; then taking the glass of water from the landlady's hand, she insisted on carrying the plate and the glass out to the lawn, where I could rest in the shade while eating. The other woman had meanwhile stared in an uncomprehending way, the dull surprise in her look gradually changing to something resembling admiration. What a strange thing it was that her lady lodger had popped into the hall, listened like a robin to half a dozen words, and understood the whole matter in a flash; and

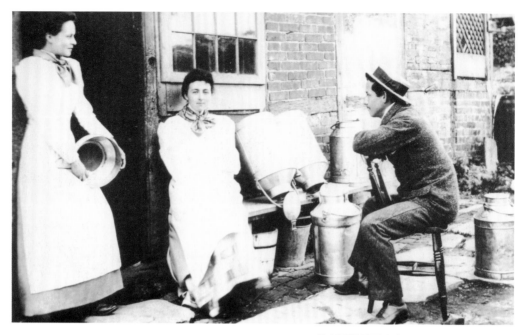

DAIRYMAIDS AND THEIR ADMIRER

that though it was no concern of hers, and she had been asked for nothing, and had her own anxieties and her ailing husband to attend to, she had in an instant supplied my wants. And not only that she had added pleasant words, spoken quite naturally in a nice voice, just as if I had been some one belonging to her instead of a rough-looking stranger. Now she, ponderous earthy soul that she was, could not have spoken in that tone if she had practised the trick for fifty years. Truly her lodger was a wonderful woman!

While eating my lunch I got into conversation with the man in broadcloth and slippers, his wife meanwhile coming and going, now with a cushion for his head or something else for his comfort, or only to flit round us in a bird-like way and see how we were getting on. But when I had finished the water and went back for more, she met me in the hall with a bottle of ginger-beer. Now that is a drink which I care not for on account of its mawkishness, but on this occasion the taste was delicious; and even its whitish colour, which had always been unpleasant to my sight, now looked beautiful, and was caused by a mixture of that precious fluid which is more refreshing and gladdening to the heart than purple wine or any other drink.

W. H. Hudson

BULL-BAITING

On this market-place the Abbot's weekly market—one of the special privileges of the monastery—used to be held every Sunday, and the annual fair still takes place on the 22nd of November. Every one pitching a tent or booth, or tethering cattle on the ground, pays the ancient toll to the Abbey. In the centre remains the old bull-ring, through which passed the rope fastened to the poor animal—a heavy iron ring, bolted to a great block of wood, further secured by two cross beams buried in the ground. Bull-baiting seems to have lingered on in Sussex longer than elsewhere. 'It was one of the legitimate amusements of Whitsun-week, as cock-shying was of Shrove Tuesday, at the close of the seventeenth and beginning of the eighteenth centuries, and was continued at Petworth up to the present one, when it was last put down through the interference of the late Lord Egremont.'—Sussex Archoeolog. Collections. In earlier times there used to be 'a municipal enactment in all towns and cities, "that no butcher should be allowed to kill a bull until it had been baited, " and there was scarcely a town or village of any magnitude without its bull-ring.'—Wright's Homes of other Days. It was not finally forbidden by Act of Parliament till 1835.

Duchess of Cleveland

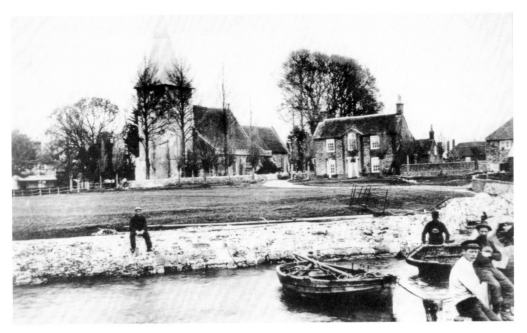

BOSHAM

THE FREEDOM OF THE DOWNS

Here on the summit of the open Down, we can lie in the sunshine and hear the still small voice whisper through the aspen grasses about our ears. What many inflections we find in it, now that we listen! Upstanding, with heedless ears, we miss all these undertones. They come from far and near, from insect and bird, from farmstead and flock, from rustling grass and homing bees, and from the distant murmur of the sea.

As we lie with closed eyes, we may perhaps feel the shadows passing over us, if there are clouds above. How Much beauty they add to the hills! These rolling Downs are pre-eminently the earthly home of the clouds—if any steadfastness can be attributed to such light-o'-loves and wanderers. 'No,'—says a dissentient voice—'surely Marshland is most favoured: there nothing breaks the view!' True, but clouds do not love the marshes. They are the home of the mist. Clouds gather round and among the hills, and where in lowlands they are but mirrored in the pools, in Downland their very shadows become instinct with life. The hills arc their playground. Above, they range slowly enough before the face of the sun; but, look around, how swiftly fleet their giant shadows from hill to hill, joyfully sliding out of sight over each smooth rounded crest into the coombe beyond, and tip the next slope in a twinkling!

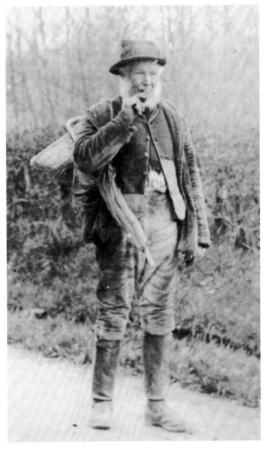

ITINERANT WORKMAN

CHILDREN AT PLAY

Even more beautiful is the progress of the sunbeam when the clouds thicken. The chink is tiny indeed, but the ray widens out till it illumines a great space of turf, and moves slowly onward, like a thought of God for us, neither hurrying nor at rest, but bounteous with blessing.

Just as the early autumn and the harvest bestow the loveliest colours on the Downs, so the summer's largess of unchecked sunshine brings the freshest beauty: skies with blue of deepening tint towards the zenith, and on the horizon massed clouds of creamy white, rising from who knows where? The farthest blue hill ends, and that other blue begins, but the base of the 'cloud continent' emerges from a gradation of azure which is the despair of artists.

And as if to deck the green below with flecks of heaven's own tint, the butterflies of the Downs are mainly blue. One small flutterer recalls the pearly hues of early morning, or that sweet colour round the waning moon when the dawn finds her still awake. Another—the most common, as is meet—reflects the wonted blue of Downland skies, with just that tinge of violet or lilac tenderly blended we love so well; while a third—fitly named Adonis— flits in unequalled beauty from flower to flower, more brilliantly and deeply blue, like to the bluest summer sky. A fourth has splashes only of imperial colour on its wings—as if to mirror the tincture of those rare days when the purple-blue of southern climes seems to reach as far north as even this.

Many other simple wonders are to be seen upon the Downs. The sapphire-blue rampion, called 'the pride of Sussex'—a flower as rare as it is beautiful. The tiny burnet-rose, no taller than an elf, whose blossoms of purest ivory-white bestar the fairy rings upon the sward. Of that other frail bloom bearing also the name of the Flower of Love—the rock rose—it would be hard to say which is the more delicate, the petals or the colour upon them. The exquisite harebells and scabious are in such profusion that, between them, they seem to reflect the sky upon the surface of the grass. The blackberry bushes, pushing out thorny, laden arms towards the passer-by, like some kindly barbarian eager to bestow his gifts, saying 'Take and eat!' And to those who know its haunts, the wild raspberry gives rare refreshment in a waterless land. The timid rabbits; the solitary hare that starts up before you and flees athwart the slope, showing for a moment against the sky and then is gone. The wheatears, and other small birds in flocks, an alternate facet of dark and light as the wings or underwings are seen in spiral ascent.

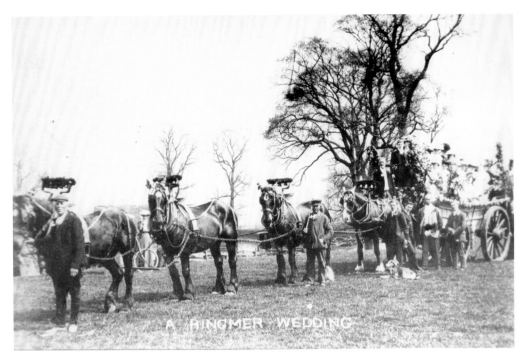

A RINGMER WEDDING

BELL TEAM

Those rascally rooks and their ways, all the more whimsical because they are so serious; the poising hawk and sweeping swallow—these, and the bees, the grasses and flowers, all are there to pleasure us, and we will!

Therefore come with me on such a summer day as I shall choose, and breathe the freedom and air the Downs only can give, and stay among them until the evening closes 'at blushing shut of day.'

Arthur Stanley Cooke

BELL TEAMS

As was pointed out to me when I was a boy, if you carefully examine the old Roman road which runs parallel with the foot of the Downs, or any other old narrow Sussex road, you will find here and there, where it has not been altered and made wider, and remains wide enough for one waggon only, that at certain intervals the bank curves outward on each side for a few yards, and leaves a space sufficient for two waggons to pass. The bells were used to give notice when two waggons were approaching in opposite directions, so that One Could stop in a recess and allow the other to pass. In my younger days a bell-team was by no means uncommon, and the Sound of the bells on a bright sunny morning was perfectly delightful. The bells, which were in perfect tune, were fixed in a frame and carried on the collar of each of the four horses and the carter took the greatest pride in his peal of bells. One was reminded of Theseus' description of his hounds in *A Midsummer Night's Dream*, which ends:

> Slow in pursuit,
> But match's in mouth like bells,
> Each under each.

In former days carters took great pride in their horses and looked well after them and enjoyed seeing them ill high condition with glossy coats. When they went on a journey away from the farm, especially is it were into a town, they used to put the bells on the shoulders of their teams, rosettes on each side of the bridle, the forehead plate (a plate of ornamental bright brass) on their foreheads and plait their manes and tails with bright coloured ribands. It gives rather a pang when one sees the bells used as dinner gongs, and the forehead plates as ornaments in a room.

N. P. Blaker

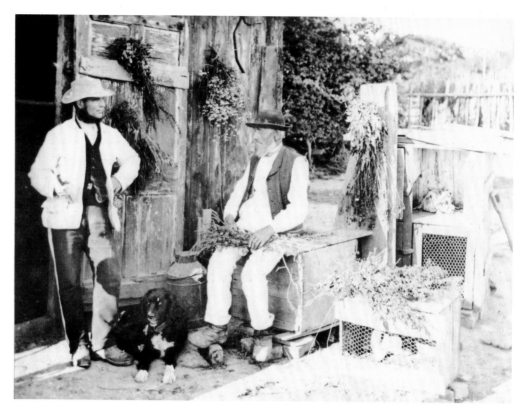

GAME-KEEPERS

SUSSEX WAYS

A Sussex man will not plant early. You may pay him to do so, and if you pay him enough he will do so once or twice; but before you have your garden many years, you will find he is planting again at his accustomed dates. He will not use silos. You may prove to him in a thousand ways that he would be richer for using them. You may pay him as your servant such a wage that he may begin using them, but his abhorrence of a new method of that sort will express itself in the result, that you will lose a great deal of money by your experiment. He will hatch no eggs in an incubator, he will keep no bees in a new-fangled hive. He will give his pig too much barley meal if he can get it, and will remark when he has done so that pigs do not really pay. He will bargain in his traditional fashion if you send him to market, and you will not by any payment or pressure cause him to express dissent in any other manner than by silence.

It will be of interest to watch the near future and to see if his characteristics can be retained as the county gets better and better known, and more thoroughly spoiled by the advent of what is called the leisured class. So far those who have been able to watch this peasant for the last thirty years have seen very little change indeed. And even the noble and rich south country accent, which education was to have destroyed, is as perfect in the little children of the last few years as in the mouths of the oldest men. And that peculiar emphasis upon the latter syllable—Amber*ley*, Billings*hurst*, and the rest—has not disappeared, at least in the western half of the county.

W. Ball

ACKNOWLEDGEMENTS

I wish to acknowledge the help, advice and support I have received from the following in the compilation of this book, without their encouragement and knowledge, so willingly given on every occasion, this publication would not have been possible:

C. R. Davey, County Archivist, East Sussex Record Office: Mrs P. Gill, County Archivist. West Sussex Record Office; Brion Purdey, Principal Librarian, Hastings Library; The staff of Bexhill Public Library for their help in checking copyrights, Ms Mary Laney, Reference and Information Services, Brighton Reference Library; Mr M. Hayes, Principal Librarian, Local Studies, Worthing Reference Library; Mrs R. B. Rector and the Sussex Archaeological Society; Ms Victoria Williams, Curator of Hastings Museum; Miss Brenda Mason, Curator of Bexhill Museum; Miss Penny Johnson, Curator, and Miss Catherine Tonge, Local History, of Towner Art Gallery and Museum, Eastbourne; David J. Rudkin, Director of Fishbourne Roman Palace and Marlipins Museum, Shoreham; The Arundel Museum and Heritage Centre; Ditchling Museum; Horsham Museum, Ken Dixon and Bramber and Beeding Historical Society; Mrs Shippam on behalf of the late Charles Shippam; Willy Bergin for the loan of his many books; and East and West Sussex County Councils for the loan of their many photographs.

While every effort has been made to contact all copyright holders, both authors and publishers, in some instances this has proved impossible and to them I apologise. In this connection credit must be given to the contributors of The *Sussex County Magazine* which was published by T. R. Beckett Ltd, from the first volume which was printed in December 1926, to the final one in the series, volume 30, published between January 1956 and July of that year. The first editor of this delightful magazine was T. R. Beckett.

TEXT

The main sources for descriptive text are N. P. Blaker, John Coker Egerton and articles by various writers published in The *Sussex County Magazine*, volumes 1 and 2 (1927–8).

ILLUSTRATIONS

Many of the photographs held by Hastings Museum reproduced here and those in the John E. Ray Glass Negative Collection, held by the East Sussex County Council and lodged at Hastings Reference Library were taken by George Woods, an outstanding Victorian photographer. He was born on 15 May 1852, the son of a successful draper, a trade which he subsequently entered. In the late 1880s George sold his shop in Wokingham and moved to Hastings, where he spent much of his time taking pictures of the beach and countryside, many between the years 1890–5. George Woods' first wife, Mary, died in 1896, and his only daughter, Margaret, who appeared in many of his photographs in different guises, died in 1911. George married for a second time in 1902: his wife, Ethel Rant, came from a wealthy family and the couple spent many happy years cycling through the Kent and Sussex countryside and his pictures convey not only his love of this but also his abiding interest in Hastings and in particular the fishermen there.

George Woods died in 1934 leaving over two thousand photographs. His wife gave these to Hastings Museum. The glass negatives were acquired by John E. Ray, a local solicitor and collector of historical material, the bulk of these were lodged in Hastings Reference Library. They are the property of the East Sussex County Council and may not be reproduced in any form without prior consent.

I acknowledge both these sources and am extremely grateful to them for the use of their property in the compilation of this book.

Further information on the life of George Woods may be found in a book by Irene Rhoden and Steve Peak entitled George Woods, Photographs from the 1890s from which the above facts were taken.

The pictures held by the Sussex Archaeological Society are all from the Reeves Collection. Edward Reeves' career lasted from 1854–1905 and he operated his business at 159, High Street, Lewes.